D1631706

SCOTLAND CREATES

5000 YEARS OF ART AND DESIGN

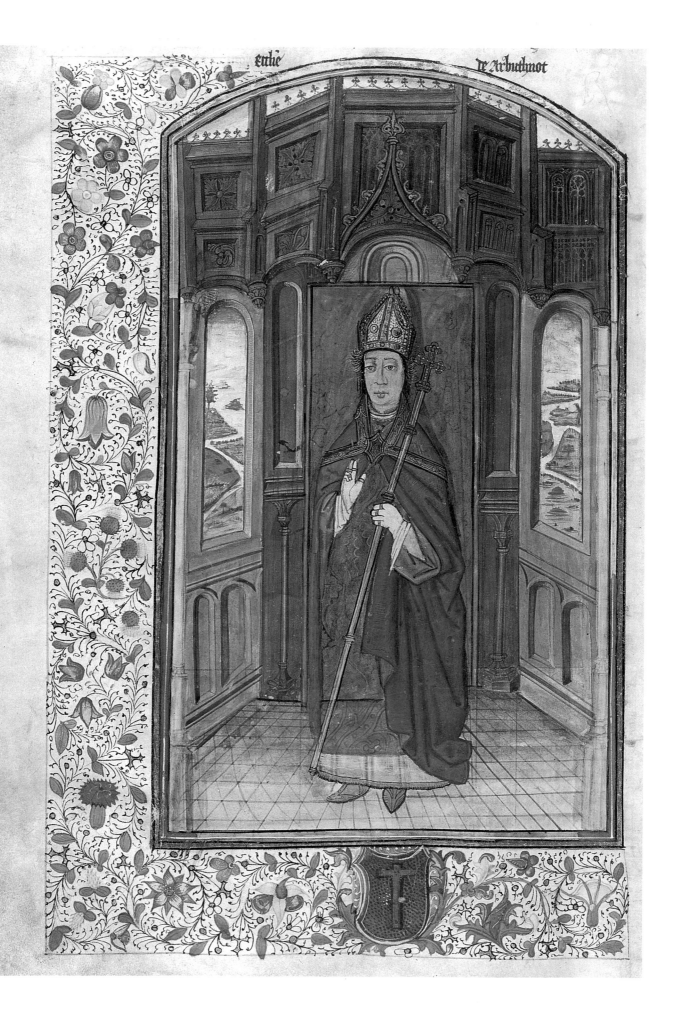

SCOTLAND CREATES

5000 YEARS OF ART AND DESIGN

EDITED BY WENDY KAPLAN

NATIONAL GALLERIES OF SCOTLAND

NATIONAL LIBRARY OF SCOTLAND

NATIONAL MUSEUMS OF SCOTLAND

GLASGOW MUSEUMS & ART GALLERIES

Catalogue published in 1990 in association with

WEIDENFELD AND NICOLSON, LONDON

Copyright © Glasgow Museums & Art Galleries 1990

Published to accompany an exhibition at the McLellan Galleries, Glasgow,
17 November 1990–1 April 1991.

First published in 1990 by
George Weidenfeld and Nicolson Ltd
91 Clapham High Street, London SW4 7TA
in association with Glasgow Museums & Art Galleries
Kelvingrove, Glasgow G3 8AG, Scotland

All rights reserved. No part of this publication may be
reproduced, stored in a retrieval system,
or transmitted in any form or by any means,
electronic, mechanical or otherwise, without
prior permission in writing
of the copyright owners.

British Library Cataloguing in Publication Data
Scotland creates: 5000 years of art and design.
1. Scottish visual arts, history
I. Kaplan, Wendy
709.411

House editors Emma Way and Alice Millington-Drake
Designed by Harry Green

Phototypeset, printed and bound in England by Butler & Tanner Ltd, Frome and London
Colour separations by Newsele Litho Ltd, Italy

Fig. 2.20 Portrait of St Ternan from the Arbuthnott
Missal, *c.* 1491
Vellum, f. 98v: 39.5 × 27.5 cm ($15\frac{9}{16} \times 10\frac{13}{16}$ in)
Paisley Museum and Art Galleries, Department of
Arts and Libraries, Renfrew District Council

CONTENTS

Directors' Foreword

The exhibition and book 'Scotland Creates: 5000 years of Art and Design' represents the first work of collaboration among the National Galleries of Scotland, National Library of Scotland, National Museums of Scotland and Glasgow Museums & Art Galleries. The scope of the project was ambitious – to examine and celebrate the very best that Scotland has produced in the fine, decorative and industrial arts. No single exhibition or book can hope to be comprehensive on such a subject, but the keepers and curators rose to the challenge and presented a representative selection of Scotland's peaks of achievement. Curators at Glasgow Museums worked closely with their colleagues at the three National Institutions to produce an objects list which was then refined with the help of Exhibition Co-ordinator, Andrew Patrizio, and Murray and Barbara Grigor, who devised the exhibition.

The paintings and objects illustrated in this book were drawn largely from the exhibition it accompanies. A team of curators from the collaborating institutions advised Editor Wendy Kaplan on the selection of essay topics and authors; four curators from the National Institutions contributed essays to the book. Written by leading experts in their respective fields, the eleven essays offer a wide range of views on key issues in the history of Scottish art and design. The question of patronage is addressed, from the church's role before the Reformation to the role played by Glasgow art dealers at the turn of the century. Defining what is Scottish about Scottish art is an issue discussed by many of the authors, whether in paintings, bookbindings or interior design. Connections and comparisons provide another important theme – whether between Scotland and Europe, Highland and Lowland art, or Scottish literature and painting. The result is a work that makes a substantial contribution to the study of Scottish art and design, a field too long and unjustly neglected.

The book and exhibition would not have been possible without both Government and private sponsorship. The National Institutions and Glasgow Museums are grateful for a major grant awarded by the Secretary of State for Scotland. We also acknowledge the generous support given by Glasgow District Council. Lilley plc has once again demonstrated its commitment to the arts in Scotland with a substantial contribution to the exhibition. Lilley plc refurbished the McLellan Galleries and it is fitting that they should be associated with the climactic exhibition in the Galleries' 1990 programme – an exhibition which is dedicated to showing Scottish art and design at its best.

TIMOTHY CLIFFORD, *Director, National Galleries of Scotland*

I. D. MCGOWAN, *Librarian, National Library of Scotland*

ROBERT ANDERSON, *Director, National Museums of Scotland*

JULIAN SPALDING, *Director, Glasgow Museums & Art Galleries*

Preface

As European City of Culture 1990 Glasgow celebrates a definition of culture which extends far beyond the City's own boundaries. The variety of contributions to the City of Culture programme has been one of its great strengths but it is right that it should include before the end of 1990 a contribution from three of Scotland's great national cultural institutions, the National Galleries, the National Library and the National Museums of Scotland. Based as they are in Edinburgh, these National Institutions are sometimes too narrowly associated with the capital city and I shall be glad to see some of the greatest of our national treasures on display in Glasgow for this special occasion.

I have been very happy to help fund this innovative collaborative venture, in which the National Institutions have collaborated with Glasgow Museums and Art Galleries on both the exhibition and this related book. In doing so I salute Glasgow as European City of Culture 1990 and I salute the renewed vitality of Scotland's art and design and indeed its cultural activity generally.

MALCOLM RIFKIND
Secretary of State for Scotland

See Fig. 5.17

Preface

The contribution from Glasgow City Council's Museums and Art Galleries to our year as Cultural Capital of Europe has been immense and the exhibition and book 'Scotland Creates: 5000 Years of Art and Design' will provide a fitting finale for the McLellan Galleries to a highly successful and popular programme.

The Director and staff in co-operation with the three National Institutions are to be congratulated for their hard work and initiative in putting together a significant exhibition of much of the best work created by Scottish artists and designers.

The quality of this presentation will be appreciated by Glasgow citizens who are already aware of the contribution made by the often underestimated talents of our compatriots working in ceramics, glass, metalwork, sculpture, manuscripts and books.

This particular exhibition will, I am sure, prove to be one of the highlights of 1990. The book itself is an important examination of what has been done and what has been achieved. It makes a valuable contribution to the exhibition and will enhance our enjoyment of it.

The McLellan Galleries have in the past made an important contribution to the cultural life of the city, indeed prior to the opening of the Art Gallery and Museum at Kelvingrove it was our premier gallery. Now splendidly refurbished and with all the security and environmental controls required of a modern gallery it will continue as a legacy of 1990 fully equipped to play an increasing part in the life of the city into the next century. It is an exhibition gallery that competes with the best in Europe.

My thanks to all those who have contributed to both the exhibition and the book. I am sure both will be enjoyed by thousands and accepted by the art world as yet another triumph in this special year in the history of Glasgow.

COUNCILLOR PAT LALLY
Leader, Glasgow City Council

LILLEY

Lilley plc is delighted to be prime sponsor of 'Scotland Creates: 5000 Years of Art and Design'. The aim of this major exhibition is to chart the high points of Scottish art and design over the centuries. Lilley has been involved in the building and architecture side of the Scottish arts scene since 1918, helping to shape the face of Glasgow as it stands today. It is therefore appropriate that we should be associated with this imaginative project during the city's Year of Culture.

The newly restored McLellan Galleries are an ideal venue for such an event and we are particularly pleased that MDW, a Lilley company, has been very active in its recent restoration. We are sure that 'Scotland Creates: 5000 Years of Art and Design' will prove to be a highly popular and exciting exhibition.

Lewis Robertson

LEWIS ROBERTSON
Chairman, Lilley plc

List of Lenders

Aberdeen City Arts Department, Art Gallery and Museums

Aberdeen University Library, Department of Special Collections and Archives

The Adam Collection

Angus District Council Museums Service, Montrose

Trustees of the Tenth Duke of Argyll

His Grace the Duke of Atholl's Collection at Blair Castle, Perthshire

John Bellany

Biggar Museum Trust

The Marquis of Bristol

British Architectural Library Drawings Collection/Royal Institute of British Architects

British Library Board

Trustees of the British Museum

British Rail Pension Fund Trustees

Dr Iain G. Brown

Syndics of Cambridge University Library

Sir John Clerk of Penicuik

Doug Cocker

Cunninghame District Council

Aedrian and Althea Dundas-Bekker

Dundee Art Galleries and Museums

University of Edinburgh

Lord Eglinton

Kirk Session, Ellon Parish Church

Falkirk Museums

Forbes Magazine Collection, New York

Cyril Gerber Fine Art, Glasgow

Gladstone Pottery Museum

Glasgow Museums and Art Galleries

Glasgow School of Art

Business Records Centre, Glasgow University Archives

Murray Grigor

Hamilton District Museum

Highland Folk Museum, Highland Regional Council

Historic Buildings and Monuments, Scotland

The Patrick Allen-Fraser of Hospitalfield Trust

Trustees of Hopetoun House Preservation Trust

James Howden and Co. Ltd, Glasgow

Hunterian Art Gallery, University of Glasgow

Hunterian Museum, University of Glasgow

Jean Jones

Kirkcaldy Museum and Art Gallery

Gerald Laing

Leicestershire Museums, Arts and Records Service

Dr James Macauley

The Earl of Mar and Kellie

Marlborough Fine Art, London

The Oscar Marzaroli Trust

Mitchell Library, Glasgow

Trustees of the National Galleries of Scotland

Trustees of the National Library of Scotland

National Maritime Museum

Trustees of the National Museums and Galleries on Merseyside

Trustees of the National Museums of Scotland

National Trust

National Trust for Scotland

The Duke of Northumberland

Paisley Museum and Art Galleries, Department of Arts and Libraries, Renfrew District Council

Andrew McIntosh Patrick

Perth Museum and Art Gallery

Flavia Philips

Röhsska Konstslöjdmuseet, Gothenberg

The Earl of Rosebery

The Duke of Roxburghe

Royal Commission on the Ancient and Historical Monuments of Scotland

Royal Photographic Society

Royal Scottish Academy

University of St Andrews

Trustees of the Science Museum

Scotch Myths Archive

Keeper of the Records of Scotland, Scottish Record Office

Jean Smith

University of Stirling, Fergusson Collection

City Museum and Art Gallery, Stoke-on-Trent

Session of Strathblane Church

Lord Strathnaver

Trustees of the Tate Gallery

Board of Trustees of the Victoria and Albert Museum, London

Wave Energy Project, University of Edinburgh

Acknowledgements

'Scotland Creates: 5000 Years of Art and Design' collects together exhibits of exceptional quality which represent the peaks of achievement in Scottish art and design through the ages. At its inception, three curators from Glasgow Museums & Art Galleries – Andrew Foxon, Jonathan Kinghorn and Sheenah Smith – did substantial work in compiling preliminary lists of artefacts and themes to illustrate this idea.

In time, the project developed into a collaboration with the National Institutions, and colleagues from Edinburgh were invited to assist with the selection of exhibits. We would like to thank the following for sharing their knowledge and for offering valuable advice: Iain Brown, David Bryden, Charles Burnett, David Caldwell, Hugh Cheape, David Clarke, George Dalgleish, Patrick Elliot, Lindsay Errington, Godfrey Evans, Kenneth Gibson, Virginia Glenn, Keith Hartley, Brian Hillyard, James Holloway, Dale Idiens, Alan Marchbank, John Morris, Fiona Pearson, Alison Sheridan, Sara Stevenson, James Wood, Elizabeth Wright and Elspeth Yeo.

As well as the three curators, other Glasgow Museums & Art Galleries staff whose specialist advice has been greatly appreciated are Geraldine Glynn, Judith Wilder, John Clayson and Deborah Haase. We would also like to thank all members of the four collaborating institutions who have helped with curatorial, conservation and installation tasks relating to the exhibition. In the initial planning of the exhibition we benefited immeasurably from the presence of Wendy Kaplan. Her expertise and knowledge of the organizational problems in an exhibition of this nature proved invaluable.

Amongst the individuals outside the four institutions we would like to thank the following: Annette Carruthers, Ian Gow, Tessa Jackson, Margaret MacLean, Robert Palmer, Michael Preston and Wendy Stephenson, and the members of the design team who have helped to realize such an ambitious scenario for the exhibition: Andrew Semple, John Leonard, Graham Metcalfe, Antoinette and Trevor Watkins and to Store Design Havelock plc who gave generous support on building the major exhibition constructions. Finally, a special thanks to all the lenders, both private and public, national and international, who so generously parted with their material for the duration of the exhibition.

ANDREW PATRIZIO
Project Co-ordinator

MURRAY AND BARBARA GRIGOR
Exhibition Designers

The completion of the book would not have been possible without the assistance of a number of people. First, thanks must be extended to the curators at Glasgow Museums and the National Institutions who advised on the selection of chapter topics and authors: Sheenah Smith, Jonathan Kinghorn, Andrew Foxon, Iain Brown, John Morris, Keith Hartley and David Caldwell. Jenni Calder, Publications Officer at the National Museums of Scotland, also provided help and advice.

We gratefully acknowledge the assistance of the staff at collaborating and sister institutions, who provided photographs and caption information at short notice. Deborah Hunter at the National Galleries of Scotland and Shona McGaw of the Royal Commission on the Ancient and Historical Monuments of Scotland deserve special thanks for processing large numbers of photographic orders quickly and with great courtesy.

Sheenah Smith devoted many hours to a careful review of all the manuscripts; her comments and suggestions were both useful and insightful. Andrew Foxon, Sally Foster and Alison Sheridan generously assisted John Barrett in preparing his chapter. Hugh Stevenson and Andrew Patrizio read several of the chapters on painting and offered helpful comments. Special thanks are due to Jean Pollock and Margaret Sutherland of the McLellan Galleries not only for their word-processing skills but also for their assistance with many of the organizational details.

Finally, thanks are due to all the scholars who contributed to the book for their timely submissions of manuscripts, willingness to make changes in their text in the interest of greater unity for the entire work and, most important, for the very high quality of their essays.

WENDY KAPLAN
Editor

INTRODUCTION

WENDY KAPLAN

What is Scottish about Scottish art and design? An attempt to define a national identity pervades most of the essays in this book. From this issue other themes emerge concerning patronage, interaction with European countries and the turbulent relationship with England.

From the beginning, a Scottish identity was inseparably linked to the assimilation of foreign influences. Monarchy and the Christian church – the two institutions that were to unify the various peoples inhabiting Scotland two thousand years ago – were themselves in large part Irish imports. In the first essay, where John Barrett discusses the small-scale communities of pre- and early history, one sees how the conversion to Christianity and development of an aristocracy led to the creation of a much larger shared culture.

John Higgitt analyses the role of the medieval church as a patron and focus of the arts and the church's essentially international nature. From the twelfth century onwards, many of the monastic houses had close ties with orders in England or France, craftsmen often came from abroad and much art was imported. Higgitt does suggest that, although Scottish medieval art was strongly influenced by England, France and the Low Countries, by the fifteenth century, a vigorous Scottish vernacular style was beginning to emerge, particularly in architecture.

The question of how native and foreign traditions came together to form a distinctively Scottish art is central to David Caldwell's essay. He asserts that the art of the Highlands, from the fourteenth to the nineteenth century, demonstrates far more qualities indigenous to Scotland than did Lowland art. The Highland Scoto-Irish tradition was characterized by interlace, animal heads and highly-charged surface decoration. The designs of surviving shrines, standing stones, carvings, brooches and decorated weapons were predominantly Celtic, in contrast with the Lowland work, which was fundamentally European and reflected a culture of cities and towns. (Trade links with Europe were centred in the Lowlands, as were the Scottish kings with their ties to royalty throughout the Continent.)

Many of the essays address the consequences of historical events, since an understanding of them is essential to an appreciation of Scottish art. The three greatest upheavals arose from the Scottish Reformation in the sixteenth century, the Union of the Crowns of England and Scotland in 1603 and the Act of Union of 1707, whereby the independent Scottish Parliament became part of a single Parliament of Great Britain.

In discussing what survives of medieval churches, sculpture, metalwork and illuminated manuscripts, Higgitt highlights what was lost as a result of the Reformation, when much of Scotland's ecclesiastical art was destroyed by the followers of John Knox. The new reformed church was austere; since all religious imagery was rejected as idolatrous and Popish, churches

had to remain unadorned. Scotland's radical Protestantism not only deprived painters and craftsmen of Church patronage but also left a legacy of deep suspicion towards all the visual arts that lasted for centuries.

There was one art form, however, that was actually encouraged by the Protestant church – that of the book. As John Morris explains, printing played an important role in the Reformation. Calvinism and the Reformed Church of Scotland emphasized that the will of God is manifested in the Bible; therefore, all good Christians should be able to read it, a radical assertion even in an age of increased literacy. The printed word thus assumed an importance in Scottish culture that it had never previously received. While churches were stripped bare (with singing only permitted unaccompanied) and theatre banned, bookbindings were elaborately decorated and, in the seventeenth century, a unique native style developed.

The Union of the Crowns in 1603 had a devastating effect on Scottish art, depriving the country of the other major source of patronage – the royal court. The period of the Commonwealth and the Restoration was precarious for artists (indeed for any professional); James Holloway points to John Michael Wright as an example of a Catholic artist who found it advisable to leave Britain in the 1680s because of his religion. The union of the Scottish and English parliaments in 1707 meant the further concentration of influential people and hence patrons, in London. From the early seventeenth to the end of the eighteenth century, most of the best Scottish painters had to leave their country for long periods in order to study and to secure commissions; training in Italy was usually followed by residence there or in London. Yet the influence was not all one way; for example, Scottish artists, architects and antiquaries in Rome were the pioneers of the neoclassical movement and, more specifically, Holloway's essay discusses the influence of Gavin Hamilton on the French painter Jacques Louis David.

The greater ties between England and Scotland were not always deleterious for the latter. The Act of Union removed trade restrictions, thereby leading to a new prosperity that would foster the arts. Although the closer political bonds were accompanied by greater stylistic influence from England, Scottish architects, artists and designers flourished in the eighteenth and early nineteenth century. Art schools were established (making it possible for the first time to give aspiring artists formal training in Scotland), exhibition societies founded and private patronage extended by a new class – the wealthy industrialist. Ian Gow notes that the Scotsmen Colen Campbell and James Gibbs became the leading architects in England in the 1700s and that, later in the century, Robert Adam became the most celebrated neo-classical architect in all of Britain. Allan Ramsay, William Dyce and David Wilkie were among the most successful painters in both Scotland and England (for years the Royal Family refused to sit to any other painter than Ramsay). John Hume's essay discusses Scottish industrial design leadership during this period in iron founding, engineering and shipbuilding. The philosopher David Hume queried in 1757, 'Is it not strange that, at a time when we have lost our Princes, our Parliaments, our independent Government, even the Presence of our chief Nobility … that, in these Circumstances, we shou'd really be the People most distinguish'd for Literature in Europe?'

Scottish achievements in the arts and sciences should not obscure the country's frustration at the exodus of political power and the national loss of confidence that followed the Union. Ironically, it was literature that played an important role in helping to re-establish a strong Scottish identity and national pride. From the poetry and historical novels of Walter Scott emerged a romantic view of the Scots as a fearless people imbued with integrity, spirit, folk wisdom and humour in the face of great suffering, inhabiting a dramatic, untamed landscape of mountains, glens and waterfalls. His vision of the tragic but noble Scot was embraced throughout Europe and created an industry for all things Scottish. Lindsay Errington emphasizes that 'Scott's importance for the national school of painting throughout the century can scarcely be overestimated.' Not only did he provide painters with subject matter but his work helped validate the worth of a new narrative school of painting that drew its subject matter from the Scottish landscape and past. While both Scott's novels and the paintings of David Wilkie, John Phillip and John Pettie present a nostalgic, idealized view of the past, they restored the country's pride in its heritage.

This attempt to recapture lost 'Scottishness' assumed another form at the turn of the century. Elizabeth Cumming analyses the impact of the Arts and Crafts

movement, with its celebration of the vernacular, on design in Edinburgh. The Arts and Crafts movement there can be considered in part as a continuation of Scott's and his circle's reverence for an earlier idealized era when Scottish society was seen as unified and values as still pure. Patrick Geddes and other leaders added to this romantic nationalism a moral aesthetic: a passion for handcraftsmanship, for employing only those styles that had evolved as a response to Scotland's own landscape and traditions and for reviving art forms associated with a better, simpler past such as bookbinding, hand weaving and mural decoration.

The issues of nationalism and a Scottish artistic identity continue throughout the twentieth century. No consensus exists regarding how to define the nature of Scottish art and *Scotland Creates* reflects a wide diversity of opinion about the issue. Tom Normand protests against those artists whose work he sees as feeble imitations of the Fauves, as 'counterfeit French style'. Subscribing to the philosophy of the poet and critic Hugh MacDiarmid, Normand considers art 'Scottish' if it was inspired by the country's own culture. The artists who have expressed a national identity are those who have examined 'the Scottish landscape and the Scottish people within the figurative tradition'.

By giving approbation only to those artists who chose Scottish subject matter and by viewing international styles such as modernism as a submergence of national identity, Normand differs from many other points of view expressed in the book. James Holloway and Roger Billcliffe judge art in terms of its inherent merit: if the person was Scottish and produced excellent work then he or she was a Scottish artist. In contrast to Normand, Holloway praises artists who have participated in a larger European arena; for example, he notes with approval that, 'whereas the magnificent portraits of his contemporaries, Reynolds and Gainsborough, remained essentially British in style, Ramsay's work was truly international'. He brings this opinion up to the present, seeing the Scottish Arts Council's renting an apartment for artists in Amsterdam as 'a positive step in fastening Scottish art securely to Europe'. While Billcliffe identifies which aspects of the Glasgow Boys' style were of French inspiration and which were Scottish in origin, he does not judge one superior to the other. Furthermore, he identifies what is Scottish about the Glasgow Boys' approach to painting

more by technique than by subject matter, stating: 'A fondness for the liquidity of paint, a sense of craftsmanship in its manipulation and an awareness of the power of colour identifies the best of Scottish painting during the nineteenth century.'

This 'painterliness' or materiality is one aspect of Scottish art since the seventeenth century that most of the authors agree is integral to a national identity. Normand points to MacDiarmid's assertion that the Scots had most distinguished themselves in practical areas – in shipbuilding, engineering, industry and science – and that these 'should become the example and model for an authentic Scottish art'. Hume lauds the Scottish affinity for the well-made object, which he sees manifested not only in industrial design but also in paintings and architecture, and relates to the Rationalist inheritance of the eighteenth-century Enlightenment. Although the question of what is Scottish about Scottish art and design is still an open one, no doubt should remain about its quality nor of the myriad contributions the country's artists, designers and craftsmen have made to European culture over the centuries.

EDITORIAL NOTE
Unless otherwise stated:

Dimensions are taken at the widest point. Dimensions of paintings, architectural drawings and books are given with height preceding width; all other media are given as height by width by depth. The following abbreviations are used: d. (diameter); h. (height); w. (width); l. (length).

All photographs were taken by the institutions which own the objects.

All objects are considered to be Scottish unless another country of origin is specifically stated. Scottish in this context means the artist, craftsman or manufacturer either was born in Scotland or worked there.

Circa (*c.*) indicates that the object is not dated but stylistic or documentary evidence points to that date.

ART AND DESIGN, 3000 BC–AD 1000

JOHN C. BARRETT

Introduction

Neither the term *art* nor the term *design* have meanings which we can regard as fixed. Any survey must begin by recognizing that the use of these words can lead to the misapplication of present day assumptions upon past circumstances that were quite unlike our own. We sometimes talk about art as a medium of individual expression which challenges the aesthetic judgement and interpretive skill of an audience; such a view of art has no general validity even within recent European history, and is quite inapplicable to the periods covered here. When archaeologists speak of 'art', be it applied to Palaeolithic representations on cave walls, or to the 'Celtic Art' of Iron Age metalwork, they mean that these representations have some aesthetic appeal for us today. This says little about the ways such representations were created, used and understood in those earlier periods. Similarly 'design' evokes the idea of a planned form; implying knowledge and intention, and a technology through which both may be executed. However, the past is different simply because of the differences in the ways such bodies of knowledge were maintained, the differences in peoples' intentions, and the differences in the technologies of execution. There is no timeless logic behind the concept of 'design'. An example of the kind of muddle which can arise when we apply the logic of our own world to an interpretation of the past may help to make the point.

Some four thousand years ago a large number of stone-circles were erected within the British Isles. Detailed surveys of these monuments show that many of them are not true circles, but that they may be *described* as arcs of stones. Description in such geometric terms is a modern technique and it is quite wrong to assume that a similar geometry must also have been used to *design* these 'circles' originally. Indeed a very good case can be made for quite different, but equally complex procedures being used to create these monuments. There may never have been a single 'original design' to be recreated through the setting up of the stones. We should not assume that the language *we* use to describe the monument is the same as the original language of execution.

This introduces a question which is fundamental to the study of humanity; to what extent and upon what basis is an understanding of other people possible? For the case that the concepts 'art and design' change through time to be made, some common baseline against which such changes can be recognized must be established. The differences that make up the past must be capable of being described in our own terms if we are to understand them. Thus the constant struggle for the archaeologist, historian or anthropologist is to render other human actions understandable to us, without, at the same time, reducing those actions to the same cultural, political, economic or social motivations as our own.

These issues are introduced here for two reasons.

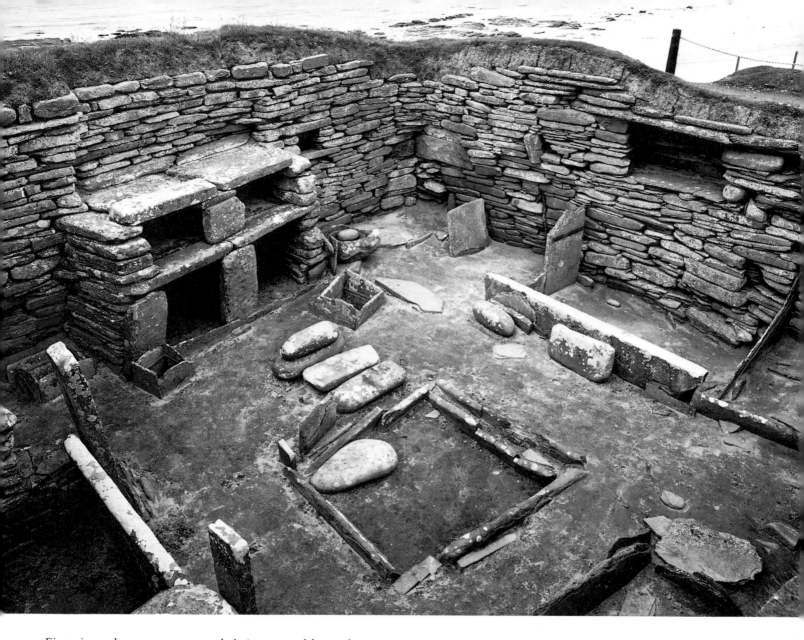

First, in order to treat *art* and *design* as problems that archaeologists have to resolve through their study of the material rather than as firm categories from which to start. Second, to make clear that such study must nonetheless originate from an analytical framework that allows the identification of differences in the definitions of art and design in a way which makes them comprehensible. What form can such a framework take? The range of the material is after all vast, covering artefacts which were made and used by communities inhabiting what is now Scotland over a period in excess of four thousand years. However, one feature is common to nearly all these communities, namely, that they belong to what we might call 'small-scale societies'. Such societies can be defined as those where all social transactions take place on a face-to-face basis. Our understanding of art and design must be considered in this context, since the artefacts with which we are concerned will have been intimately connected

Fig. 1.1 Skara Brae, House I interior (Orkney), 3100–2500 BC
Photo: Historic Buildings and Monuments, Scotland (Edinburgh)

with this very localized, face-to-face communication and exchange between groups of people.

When any person enters the presence of another they do so generally knowing how to act and what might be expected of them. They therefore carry certain expectations with them, and such expectations enable us to operate effectively. When we feel out of place we often become silent or clumsy, we do not know what to expect and look around for clues as to how to proceed. All our actions are guided by our expectations and our ability both to understand what is going on around us and the responses we are getting from others.

Effective action by participants in such day to day, and often routine, activities, involves the use of a large number of cultural assumptions about how the world

should work and the place of people within that world. Such assumptions are constantly put to the test since people are able to read the situation they find themselves in and act in accordance to their understanding of changing circumstances. All such situations offer a considerable amount of information which people may be able to interpret and a range of resources or 'props' which will aid effective action by the participant.

A theatrical analogy may help the argument. The setting of any encounter may be regarded as a stage, whose architecture (or scenery) guides the entrances or exits of the players, highlights certain places where people stand, or breaks the stage up into smaller regions where actions may be hidden from general view. The dress (or costumes) worn by the participants communicate their status, how they may be expected to behave, and how they should be treated. Finally other portable items – tools, items of display or exchange – may be used to achieve a variety of results in the actions of our players.

From this perspective it would be possible to view the greater proportion of the objects under discussion in one or other of these categories. Much of the material belongs to categories of dress or bodily ornament, whether it is the simple bone pins from Skara Brae or the elaborate bronze arm rings of the northern Iron Age. Before considering some of this material in terms of two very broad chronological periods, one final warning must be sounded. These periods were long and contained a huge and complex number of different encounters between people in which all this material was drawn into play. All that can be presented here are a number of fragmentary images of the past to evoke some possible ways in which these objects were used.

Early Farming Communities, 3000–1000 BC

The most regularly occupied 'stages' of social life are those presented by the home and the workplace; in the case of nearly all the communities discussed here, the latter was set within the agricultural landscape. Little survives of either to allow any kind of detailed understanding of this architecture of 'every-day' life. However, in Scotland there are some remarkable exceptions to the general rule. At Skara Brae in Orkney, sand buried the stone buildings of a settlement dating to about 2500 BC (fig. 1.1) and here we can see, with considerable clarity, something of the design of

domestic architecture. Each house is quite small, and upon entering one's perspective is dominated by a central hearth beyond which stands a 'dresser'. This may have been part of the storage space of the house, but the upper shelves could have been used for display, or could even represent some form of domestic shrine. To left and right of the hearth, against the wall, are two beds, the right-hand bed being the larger of the two. Storage spaces include cupboards set into the wall. The architecture of the house created a framework for living out some of the fundamental norms of social behaviour, involving differences in the roles and statuses that went with age and gender.

The earliest monumental architecture emerges with the establishment of some form of agricultural

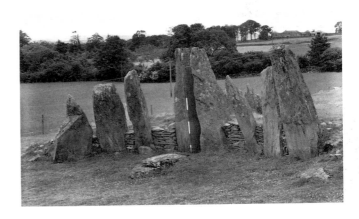

Fig. 1.2 Cairnholy 1, Chambered cairn façade (Kirkcudbrightshire), 4th millennium BC
Photo: The Royal Commission on the Ancient and Historical Monuments of Scotland, Edinburgh

economy in northern Britain by about 4000 BC, represented by the communal burial monuments of the period. In western and northern Britain many of these were built in stone. The form of this architecture was simple: a storage chamber held the ancestral remains and was contained within a cairn of stones, at one end of which often stood an upright stone façade. The example of Cairnholy 1 (fig. 1.2) demonstrates how this arrangement could have operated, with the façade forming an obvious backdrop to a small stage lying in front of the cairn. Here the officiant might lead ceremonies in front of a small group of people who gathered to face the tomb. By 2000 BC the complexity of these ceremonies may have increased. At Callanish on Lewis (fig. 1.3) the tomb now lay at the centre of a

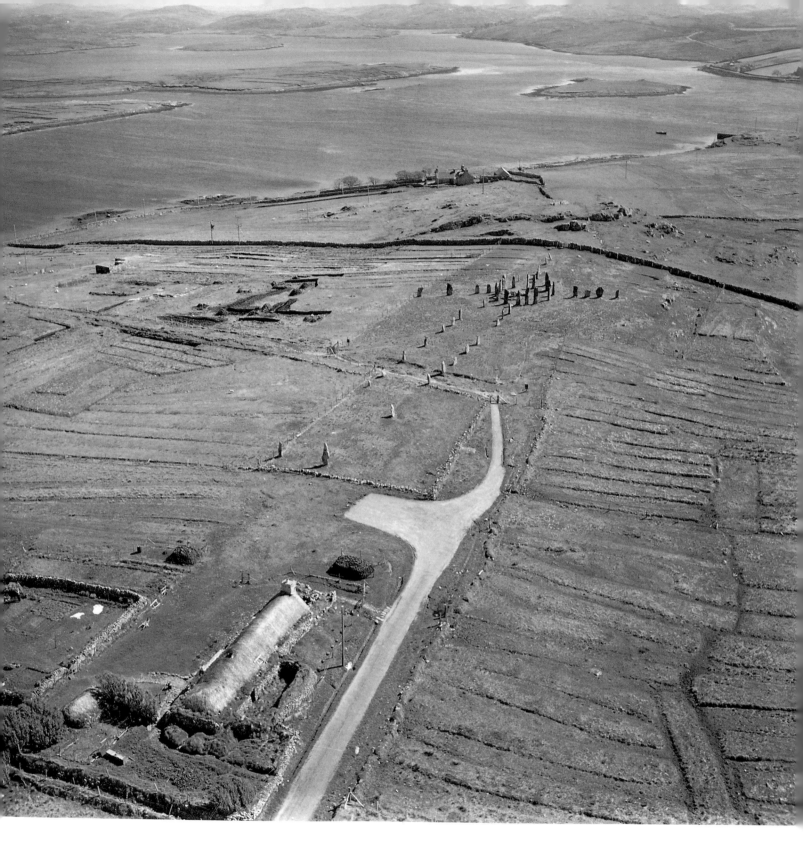

series of substantial processional avenues. These monuments form obvious foci for ritual activity, but other kinds of ritual may also have occurred away from such monuments. The roles actors play on the domestic or the ritual stage help to define them through different types of social identity. Were these different identities also marked out by dress and bodily ornamentation? We know, unfortunately, little about dress for most of

Fig. 1.3 Callanish, Standing stones and chambered cairn (Lewis), 3rd millennium BC
Photo: The Royal Commission on the Ancient and Historical Monuments of Scotland, Edinburgh

this period. What limited evidence survives includes the bone pins (fig. 1.4) and necklaces from Skara Brae. However, by the time of the earliest metal artefacts quite rare materials were employed in the creation of

dress ornament. This includes some of the earliest use of gold, as well as jet to fashion belt fittings and buttons (Harehope cairn, Peeblesshire) or more elaborate necklaces (Poltalloch, Argyll). The grave goods from Culduthel, Inverness give a glimpse of what may have been an elaborate insignia of personal identity (fig. 1.5). The body was accompanied by a set of archery equipment as well as a small bead of amber and a bone toggle, probably from a belt. A beaker, one of the more elaborate pottery vessels of this period, was also found in the grave. It is important to realize that if such material did form some kind of personal insignia then those insignia seem to have been widely used and

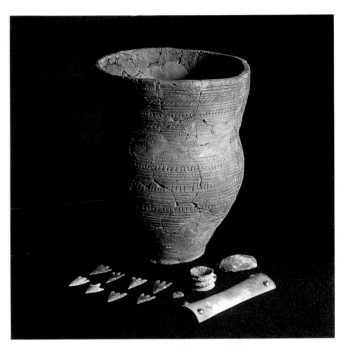

Fig. 1.5 Eight arrowheads, wristguard, beaker, bead and toggle, grave assemblage (Culduthel, Inverness), c. 2000 BC
Barbed and tanged arrowheads: flint, l. 2.5 cm (1 in), 2.8 cm (1⅛ in), 2.6 cm (1 in), 2.3 cm (15⁄16 in), 3.2 cm (1¼ in) 2.6 cm (1 in), 2.6 cm (1 in), 2.8 cm (1⅛ in); Archer's wristguard: mottled green and grey stone, l. 11.6 cm (4 9⁄16 in); Beaker: pottery, h. 22.6 cm (8⅞ in); Bead: amber, l. 1.4 cm (9⁄16 in); Toggle or belt-ring, bone, max. d. 2.95 cm (1 3⁄16 in)
Trustees of the National Museums of Scotland, Edinburgh

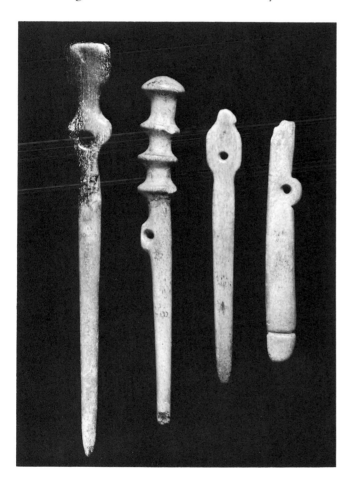

Fig. 1.4 Pins (Skara Brae, Orkney), 3100–2500 BC
Whalebone, l. of longest 24.89 cm (9 13⁄16 in)
Trustees of the National Museums of Scotland, Edinburgh

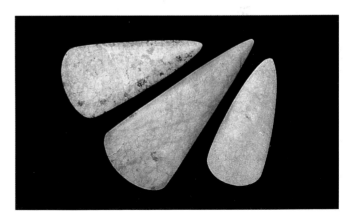

Fig. 1.6 Axeheads (Cunzierton, Roxburghshire [left and right]; Greenlawdean, Berwickshire [centre]), 4th or 3rd millennium BC
Jadeite, l. left 19 cm (7 15⁄32 in), right 17.4 cm (6 13⁄16 in)
Trustees of the National Museums of Scotland, Edinburgh

understood throughout western and central Europe in the centuries around 2000 BC. This contrasts with the very limited evidence for the expression of any kind of ethnic identity at this time.

Social identities maintain differences between people. These differences can be further sustained by securing differential access to certain kinds of artefact. This does not include simply the accumulation of wealth, but also the ability to take part in restricted forms of exchange and communication between others who belong to, or who aspire to, a particular social status. This kind of exchange seems to occur in the way foreign or 'exotic' materials are used in the production of artefacts that are then exchanged over very large distances. Stone axes, for example, may seem quite mundane, utilitarian objects; they were certainly among the most essential tools employed by these agriculturalists. However, some very fine examples have been found, bearing little or no sign of use, which were produced in rare types of stone that may have been specifically selected for their colour. One example

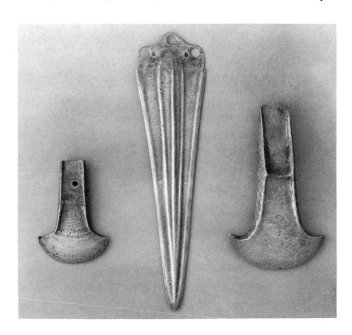

Fig. 1.7 Two axeheads and dagger, hoard (Gavel Moss, Renfrewshire), early 2nd millennium BC
Axeheads: bronze, l. 15.3 cm (6 in), 9.34 cm ($3\frac{11}{16}$ in); Dagger: bronze, l. 25.6 cm ($10\frac{1}{16}$ in)
Glasgow Museums & Art Galleries

is the use of jadeite: two unused axes which originated from the continent come from Cunzierton, Roxburghshire (fig. 1.6). Perhaps these items were exchanged in a quite restricted fashion, uniting only those people of a certain status who were able to procure them. Significantly, many of these artefacts were deposited in rivers or peat bogs, probably as

votive sacrifices, as was the case with the fine metal hoard from Gavel Moss (fig. 1.7). These sacrifices were a very powerful use of such restricted material. Not only did they emphasize the status of those involved, but they also highlighted the exclusion of others who, unable to procure these exotic and elaborate items, were thus unable to sacrifice in this way.

Later Prehistory and Early History,
1000 BC—AD 1000

The division between this and the earlier period is somewhat arbitrary, since many of the themes continue. Body ornament and insignia, for example, remain the major component of the portable material. Nonetheless changes took place in the way some of these objects functioned as well as in the technology of production and in the design of the artefact. There was an increasing emphasis upon weaponry; spearheads, swords and shields are obvious examples but the display of the warrior also extended to the decoration of the horse, including the famous Torrs chamfrein (pony cap), and the Deskford carnyx (battle trumpet). Gold continued to be used in hair or neck ornaments (fig. 1.8), but ornaments such as the massive bronze arm-rings, some with inlaid enamel (fig. 1.9), seem a phenomenon localized roughly to Grampian and Tayside. Such localized distributions *might* indicate that dress items not only marked out personal status but may now display a more conscious concern with regional ethnicity. Certainly by the end of the period we can talk of 'Viking' metalwork, such as that represented by the Skaill silver hoard (fig. 1.10). Thus not only may some of the finest items of metalwork have been worn as visible indicators of rank, for example, the Hunterston brooch (fig. 1.11), but ethnic differences also may have been formulated during this period and marked out, in part, by dress.

Against this backdrop a further contrast with the earlier period may be noted: the lack of a monumental architecture concerned primarily with ritual. The widespread adoption of a religious architecture re-emerges only with the establishment of Christianity. This difference is further emphasized by some of the domestic architecture of the period; hill-forts and other enclosures, by their form and their location, take on a monumental role within the contemporary landscape. The brochs of the west and north of Scotland were

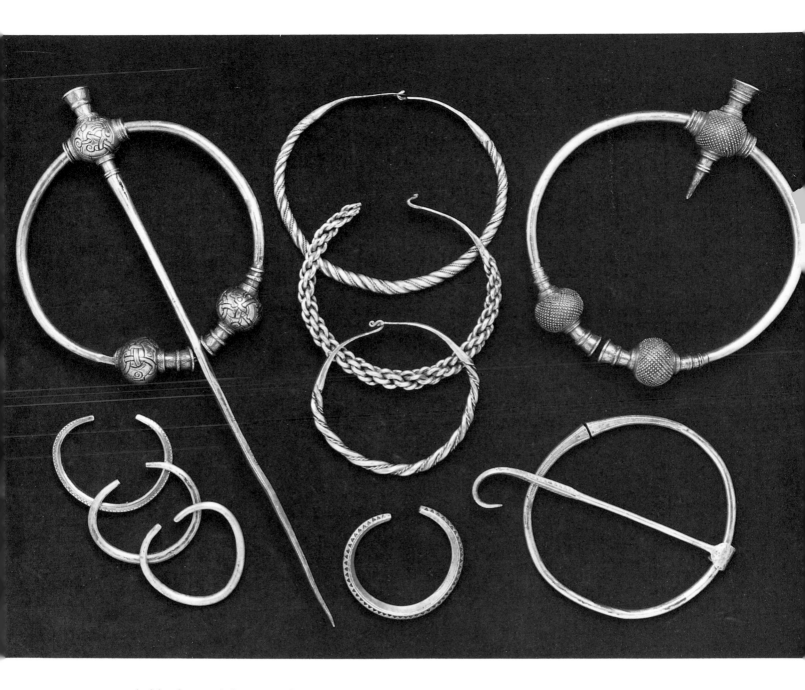

most probably first and foremost domestic structures that had been constructed to monumental proportions. The Orcadian broch of Gurness (fig. 1.12) lies at the heart of a defensive enclosure. Within the broch some of the stone furnishings are still visible, whilst around it lie ancillary buildings. A road runs from the enclosure entrance toward and then around the broch giving access to these marginal buildings. This architecture was simply a physical manifestation of the social differences that would have dominated the daily lives and perceptions of all the inhabitants of such a settlement.

The lack of a clearly developed, explicitly religious

Fig. 1.10 Brooches, neck-rings and arm-rings from hoard (Skaill, Orkney), deposited c. AD 950
Silver, d. of largest brooch 17.8 cm (7 in)
Trustees of the National Museums of Scotland, Edinburgh

architecture does not imply a diminution in religious practices. Votive deposits remain an important feature of this period, and again they are characterized by the sacrifice of prestige insignia, access to which would have been limited to specific categories of people. For example, the deposit of three bronze shields at Yetholm, or the swords thrust into the peat on Shuna,

21

Fig. 1.8 Ribbon torcs
 from hoard (Law Farm,
 Moray), c. 1100 BC
Gold, d. of largest 11.4 cm
 (4½ in)
Trustees of the National
 Museums of Scotland,
 Edinburgh

Fig. 1.9 Armlets, hoard
 (Castle Newe,
 Aberdeenshire), 1st
 century BC–2nd century AD
Cast bronze and enamel, d.
 11.5 cm (4½ in)
Trustees of the British
 Museum, London

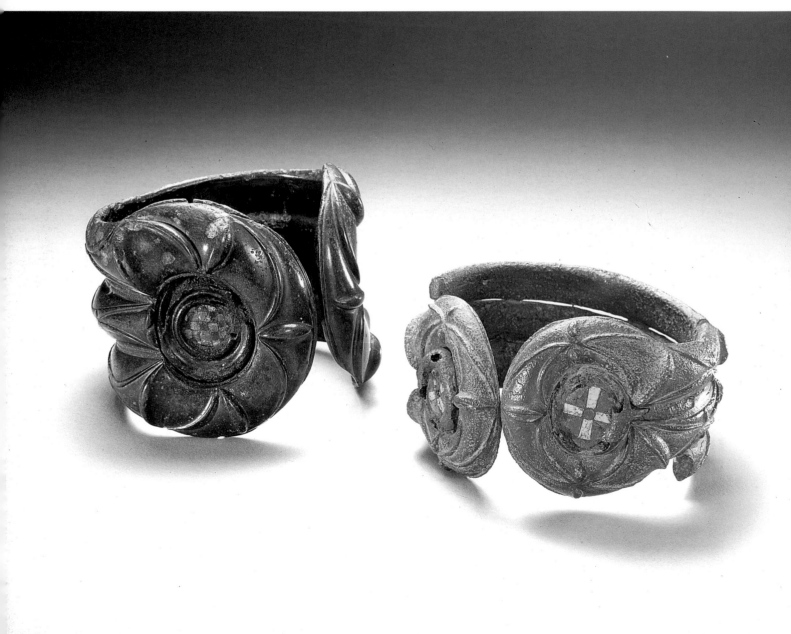

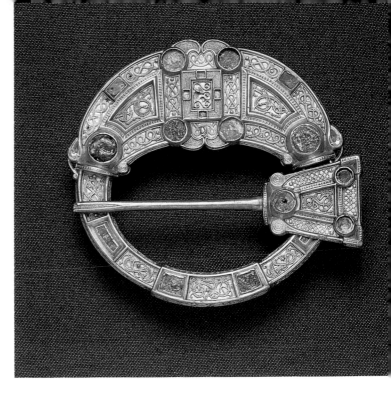

Fig. 1.11 Penannular brooch (Hunterston, Ayrshire), late 7th
to early 8th century AD with 10th-century Scandinavian runic
inscription
Gilded silver with amber inlay and filigree and gold foil panels,
d. 12.2 cm ($4\frac{13}{16}$ in)
Trustees of the National Museums of Scotland, Edinburgh

Fig. 1.12 Gurness, Broch (Orkney), late 1st millennium BC
Photo: The Royal Commission on the Ancient and Historical
Monuments of Scotland, Edinburgh

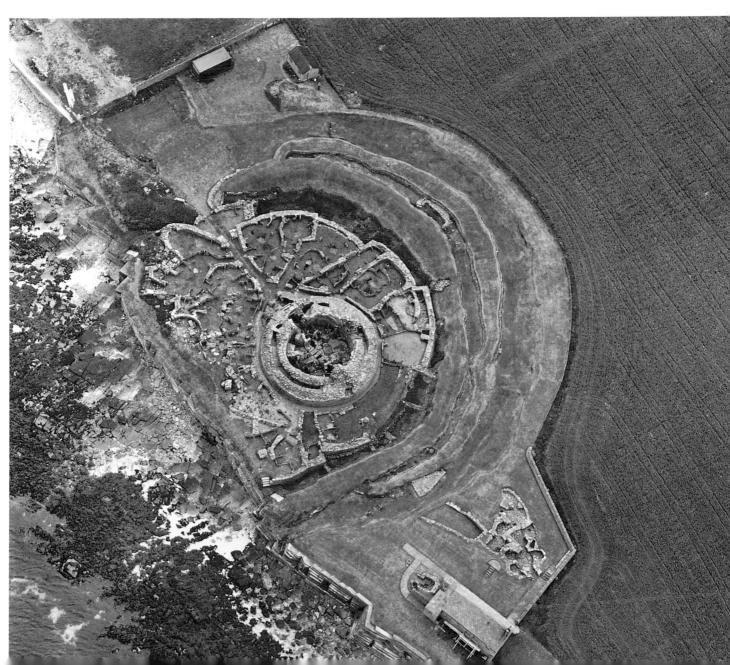

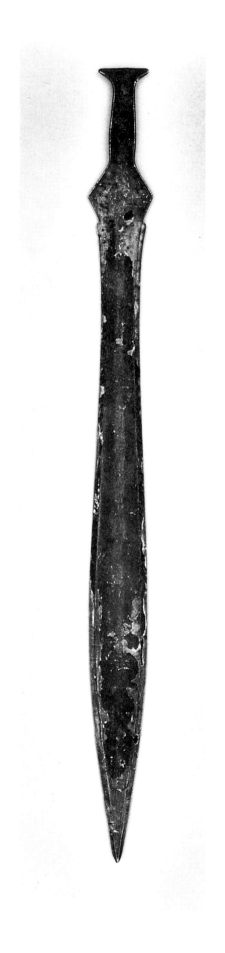

Argyll (fig. 1.13) were more than likely votive sacrifices made by young male warriors. The sacrifice as well as the display of items restricted in their availability would have continued to maintain the identity of these particular groups, as would the exchange of prestigious items between the members of a status group. Homeric accounts of a partly mythical, heroic age in Greece, or the heroic poetry of the Irish, British and English in the early historic period, all exemplify the competitive nature of such exchanges and the almost obsessive concern with personal honour and status. The exchange of objects in this manner would also have been extended to food and drink; feasting is itself a recurrent theme of heroic literature. It is tempting to see the recovery of sheet-metal cauldrons from peat bogs in Scotland as not only indicating the sacrifice of finely made objects, but also of the sacrifice of food (fig. 1.14).

We may be able to identify the lengthy use of particular forms of object in certain types of social exchange, as in dress for example. However, the likely emergence of a concern with ethnicity, which may be expressed by personal appearance, or an increasing emphasis upon warfare, or the emergence of religious sacrifice at natural sanctuaries replacing the formal ceremonies at humanly constructed monuments, all indicate the way artefacts contributed to creating new ideas of social order. The 'artwork' and designs of these objects will have had different meanings in different contexts.

Up to now our discussion has been concerned with 'small-scale societies'. The implication is that all this material would have been used within local, face-to-face exchanges. This may be true, but the possibility still exists that ideas or principles could have been introduced into these very local exchanges which originated some distance away, which were part of local exchanges across a wide area, and therefore, which created large homogeneous areas of cultural and political belief. The establishment of the Roman Empire and of the Christian Church are two examples of this type of process during this period.

Few Roman artefacts are represented in this exhibition, even though the period concerned covers the history of the Empire and of the Roman military

Fig. 1.13 Sword from hoard (Shuna Argyll), 9th century BC
Bronze, l. 64.2 cm ($25\frac{1}{4}$ in)
Glasgow Museums & Art Galleries

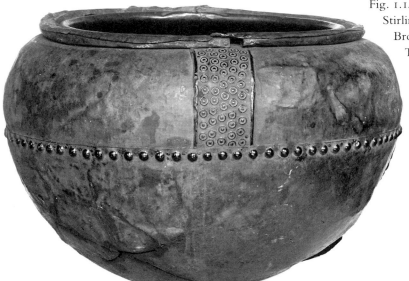

Fig. 1.14 Cauldron (Kincardine Moss,
Stirlingshire), 1st century BC–2nd century AD
Bronze, d. 63.6 cm (25 in)
Trustees of the National Museums of
Scotland, Edinburgh

Fig. 1.15 Antonine Wall
distance slab (Hutcheson
Hill, Bearsden,
Strathclyde), 2nd century AD
Yellow sandstone, l. 95 cm
(37½ in)
Hunterian Museum,
University of Glasgow

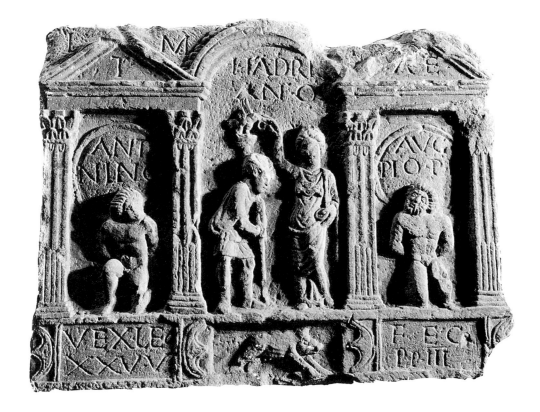

presence in northern Britain. This virtual exclusion of Roman material does tell us something about the relationship between the authority by which that Empire was held together and the indigenous inhabitants who lay beyond its frontier in northern Britain. Apparently little of the Roman political or cultural world intervened in the way the native population lived their own lives, except for the placement of military installations, including the frontiers themselves. These frontiers, in particular the walls of Hadrian and Antoninus Pius (the latter slicing through the midland valley of Scotland), made clear the idea of exclusion. Rome had triumphed over and excluded the barbarian; such propaganda is explicit in one of the commemorative slabs from Hutcheson Hill, Bearsden (fig 1.15). Here the building of a stretch of the Antonine

Wall is marked by the representation of either Victory or Britannia offering a wreath to the eagle of the victorious legion. On either side are bound and kneeling native captives; they have no place in this world other than as slaves, and they are naked.

The history of Christianity in northern Britain is quite different, since by AD 1000 most of the inhabitants in the greater part of the area had been converted and were participating in Christian liturgy. Indeed, the idea that the western, Celtic church inspired a great flowering in art and culture is today commonly held, in particular the great achievements of the metalworker (figs 1.11 and 1.16), the book illustrator and the stonemason. Once again the way such artistic achievements were used must be noted: their new role was to reveal truths about humanity's place in God's scheme of Creation and Redemption. The church's function to teach or reveal these truths, and thus to save souls, was partly facilitated through such objects. The gospel books and psalms were the means by which the monastic communities and the clergy could properly order their own devotions. These were artefacts whose use and

circulation would have been as restricted as many of the prestigious objects of earlier periods. We know something of the early monastic buildings, the most famous site being the Scottish foundation on Iona, but less of the churches which might have served the wider rural communities. Where, for example, might an item such as the 'Monymusk' reliquary have been housed (fig. 1.16)?

By converting the aristocracy the church ensured the conversion of the wider populace as well and Christianity thus became integrated within these indigenous societies. The conversion of the Picts by missions from both the Celtic and the Northumbrian churches is a story told by the English historian Bede and in a 'Life' of St Columba by an unknown author, and the conversion is documented not by surviving churches or a

Fig. 1.16 Reliquary (Monymusk, Aberdeenshire; original provenance unknown), 8th century AD
Silver and copper-alloy on wood with tubular bronze, gilt bronze and enamelled bronze fittings, l. 10.8 cm (4$\frac{1}{4}$ in), h. 9.8 cm (3$\frac{7}{8}$ in), w. 5.1 cm (2 in)
Trustees of the National Museums of Scotland, Edinburgh

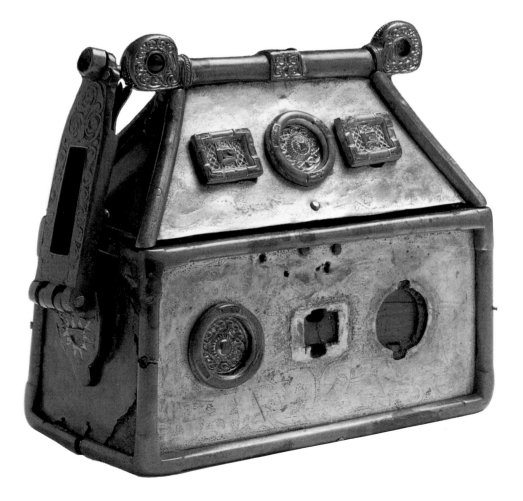

wealth of illustrated manuscripts but by those carved stones that carry both the cross and the representations of Pictish aristocratic life. One such stone of about the eighth century remains in the churchyard at Aberlemno (figs 1.17 and 1.18). On one side is the cross, before which the mass may once have been celebrated and on the other, the depiction of a battle scene. Running in three registers down the stone, this scene may be read as narrating the invasion of Pictland by the Northumbrian king Ecgbert and his final defeat at the battle of Nechtansmere. Someone would have recited this story to an audience by referring to the carvings and tracing the depiction of events down the stone. This one stone unites the worship of Christianity with the recitation of royal histories. It also demonstrates the encounter between a knowledgeable poet and a lay audience, and how widely understood symbols were used to constantly re-invent a system of religious salvation and political order.

Today we talk of putting art back into the community. The societies discussed here would not have been able to understand art in any other way.

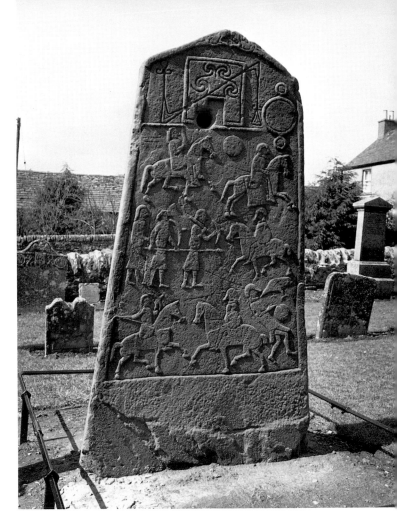

Fig. 1.18 Decorative stone, east face (Aberlemno churchyard, Angus), early 8th century AD
Photo: The Royal Commission on the Ancient and Historical Monuments of Scotland, Edinburgh

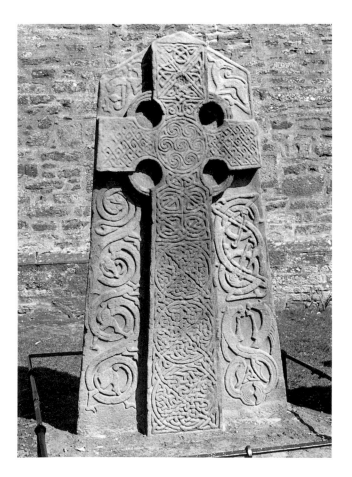

Fig. 1.17 Decorative stone, west face (Aberlemno churchyard, Angus), early 8th century AD
Photo: The Royal Commission on the Ancient and Historical Monuments of Scotland, Edinburgh

2

ART AND THE CHURCH
BEFORE THE REFORMATION

JOHN HIGGITT

The churches that survive in Scotland from before the Reformation are either wholly or partly ruined or, if still roofed, bare shells very largely stripped of their medieval furnishings and equipment. Only a tiny proportion of the pre-Reformation religious art of Scotland now remains – and, with very few exceptions, what does remain is either fragmentary or has been severed from its original context. Some idea of the scale of the losses is given by documents like the 1542 inventory of the furnishings of King's College Chapel, Aberdeen (Eeles 1956), which lists two monstrances, cross, candlesticks, censers, eight chalices, numerous vessels and other pieces of metalwork, its many precious vestments and other textiles, its altars, altar frontals, altar-pieces, panel paintings, organ and service books.

The medieval church in Scotland was comparable with the church elsewhere in Europe in its wealth of ornament and imagery.

> Behald, in euery kirk and queir
> Throuch Christindome, in burgh and land,
> Imageis maid with mennis hand . . .
> With coistlye collouris fyne and fair

David Lindsay wrote disapprovingly a few years before the Reformation (Hamer 1931, 267–70).

Medieval religious art was intended to serve a number of purposes. According to the twelfth-century Honorius Augustodunensis painting in church served three functions: it was the literature of the laity; it embellished the house of the Lord; and it recalled the lives of the saints (Migne 1854, 586). For his contemporary, a German priest and artist known as Theophilus, artistic adornment could help make the church into an image of paradise and depictions of the sufferings of Christ and the saints could move the viewer to pity and repentance (Davis-Weyer 1971, 178). There was some criticism from within the church of sumptuous or irrelevant decoration, most famously from St Bernard, the twelfth-century leader of the initially austere Cistercian order of monks (Davis-Weyer 1971, 168–70). The normal view of art in the Western church, however, followed that of Pope Gregory the Great (590–604) in condemning the adoration of images, whilst seeing a legitimate role for them as teaching aids. Those who could not read in books could read in pictures and learn from them what should be adored (Davis-Weyer 1971, 47–9).

That was the theory. But religious art also inevitably reflected other concerns of its patrons, both ecclesiastical and secular, as well as patterns of popular devotion such as the cult of saints and relics.

When the peoples in what is now Scotland gradually adopted Christianity, they were taking on an international religion but, once accepted, it soon developed regional and national traditions. The earliest visual signs of Christianity are a few inscribed stones like those at Whithorn or Kirkmadrine, mostly with Latin mem-

orial inscriptions and comparable to those in Wales, cut for Britons in southern Scotland from about the end of the fifth to the seventh century. One or two also carry modestly embellished incised crosses set within a circle. The British church in Scotland has left little other evidence of visual art. The early churches of the other peoples (the Picts who controlled most of Scotland north of the Forth until some time in the ninth century; the Scots, settlers from Ireland, whose territory expanded from Argyll to include the former Pictish areas; and the Angles of Northumbria, whose territory extended from the Forth to the Humber) on the other hand attracted and produced much spectacular art. Their religious art drew on the native traditions of Celtic curvilinear ornament and of Anglo-Saxon animal styles, both secular in origin, as well as on motifs imported from the Christian art of the Mediterranean. These separate styles merged into a supra-national 'Insular' or 'Hiberno-Saxon' style used through most of Britain and Ireland around the eighth century. Versions of this style can be seen in the decoration of the Book of Kells (which may well have been made on Iona), St John's Cross on Iona (fig. 2.1) or the Pictish Aberlemno cross-slab (see fig. 1.17). Close contacts with Rome and other Continental centres on the other hand explain the very classical appearance of some Northumbrian art, for example, the cross at Ruthwell (Dumfriesshire).

Monasteries, such as Iona, seem to have been the main centres of religious art in this period. The decoration of gospel books like the Book of Kells, which were written for use at the altar, and of liturgical metalwork and reliquaries could be particularly lavish. The great reliquaries have gone but a small, probably Pictish, portable shrine, the Monymusk Reliquary (see fig. 1.16), still survives. Stone sculpture could, as at Iona, imitate on a larger scale the forms of metalwork and manuscript. The sacred symbol of the cross was the dominant motif – simple incised crosses, the chi-rho monogram for Christ's name in books and on stone, cross-carpet pages in gospel books, standing stone crosses and cross-slabs, or crosses worked into decorative patterns. A rather limited range of Christian figure scenes was used in books and in sculpture.

Stone crosses and cross-slabs outside the monasteries could be focuses of devotion for the laity. The backs of the Pictish cross-slabs normally carry the secular

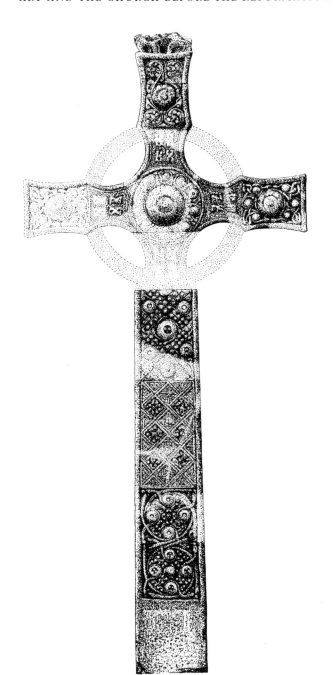

Fig. 2.1 St John's Cross, Iona (Argyll), *c.* 8th century
Stone (chlorite-schist and mica-schist), h. above base approx. 435 cm (171¼ in)
Interpretative drawing of east face: The Royal Commission on the Ancient and Historical Monuments of Scotland, Edinburgh

symbols of the Picts; and the riders, or hunting scenes, or the battle on the Aberlemno cross-slab (see fig. 1.18) surely indicate some secular involvement in the commissioning of these monuments.

There were major changes during the ninth century: Viking raids and settlement and the collapse of the Pictish kingdom. The monastery at Iona was aban-

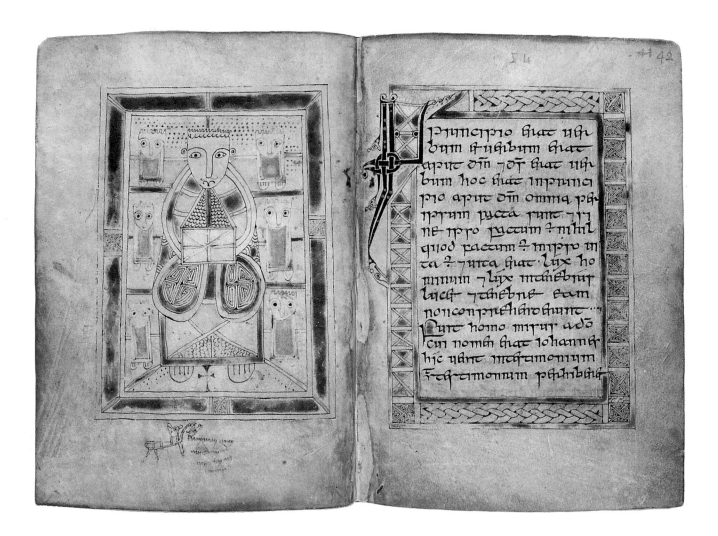

Fig. 2.2 Portrait of St John (at the opening of St John's
 Gospel) from the Book of Deer, 9th or 10th century
Vellum, ff. 41v–42: 15.2 × 11.1 cm (6 × 4$\frac{3}{8}$ in)
Cambridge University Library, MS Ii.6.32
By permission of the Syndics of Cambridge University Library

doned but sculpture in later and often cruder versions of the 'Insular' style continues. The naive but spirited decoration of the pocket gospel book known as the Book of Deer (fig. 2.2) was probably made in eastern Scotland in the ninth or tenth century.

Scotland was largely isolated from developments on the Continent until the later eleventh century, when new ecclesiastical and artistic influences from Norman England start to be felt. In about 1070 Malcolm III married the later canonized Margaret, a descendant of the Anglo-Saxon royal family. She asked Lanfranc, Archbishop of Canterbury, to send Benedictine monks to Dunfermline and she was also in contact with the

Benedictines of Durham and in particular with Prior Turgot. Turgot was probably also the author of a Life of Margaret (Forbes-Leith 1896), which stresses her piety, her patronage both of the new Benedictines and of older Scottish churches, her encouragement of ecclesiastical embroidery and her ownership of books, including an illuminated gospel book. This book may be identical with the book known as 'St Margaret's Gospels', which contains portraits of the Evangelists and illuminated initials in a late Anglo-Saxon style. The 'Celtic Psalter', which contains fine zoomorphic initials in a late, Irish or perhaps Scottish, version of the 'Insular' style (fig. 2.3) and added ornament probably by an eleventh-century Anglo-Saxon hand, could well be another of her books.

Interestingly the books that Margaret might have owned are decorated in the older 'Insular' and Anglo-Saxon styles; major changes in style did not come until the reigns of Margaret's sons, Alexander I and especially

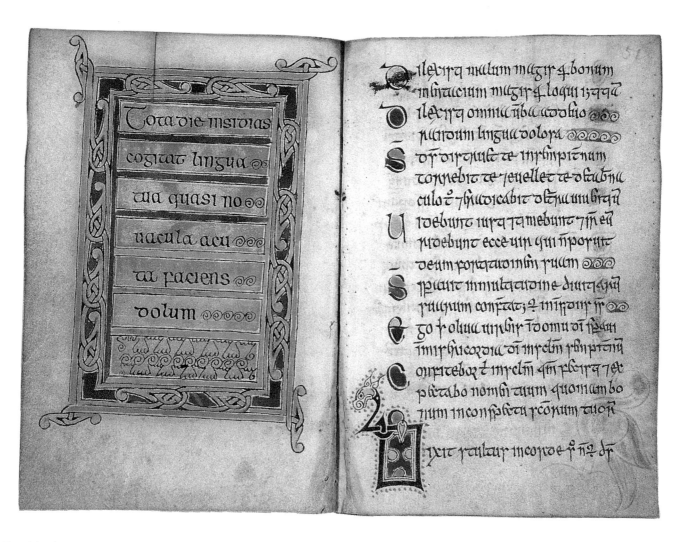

David I (1124–53). David founded religious houses for Benedictine and Augustinian communities, as well as for the new orders (Cistercians, Premonstratensians, Tironensians, Templars and Hospitallers). These were international orders and some of the founding members of these communities came from England or France. During the twelfth and thirteenth centuries the Scottish royal family and many of the major landholders were similarly international in their outlook and contacts, identifying with the French-influenced culture of their counterparts in Anglo-Norman England and some-times holding land in both countries. Artistic relations were similarly close. During the twelfth century Scot-tish churches were built and decorated in the Anglo-Norman Romanesque style. Some of the artists, such as the masons from Durham at Dunfermline, were no doubt imported from England. An idea of the lost wealth of internal and external ornament can be gained from the geometric and foliate sculpture on the apse

Fig. 2.3 Framed opening to Psalm 51 and initial to Psalm 52
 from the 'Celtic Psalter', 10th or 11th century
Irish or Scottish, vellum, ff. 50v–51: 13 × 8.5 cm ($5\frac{1}{8}$ × $3\frac{3}{8}$ in)
Edinburgh University Library, MS 56

Fig. 2.4 Painted voussoir from
 Glasgow Cathedral, 12th century
 Photo: Historic Buildings and Monuments,
 Scotland (Edinburgh)

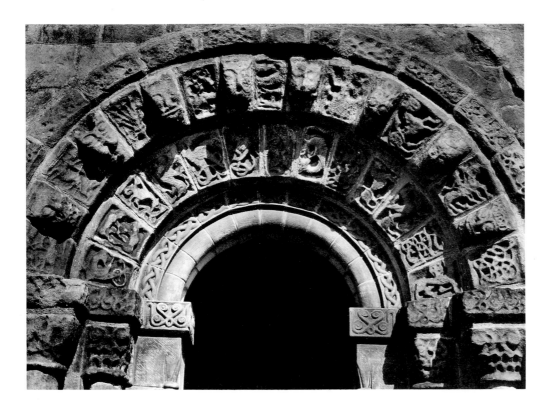

Fig. 2.5 South door,
Dalmeny Church (West
Lothian), 12th century
The innermost order of the
arch is modern
Photo: Royal Commission
on the Ancient and
Historical Monuments of
Scotland, Edinburgh

of the parish church at Leuchars or the fragment of painted foliage on a single stone from the Romanesque cathedral at Glasgow (fig. 2.4). In Scotland there must have been, as elsewhere in Europe, painted figures and scenes of scripture and of the saints on the walls of the churches; figure sculpture can still be seen in a few places such as Dalmeny (fig. 2.5), Linton and Jedburgh.

During the twelfth century the Cistercian order retained their initial austerity and rejected such decoration. One of their earliest statutes reads: 'We forbid the making of sculpture and of paintings in our churches and monastic buildings, because, when attention is paid to such things, good and necessary meditation and the grave discipline of the religious life are often neglected. We do, however, have painted wooden crosses.' (Norton and Park 1986, 324). Early Cistercian churches at Melrose and Dundrennan would have conformed to this statute. By the later fourteenth century, however, Melrose was being rebuilt with a fine array of sculpture and architectural enrichment (fig. 2.6).

During the later twelfth and thirteenth centuries Scottish ecclesiastical art and architecture continued to be closely related to those of England. Fine thirteenth-century decorative sculpture is still to be seen, for example, on the capitals and bosses of the crypt of Glasgow Cathedral. At Holyrood Abbey the deeply

recessed western door (fig. 2.7) was surmounted by figures in niches and a still-surviving lintel with busts of angels and was surrounded by an arch in several orders with rich foliage ornament. Figure painting of the thirteenth century is represented by the lower part of a group of figures painted in a tomb recess in the church of Inchcolm Priory. Although little now remains, figures in stone, paint, stained glass and other media would have been common, as would carved wooden furnishings and decorative floor-tiles.

The destruction and loss of ecclesiastical metalwork and of illuminated manuscripts of the twelfth and thirteenth centuries were, if anything, even greater. The decorated initial of the confirmatory charter granted to Kelso Abbey by Malcolm IV in 1159 contains figures of Malcolm and of his grandfather, the founder of the Abbey, David I (fig. 2.8). This very competent piece of Romanesque illumination must have been painted in Scotland (probably at Kelso) and shows that major libraries in twelfth-century Scotland could have contained illuminated books comparable to those in English libraries. Fine illuminated manuscripts were also imported both for individuals and institutions. The Iona Psalter in the National Library of Scotland was written and decorated in England, probably at Oxford, at the beginning of the thirteenth century for a wealthy

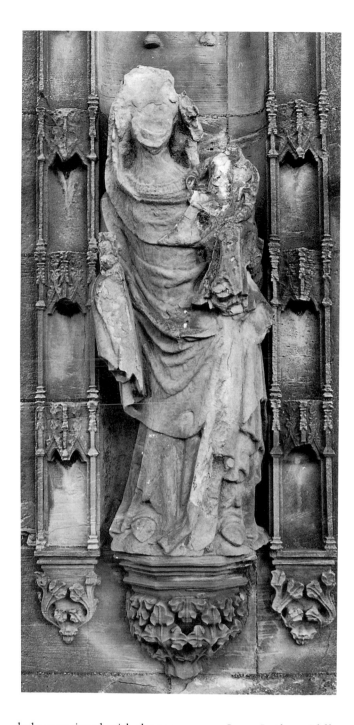

Fig. 2.6 Virgin and Child, sculpture on buttress on south side of nave, Melrose Abbey (Roxburgh), early 15th century
Photo: Historic Buildings and Monuments, Scotland (Edinburgh)

Fig. 2.7 West door, Holyrood Abbey (Midlothian), 13th century and later
Photo: Historic Buildings and Monuments, Scotland (Edinburgh)

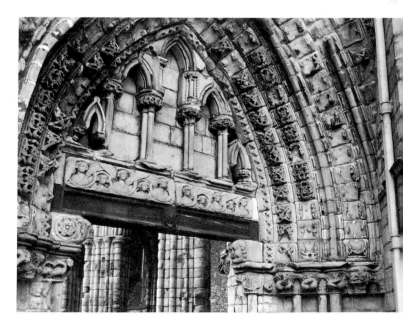

lady associated with the nunnery on Iona. In the middle of the century another psalter (Oxford, Bodleian Library, Douce MS 50), with miniatures and historiated initials, was ordered in northern France, probably in Paris, by, or on behalf of, an owner in the west of Scotland with up-to-date cosmopolitan tastes. A missal (Edinburgh, National Library of Scotland, MS Acc 2710) written for a Scottish Tironensian house, probably Lesmahagow, on the other hand, has distinctly mediocre illumination.

The twelfth-century bronze bell shrine from Kilmichael Glassary (see fig. 3.1) enshrines an earlier iron bell, no doubt regarded as a relic of a saint of the early church in Scotland. The crucified Christ and the decoration are fine work in a distinctive Romanesque style. An English enamelled crozier head of the late twelfth century was found buried with one of the bishops of Whithorn. Seals are the most common surviving type of ecclesiastical metalwork. They are usually known only through wax impressions but a

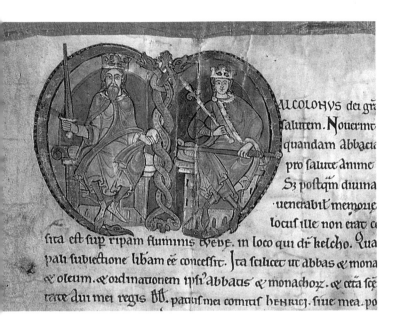

Fig. 2.8 Initial showing Kings David I and Malcolm IV from a Charter of Malcolm IV to Kelso Abbey, 1159 or shortly after
Vellum, 56.3 × 45 cm ($22\frac{3}{16}$ × $17\frac{3}{4}$ in), approx. overall size of charter
Duke of Roxburghe (on deposit at National Library of Scotland, Edinburgh)

Fig. 2.10 Portrait of James IV with his patron, St James in the Hours of James IV and Margaret Tudor, between 1503 and 1513
'Ghent/Bruges school', vellum, f. 24v: 20 × 14 cm ($7\frac{7}{8}$ × $5\frac{1}{2}$ in)
Oesterreichische Nationalbibliothek, Vienna, MS 1897

Fig. 2.9 Seal of the Chapter of Brechin Cathedral (matrix), 13th century
Front (image of the Holy Trinity); brass, 6 × 3.7 cm ($2\frac{3}{8}$ × $1\frac{1}{2}$ in)
Trustees of the National Museums of Scotland, Edinburgh

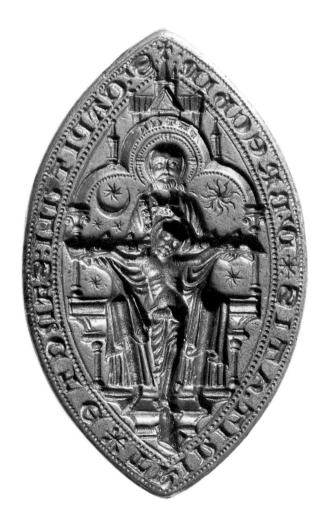

number of the metal matrices are still extant. They were designed to advertise and represent the claims of ecclesiastical officers and communities and could be works of high quality and of considerable iconographic interest. The brass matrix of the seal of Brechin Cathedral (fig. 2.9), for example, carries a finely executed image of the Trinity, to whom the cathedral was dedicated, and a foliate design on its back.

The relics of saints were a major focus of devotion and miraculous powers were attributed to them. The tomb of St Kentigern in the thirteenth-century crypt of Glasgow Cathedral was given special emphasis by the design of the piers, capitals and vaulting. In 1250 the remains of the recently canonized Queen Margaret were translated into a new shrine of precious metalwork set on a still surviving polished stone base at the east end of Dunfermline Abbey church in the presence of the king. No such large-scale reliquaries survived the Reformation in Scotland. On a smaller scale the Kilmichael Glassary and Guthrie bell shrines (see figs 3.1 and 3.11) and the shrine of St Fillan's crozier (see fig. 3.12) can be compared with Irish examples of shrines made for objects such as bells, books and croziers associated with early saints.

Secular patrons were often recorded in ecclesiastical art and founders of religious institutions and their families continued to take an interest in their foundations. They would expect to benefit spiritually from the prayers of the community and there could also be considerations of secular prestige. Patronage might be

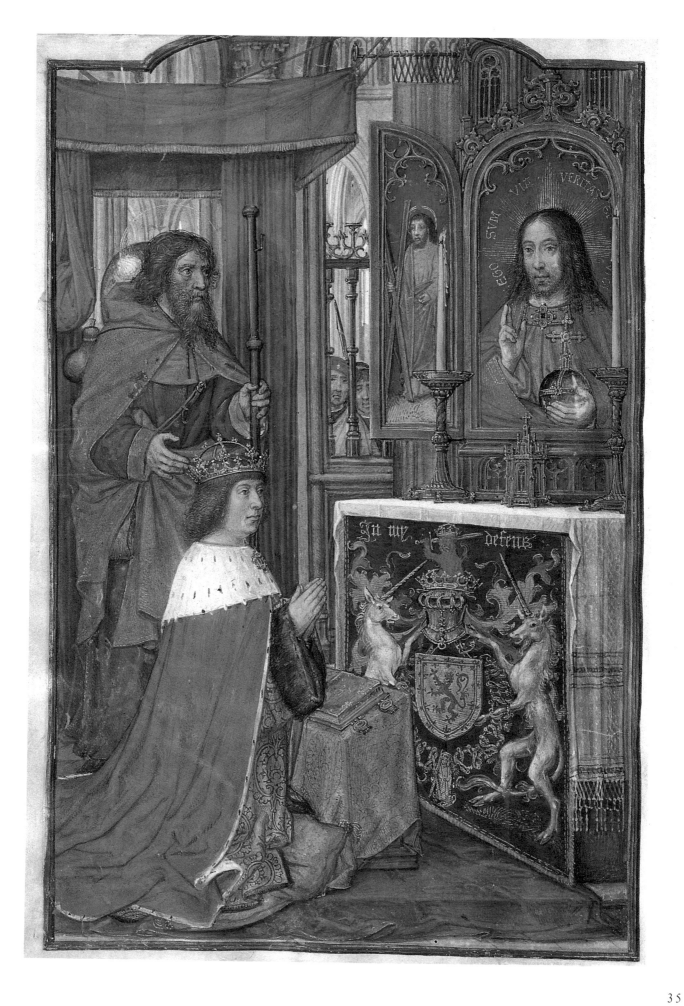

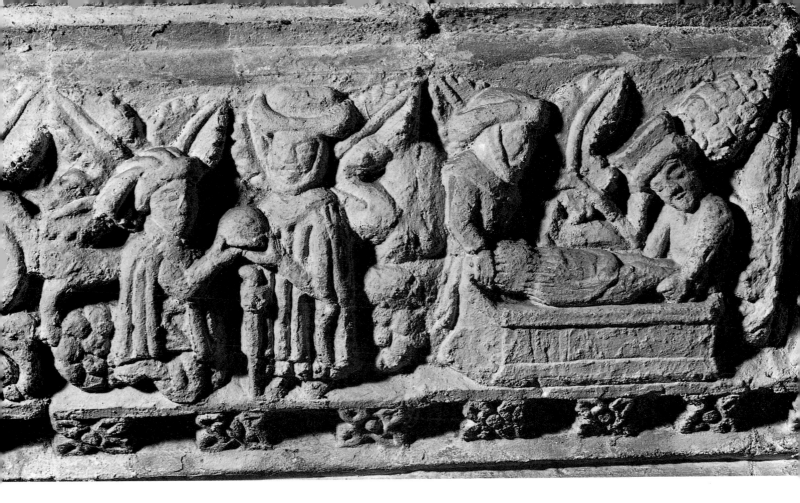

Fig. 2.11 Detail of interior sculpture, Works of Mercy, Roslin
 Chapel (Midlothian), mid-15th century
Photo: Historic Buildings and Monuments, Scotland
 (Edinburgh)

recorded in various media by portraits, or inscriptions, or heraldry. David I and Malcolm IV, for example, are portrayed as founder and patron in the initial to Malcolm's charter to Kelso Abbey (fig. 2.8). The large thirteenth-century illuminated bible (Princeton, University Library, MS Garrett 27), which seems to have been given to the Cistercian abbey of Sweetheart by its foundress, Devorgilla, widow of John de Balliol, contains the coats of arms of Carrick and Balliol.

The period of the Wars of Independence was not very auspicious for the patronage of ecclesiastical art and architecture and, although building and the production or commissioning of works in other media did not totally cease, the fourteenth century saw breaks in artistic traditions in Scotland. Not surprisingly the very close artistic ties with England which existed during the twelfth and thirteenth centuries were largely severed. Instead, during the fifteenth and sixteenth centuries many ideas and individual works of art were imported from the Low Countries and France. At the same time distinctively Scottish stylistic features began to emerge, particularly in architecture, and this new national consciousness was also reflected in the church. The sees of St Andrews and Glasgow were promoted to archiepiscopal status in 1472 and 1492 respectively and efforts, only partially successful, were made to create a specifically Scottish liturgy. The principal result was the *Aberdeen Breviary* of 1510.

Although an immense amount has been lost, much more survives, in several media, of the ecclesiastical art of the century and a half before the Scottish Reformation than from previous centuries. There is growing evidence for the importation of works of art. Examples of major commissions include: the tomb of Robert I at Dunfermline, which was carved in Paris during the late 1320s; the wooden choir-stalls commissioned in Bruges for Melrose Abbey several years before 1441, when they are the subject of legal proceedings; and the altar-piece painted in the 1470s by the leading Flemish artist Hugo van der Goes for the royal foundation of Trinity College in Edinburgh (see fig. 4.1). Flemish altar-pieces are also recorded at the beginning of the sixteenth century in Dunkeld, Dundee and Pluscarden (McRoberts 1959). By now many of the better-off in later medieval Scotland aspired to own an illuminated book of hours and many of these, ranging from the sumptuous Hours of James IV and Margaret Tudor (fig. 2.10) to more modest books, were imported from

Flanders; others, like the Playfair Hours, probably made in Rouen in the 1490s (London, Victoria and Albert Museum, MS L.475–1918), came from northern France.

On occasion Continental craftsmen came to work in Scotland. The master mason in charge of work at Melrose Abbey and a number of other projects in the early fifteenth century was, according to an inscription at Melrose, a Parisian called John Morow. French influences have been seen in some of the tracery at Melrose (Fawcett 1985) and the statue of the Virgin and Child on one of the nave buttresses there is probably the work of a French or Flemish sculptor (fig. 2.6), as probably was the monument in St Salvator's College in St Andrews of the founder, Bishop James Kennedy, with its fantastic miniature architecture of image-niches.

The work that is most characteristically Scottish is the rather heavy style of architecture seen, for example, in collegiate churches such as those at Seton or Roslin (fig. 2.11). There is none of the delicacy of much Late Gothic art and architecture. Although the sculptural enrichment tends to be coarse and 'provincial', it can be quite vigorous as at Roslin or in the sacrament house at Deskford, 1551 (fig. 2.12). The profuse sculpture on the mid-fifteenth-century church at Roslin, which is more notable for its quantity than its quality, is exceptional and was, at least in part, a statement about the wealth and prestige of the founder, William Sinclair, Earl of Orkney. The art of the sculptors and metal-workers of the Gaelic west of Scotland in the late Middle Ages is more clearly in a self-consciously national style and is even more 'provincial'.

Members of the laity were now more involved than before both as patrons and as audience of religious art. The royal family and major landholders continued to be the most important patrons but members of other classes could now take part to a greater extent, for example, through parish churches or confraternities in the growing towns. At the same time members of the laity were participating more actively in the liturgy and in other devotional practices. The response of the individual worshipper was becoming more emotional and personal. The elevation of the host before the congregation during the mass at the consecration, or the exhibition of the consecrated host in monstrances (such as that shown in the hands of the angels on the

Fig. 2.12 Sacrament House, Deskford Church (Banffshire), 1551
Photo: Historic Buildings and Monuments, Scotland (Edinburgh)

sacrament house at Deskford [fig. 2.12]) were symptomatic of the greater involvement of the laity. There was much emphasis on the suffering of Christ in the Passion, on the joys and sorrows of the Virgin, and on the intercession of the Virgin and the saints. A characteristic product of this time is the book of hours, a private book of devotions for the use of the laity built around the office of the 'Hours of the Virgin'. The contents and decoration would vary according to the needs and purse of the owner. The Arbuthnott Hours, for example, which was written and decorated in Scot-

37

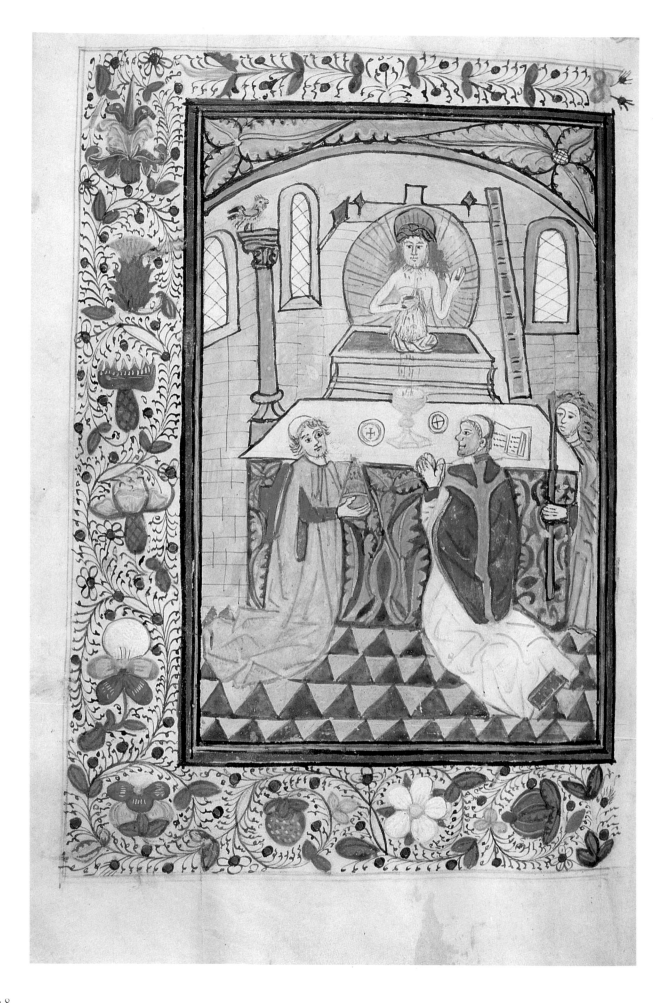

land for a member of the Arbuthnott family in about 1480, has miniatures showing St Ternan (patron of the parish church of Arbuthnott), the Annunciation, the Virgin of the Rosary, the death of a good Christian, the Crucifixion, and the Mass of St Gregory (in which Christ surrounded by the Instruments of the Passion appears over the altar and lets His blood fall into the Chalice [fig. 2.13]).

Devotion to saints either as personal patrons or because of their efficacy in facilitating certain sorts of miracles led to many depictions. Pilgrims sought the shrines of some of the most popular. There are paintings in books of hours of St Ninian and St Margaret, whose shrines at Whithorn and Dunfermline were much visited. St Andrew was achieving the status of national saint and appeared as the king's patron in the Trinity College altar-piece. James IV visited shrines in Scotland and sent a silver ship to the shrine of the Apostle James at Compostela in Spain. James appeared as the king's patron in the Hours of James IV and Margaret Tudor (fig. 2.10).

Popular devotion could take on a public and communal, even theatrical, character. Sixteenth-century burgh records give some details of processions held on the feast of Corpus Christi (Mill 1929, 124–5, 172–3). At Aberdeen the various craft-guilds appeared with their banners and each enacted pageants from scripture or stories of the saints. At Dundee a list of the props used in such processions ends with a Holy Lamb of wood, St Barbara's castle, Abraham's hat and three wigs.

The Fetternear Banner is an extremely rare survival, a medieval processional banner (fig. 2.14). It was made for use in Scotland in about 1520, probably for the lay Confraternity of the Holy Blood at the church of St Giles in Edinburgh (McRoberts 1956). It bears the embroidered image of Christ as Man of Sorrows surrounded by the Instruments of the Passion.

The more secular outlook of the later Middle Ages led to a shift of patronage towards religious institutions of particular interest for the laity: parish churches, or chapels attached to them; collegiate churches such as Roslin; friaries; or academic colleges (at St Andrews, Glasgow and Aberdeen). The cathedrals and monasteries also continued to commission building work and furnishings.

Our knowledge of the decorative schemes of chur-

Fig. 2.14 *The Fetternear Banner, c.* 1520
Processional banner depicting Christ as the Man of Sorrows with the Instruments of the Passion; embroidered linen, 156×79 cm ($61\frac{1}{2} \times 31\frac{1}{8}$ in); probably made for the Confraternity of the Holy Blood, St Giles Church, Edinburgh
Trustees of the National Museums of Scotland, Edinburgh

Fig. 2.13 Mass of St Gregory from the Arbuthnott Hours, *c.* 1480
Vellum, f. 66v: 27.4×19 cm ($10\frac{13}{16} \times 7\frac{1}{2}$ in)
Paisley Museum and Art Galleries, Department of Arts and Libraries, Renfrew District Council

Fig. 2.15 Wall painting of the 'Woman Taken in Adultery' on the interior of the north-west tower, Dunkeld Cathedral, probably early 16th century
Photo: Historic Buildings and Monuments, Scotland (Edinburgh)

ches is a little fuller for this period but it remains extremely fragmentary. Stained glass must have been common but only smashed fragments, from a number of sites including Holyrood Abbey, now remain. Melrose Abbey still has a surprising amount of its architectural sculpture from around 1400 and later: the Coronation of the Virgin on the east gable; Apostles over the south door; images of the Virgin and Child (fig. 2.6) and the Apostles in niches on the exterior and interior; and the Trinity and the Apostles on bosses on the vault over the chancel. Some small-scale figure sculpture remains in place in Roslin chapel and there are fragments and empty niches in several other places. Although it may now be hard to imagine, much, if not all, of stone sculpture would have been painted, even on the exteriors of buildings.

Painted decoration on walls and vaults would also have been normal. Late medieval figure painting is still recognizable in the north-west tower of Dunkeld Cathedral (the Judgement of Solomon and the Woman taken in Adultery [fig. 2.15]), in the nave north aisle vault of Dunfermline Abbey (Apostles) and on vaulting under the crossing tower of Pluscarden priory (elaborate but hard to interpret in its present condition). Late fifteenth-century paintings of the Last Judgement and of scenes from the Passion survive in a very damaged condition on boards from the wooden barrel vault of an aisle formerly attached to the collegiate church at Guthrie (Apted and Robertson 1961–62). The nave ceiling of Aberdeen Cathedral (McRoberts 1973) is decorated with three rows of heraldic shields:

in the centre the pope and the Scottish church; to the south the king and earls of Scotland; to the north the emperor and kings of Europe. This is a clear statement of the independent and national nature of the Scottish church.

Church spaces were divided up into functionally distinct areas by screens. The nave was divided off from the chancel (the area, normally reserved for the clergy, with the main altar and, in larger churches, choir-stalls). Chapels would also be screened off. In greater churches these divisions would be both numerous and in the case of the main screens quite substantial. Screens would be decorated and examples of carved and

pieces, some imported from Flanders (Hay 1956, 9–10). The Trinity College panels of Van der Goes are the wings of a triptych (see fig. 4.1). Some of the painted boards at Fowlis Easter showing Christ, the Virgin and Child, the Pietà and saints may also have formed part of an altar-piece (McRoberts 1983). The portrait on a panel of Bishop Elphinstone of Aberdeen (1488–1514) has probably been cut out of an altar-piece that included him as patron (fig. 2.17). At Paisley Abbey scenes from the life of St Mirin, whose shrine was at Paisley, can still be seen on the stone retable of around 1500 in St Mirin's Chapel. Stone panels with scenes from the New Testament (probably from reta-

Fig. 2.16 Painted panels from the tympanum formerly above the rood-screen showing the scene of the Crucifixion, Fowlis Easter church (Angus), second half of the 15th century
Photo: Historic Buildings and Monuments, Scotland (Edinburgh)

painted figures remain. The stone screen at Lincluden is still surmounted by angels and scenes from the Infancy of Christ and figures of the Apostles were formerly set above these. Paintings on wood of the second half of the fifteenth century are still preserved in the collegiate church of Fowlis Easter (Apted and Robertson 1961–62). These include Christ, Apostles and saints from the parapet of the screen and a Crucifixion from the wooden tympanum above the screen (fig. 2.16).

Figures and scenes appeared on carved and painted wooden altar-pieces and on stone retables (panels behind altars). There are several references to altar-

bles) have also survived in Linlithgow and at St Salvator's College Chapel in St Andrews.

The choir of King's College Chapel in Aberdeen still retains something of its early sixteenth-century arrangements with its wooden screen and canopied stalls embellished with Late Gothic tracery patterns (fig. 2.18). Other pieces of wooden furnishing to survive include stalls from Dunblane and Lincluden and the Overgate panels from Dundee.

Two other important categories of liturgical furnishing in stone that could receive sculptural elaboration were fonts and sacrament houses. The sixteenth-century octagonal font at Meigle (Carter 1959, pl. XIV) carries the Crucifixion, the Instruments of the Passion, the common late medieval *arma Christi* (the arms of Christ: a coat of arms bearing the wounded hands, feet and heart of Christ) and the Resurrection. The fifteenth- and sixteenth-century 'sacrament houses'

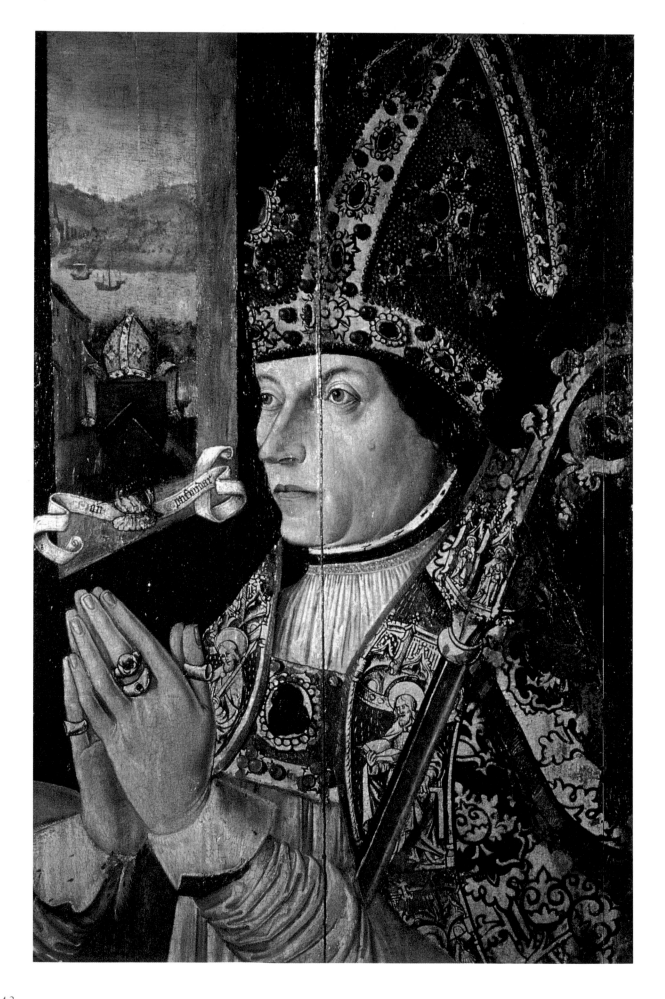

42

Fig. 2.17 Portrait of
William Elphinstone,
Bishop of Aberdeen,
between 1488 and 1514
Panel painting (probably cut
out from altar-piece);
Northern French or
Flemish, 76 × 48 cm
($29\frac{15}{16}$ × $18\frac{7}{8}$ in)
King's College, University
of Aberdeen

Fig. 2.18 King's College
Chapel, University of
Aberdeen, early 16th
century
Interior view with choir-
stalls and screen
Photo: University of
Aberdeen

Fig. 2.18a
Detail of canopy
Photo: University of
Aberdeen

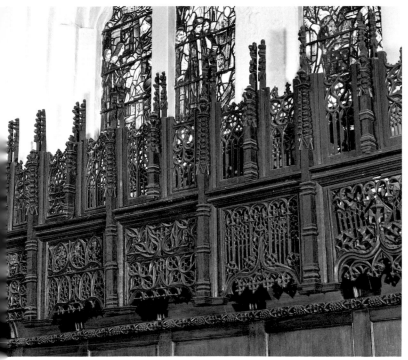

were lockable (perhaps grilled) recesses built into the wall near the altar for the reservation (and perhaps display) of the consecrated host. A Scottish development of a feature which originated on the Continent, they were given emphatic sculptural treatment as at Deskford (fig. 2.12).

Next to nothing of the more movable furnishings survives. The brass lectern commissioned by George Crichton, Bishop of Dunkeld (1526–43/4), probably in Flanders and probably for Holyrood Abbey, only escaped as booty taken by an English soldier (*Angels, Nobles & Unicorns*, 115–16). Some idea of fifteenth-century ecclesiastical metalwork can be gained from the three maces of St Andrews University with their miniature architecture and figures. The St Salvator's Mace (fig. 2.19), which was made by a goldsmith in Paris in 1461 for Bishop James Kennedy, is particularly magnificent and shows the same kind of Late Gothic refinement as his tomb.

Fig. 2.19 Mace of St Salvator's College, 1461
Detail of head with figures of Christ, angels with Instruments
 of the Passion, and a bishop; Made by the Parisian goldsmith
 Jean Mayelle, Paris, silver-gilt, h. 116.2 cm (45¾ in)
University of St Andrews

Illuminated manuscripts survive in greater numbers from the later medieval period but are scarcely representative of what is lost. Private books of devotion, mostly books of hours, have already been considered. Liturgical books were systematically destroyed at the Reformation and few remain. Illuminated examples include the large and handsome Arbuthnott Missal written for the church of St Ternan at Arbuthnott by the vicar of the church and completed in 1491. The decoration, which includes a full-page miniature of St Ternan (fig. 2.20, frontispiece), was probably done in Scotland and, if so, shows that not all illuminators working in Scotland were as charmingly naive as the artist of the Arbuthnott Hours (fig. 2.13). In the decades around 1500 there are records of service books, which were probably all illuminated, having been produced in Scotland for ecclesiastical and secular patrons – at the Cistercian monastery of Culross and by clerics from St Andrews and the Chapel Royal at Stirling. Patrons, however, often looked abroad. Bishop Gavin Dunbar turned to Antwerp for the epistolary which was written

in 1527 for Aberdeen Cathedral (Aberdeen University Library, MS 22).

In the last few decades of the medieval church in Scotland the official attitude to art came increasingly under challenge. Already in 1494, according to John Knox, a group known as the 'Lollards of Kyle' were denouncing, amongst other things, the use and adoration of images (Dickinson 1949, I, 8). In 1541 it was felt necessary to pass an Act of Parliament to protect images. It was ordained that 'nane brek Cast doune nor ony utherwayis treit Irreuerendlie nor do ony dishonor nor Irreuerence to the saidis Imagis' (Acts, II, 371). David Lindsay's poem 'Off Imageis vsit amang Cristin Men' (quoted at the beginning of this chapter) attacks as idolatrous the adoration of images of the saints. His enumeration of the many saints depicted, of their attributes (such as 'Sanct Bryde, weill caruit with ane koow') and of the various miraculous specialities that they were credited with is a vivid witness to the popularity of the saints and their images. Lindsay accepts the traditional role of images as 'of vnleirnit ... the buikis', a paraphrase of Pope Gregory's dictum, but praying or making offerings before an image he condemns (Hamer 1931, 267–70).

The Reformation sought to abolish 'Idolatry', defined by the 1560 Book of Discipline as 'the Mass, invocation of saints, adoration of images, and the keeping and retaining of the same; and, finally, all honouring of God not contained in his holy Word' (Dickinson 1949, II, 283). All religious imagery was now rejected. No distinction is here drawn between teaching with images and adoring them. Much but not all of Scotland's ecclesiastical art was deliberately destroyed at the time of the Reformation (McRoberts 1962). (There-had already been some considerable but localized damage during the English invasions of the 1540s.) The Church of Scotland had to continue issuing orders for the destruction of 'idolatrous monuments' for many decades after the Reformation (for example, the paintings at Fowlis Easter in 1610, the choir screen at Elgin in 1640 and the Ruthwell Cross in 1642).

The Reformation's revolutionary break with traditions of religious art had much support but it also met with resistance and half-heartedness. The Reformers were, however, victorious and the visual culture of Scotland was for long, and to some extent still is, marked by their suspicion of the visual arts.

3

IN SEARCH OF SCOTTISH ART: NATIVE TRADITIONS AND FOREIGN INFLUENCES

DAVID H. CALDWELL

By the twelfth century Scotland was a well-established kingdom which had expanded from a base in Argyll to dominate the north of Britain. Its ruling dynasty was securely placed and eager to open up the country to influences from abroad. Burghs were established and settled by immigrant merchants and craftsmen, houses of reformed monks and canons were founded and French and Anglo-Norman families given grants of land.

As a result Scotland was exposed to the prevailing trends in European art and architecture and developed its own thriving branch of Romanesque. By the end of the twelfth century churches in the new style were being built throughout the land. The skilled craftsmen may mostly have been foreigners, coming directly from south of the border, but one or two of the surviving pieces of applied art show evidence of local craftsmen adapting to the new style.

A bronze bell shrine found at Kilmichael Glassary in Argyll provides a good example (fig. 3.1). It was made to contain a precious relic of an Irish saint and includes dragonesque heads and panels of interlace in its decoration. It is thus firmly rooted in a Scoto-Irish tradition. The Crucifixion, however, on the front is a most accomplished and dignified piece of Romanesque art, far excelling the mass-produced enamelled crucifixes exported from the workshops of Limoges in France.

A full flowering of Gothic art and architecture took

place in Scotland in the thirteenth century that reflected the wider European developments evident in churches like Jedburgh Abbey, and Glasgow and Elgin Cathedrals. Since much of the stylistic inspiration continued to come from England, distinguishing Scottish-made pieces of applied art from imported ones is often difficult. For instance, several fine silver ring brooches have turned up in late thirteenth- and fourteenth-century coin hoards (fig. 3.2), giving Scotland a disproportionately high quantity of surviving brooches of this type. They are probably mostly of Scottish manufacture but have no idiosyncrasies of design to confirm or deny this supposition.

Both documentary sources and survivals demonstrate that foreign craftsmen were encouraged to come and work in Scotland; for example, the Parisian John Morow worked at Melrose and Paisley Abbey, Lincluden Collegiate Church and elsewhere in Scotland at the turn of the fifteenth century and an Italian executed the (now vanished) windows of the Charterhouse in Perth in the 1430s. In many other cases fine objects were imported or commissioned abroad. The Taymouth Book of Hours (fig. 3.3), a fine fourteenth-century English illuminated manuscript, was probably made for Queen Joan (wife of David II), while a later queen, Margaret Tudor, wife of James IV, had her magnificent Hours made in Ghent or Bruges. From Bruges in the 1470s came the altar-piece by Hugo van der Goes, commissioned for Trinity College in

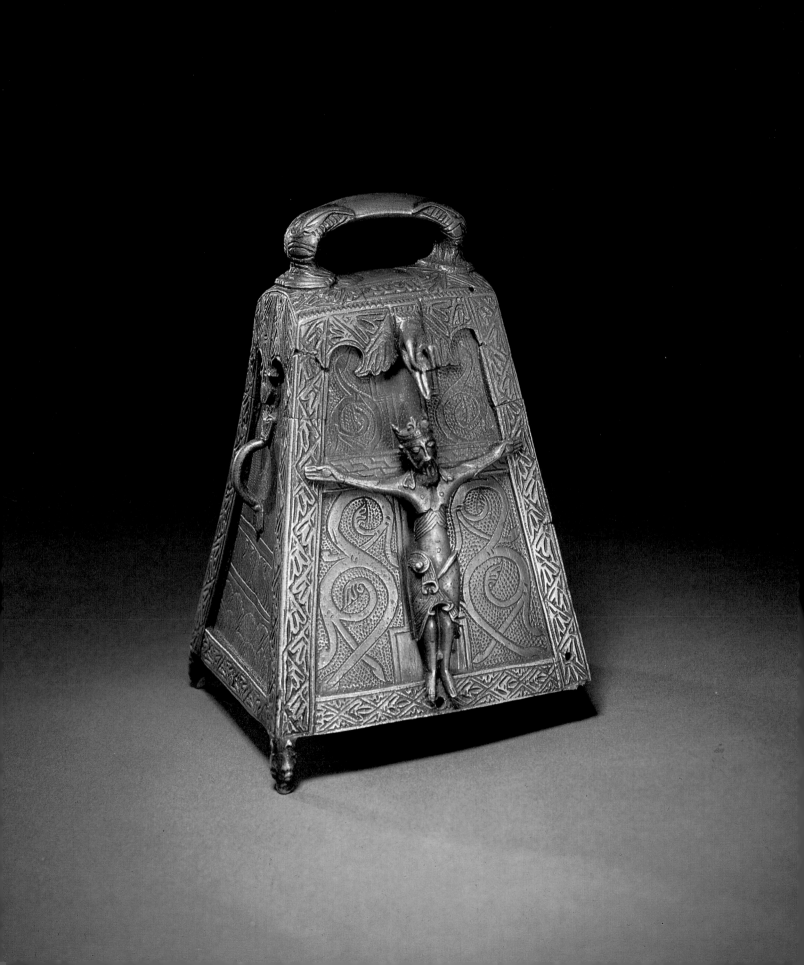

Fig. 3.1 *Kilmichael Glassary Bell Shrine*, 12th century
Copper alloy,
14.8 × 9.5 × 8.5 cm
($5\frac{13}{16} \times 3\frac{3}{4} \times 3\frac{3}{8}$ in)
Trustees of the National Museums of Scotland, Edinburgh

Fig. 3.2 Two brooches from a hoard with coins, buried at Woodhead, Canonbie, Dumfriesshire, *c.* 1300
Silver, d. 8 and 5.7 cm ($3\frac{1}{8}$ and $2\frac{1}{4}$ in)
Trustees of the National Museums of Scotland, Edinburgh

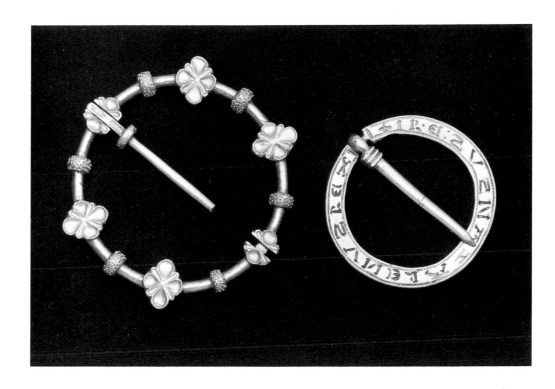

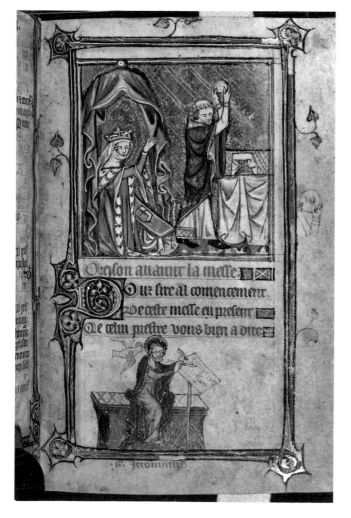

Edinburgh (see fig. 4.1). When Bishop James Kennedy wished to grace his new foundation, St Salvator's College, with a fine mace he turned to a Parisian goldsmith, Jean Mayelle. His mace of 1461 is still much treasured by St Andrews University (see fig. 2.19).

What of work produced in Scotland? Because little evidence exists to associate the names of particular craftsmen with surviving pieces, there has been a regrettable tendency among scholars to assume that good quality pieces have to be imports and poor quality ones native imitations. Not surprisingly, we cannot identify any area of the arts in the Middle Ages where the Scots were in the vanguard of fashion or excellence, and much of the work produced here was obviously imitative and of poor quality. The great seal of David II (fig. 3.4) ineptly copies the seal of his father, Robert I, which was probably made in France. David's bears the letter D, arguably for Donatus Mulekyn, one of his moneyers. Sometimes, as with some fifteenth-century books, even the models themselves were not very well executed.

Fig. 3.3 The Taymouth Hours, *c.* 1325–40
Lady at Mass, St Jerome in the border; English; Illuminated manuscript, page: 16.3 × 11.5 cm ($6\frac{3}{8} \times 4\frac{1}{2}$ in); Made for Joan, daughter of Edward II of England and wife of David II of Scotland
British Library, London

Fig. 3.4 *Great Seals of Robert I and David II, c.* 1320 *and c.* 1341
Robert I (left), French (?); David II (right), Scottish; 19th-
 century casts of the original wax seals; d. of originals 10.2 cm
 (4 in)
Trustees of the National Museums of Scotland, Edinburgh

Fig. 3.5 *Groat of James III, c.* 1485
Silver coin, d. 2.5 cm (1 in)
Trustees of the National Museums of Scotland, Edinburgh

Some of the Scottish coinage, however, shows that skilled craftsmen were available in Scotland to produce quality work, like the fifteenth-century gold coinage of James III and the superb portrait groats of that same king (fig. 3.5) which are among the earliest true coin portraits since Roman times. Armed with this evidence we should be wary of taking too minimalist a view of Scottish artistic talents in the Middle Ages. The royal sceptre was remodelled in 1536 by the Edinburgh goldsmith Adam Leys, some of whose seals also survive in the form of impressions. Made in 1540, the crown itself is the work of John Mosman, another Edinburgh goldsmith.

Other outstanding examples include a late medieval silver gilt ring brooch from Kindrochit Castle with a French inscription integral to its design (fig. 3.6). The garbled phrasing of the inscription eliminates the possibility that it could have been made in France. A sixteenth-century silver covered cup with a crystal stem, known as the Methuen cup (Los Angeles County Museum), is thought to be Scottish, possibly the work of Walter Hay of Aberdeen.

The provenances of three fifteenth-century uni-

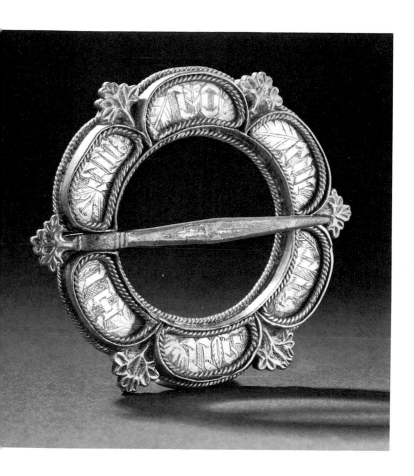

Fig. 3.6 Brooch, found in the pit prison at Kindrochit Castle, late 15th century
Silver gilt, d. 8.8 cm ($3\frac{1}{2}$ in)
Trustees of the National Museums of Scotland, Edinburgh

versity maces – one from Glasgow, two from St Andrews, which all have heads in the form of three stage hexagonal towers – have been in doubt. Only one, the so-called 'Mace of the Faculty of Canon Law' (St Andrews) has been considered to be Scottish – a cruder copy of the Mace of the Faculty of Arts (fig. 3.7). No documentary evidence has been uncovered to prove that the Canon Law mace is later and all three are different from continental or English silverwork. Since they are unlike any of the university maces surviving elsewhere, it is therefore surely more reasonable to assume that they are all Scottish work.

It is equally reasonable to believe that the Beaton panels, elements of a decorative scheme of woodwork done for Cardinal Beaton in the 1530s, are Scottish. The Cardinal could command the services of the best craftsmen working in Scotland and we know from some surviving accounts that he did. The panels are among the latest and best of a whole series of Late Gothic wood carvings in Scotland. Their general similarity to other north European work, and their depictions of the Tree of Jesse and the Annunciation (fig. 3.8), which were copied straight from a French printed book of hours by Thielman Kerver of Paris, does not provide evidence against their Scottish manufacture. Scotland, with its trading links in the Low Countries, its alliance with France and its church tied to Rome was firmly part of a European world and its art was essentially European.

There was, however, another art in medieval Scotland, that of the West Highlands. From the fourteenth century distinct areas in Scottish art and culture emerge, the Highlands and the Lowlands. That Scots themselves recognized a difference can be seen from the work of the late fourteenth-century chronicler John of Fordun and many others who came after him.

While most art work in the Lowland zone was done by workers in the burghs and larger towns under the aegis of craft incorporations, no successful burghs existed in the Highland zone. Some craftsmen there were directly dependent on the patronage of the lordly houses of the area and were maintained by them, as were poets, harpists and pipers. Other were itinerant, like some of the carvers of graveslabs in the sixteenth century. Craftsmen were well respected and had high status in Gaelic society in the Middle Ages. One small but important group of them worked on Iona and another about Loch Sween in Knapdale in the fifteenth century.

By the fifteenth century the Western Isles and much of the western seaboard were ruled by the kingly Lords of the Isles who came to be direct competitors with the Stewart dynasty for control over much of Scotland. They gained the Earldom of Ross and their influence extended eastwards into Perthshire. Since much of their power was sea-based, galleys figure prominently in the arms and on the tombs of West Highland families. Owing to the mountainous tracts which hemmed in the few fertile areas, society was organized on a tribal and warlike footing, military aggression being one of the few obvious avenues for expansion. A warrior élite was fostered who in their turn were the benefactors of craftsmen, particularly stone carvers who have left a rich heritage of free-standing crosses and graveslabs.

The crosses do not appear to be funerary in nature

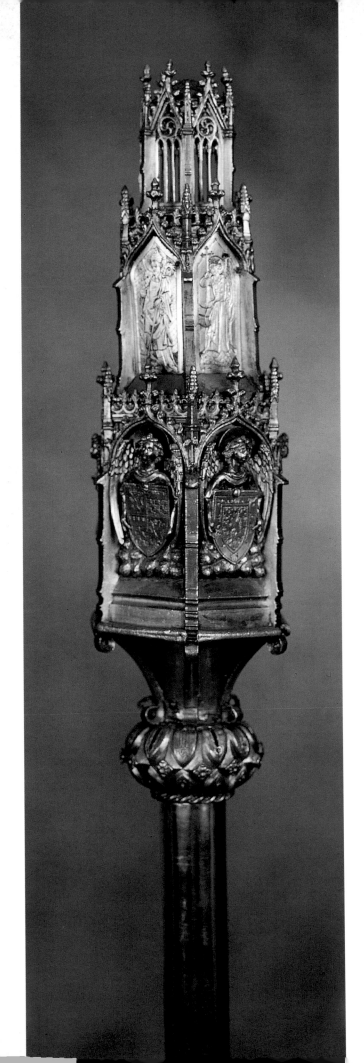

Fig. 3.7 Mace belonging to St Andrews University, said to
 be for the Faculty of Arts, early 15th century
Silver, partially gilt, and enamel, l. 127 cm (50 in)
University of St Andrews

but were erected to the glory of God and the living.
A late manifestation of a Scoto-Irish tradition, they are
the successors in spirit but not design of such ninth-
century masterpieces as St John's Cross on Iona and the
cross at Kildalton on Islay. Their decoration, like that
of the graveslabs, is essentially Romanesque. Con-
servative but immensely rich, the style can clearly be
distinguished from contemporary Lowland carving,
which is characterized by an emphasis on heraldry,
architectural frameworks of Gothic niches and figure
sculpture. Except on those slabs with high-relief effigies
of knights and ecclesiastics, no significant areas of stone
are left bare. Early slabs have a cross shaft with floriated
head running the length of the stone and a sword at
one side. Symbols of status such as swords are a recur-
ring theme, as are attributes – for instance, a clarsach
(harp) for a musician, tools for a craftsman, a chalice
for a priest. Scrolling leaf designs, often developing
into fantastic animal or dragon heads, are ubiquitous.
On some stones animals are carved naturalistically
(fig. 3.9), sometimes in hunting scenes, sometimes
intermixed with unicorns, griffins, dragons and other
animals from the bestiaries. Panels of interlace are quite
common, possibly reflecting an awareness of an earlier
tradition of art in Scotland.

 In a study made several years ago Dr Steer and Dr
Bannerman distinguished four main schools of carving
centred on Iona, Oronsay, Kintyre and Loch Awe, and
a lesser grouping emanating from the Loch Sween area
in Knapdale. They were not all operating sim-
ultaneously; the Iona workshops were in production
earliest (by the middle of the fourteenth century), and
those of Oronsay not until after 1500. By the beginning
of the sixteenth century much of the work was done
by individual craftsmen who may have travelled
around for work. The Reformation hastened the end
of a tradition that was already in decline.

Fig. 3.8 *Annunciation* from the Beaton Panels, *c.* 1524–37
Carved oak, 144.8 × 670.6 cm (57 × 264 in complete panels);
 Made for Cardinal David Beaton
Trustees of the National Museums of Scotland, Edinburgh

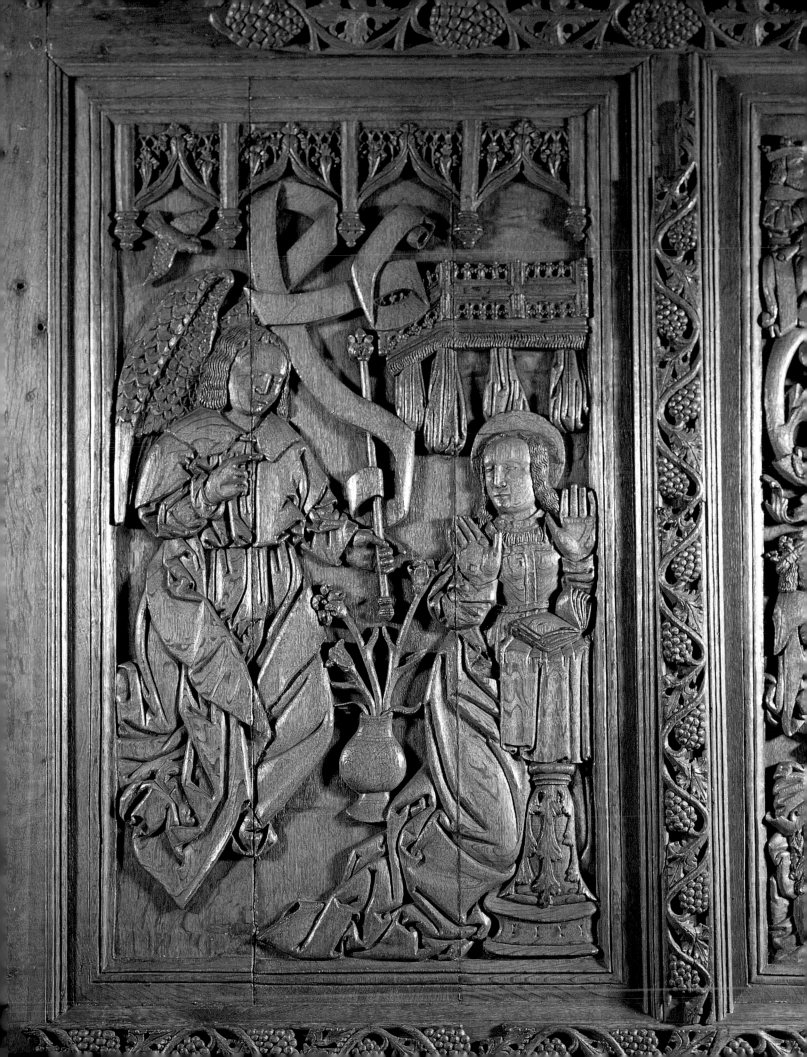

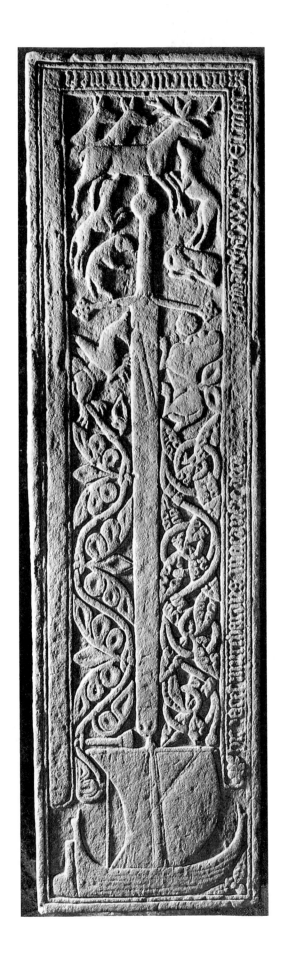

Fig. 3.9 *Graveslab of Murchardus MacDuffie of Colonsay*, 1539
Oronsay School, carved stone, 170 × 48 cm (67 × 18⅞ in)
Oronsay Priory
Photo: The Royal Commission on the Ancient and Historical
 Monuments of Scotland, Edinburgh

Slabs with long shafted crosses with floriated heads occur widely in the British Isles in the thirteenth and fourteenth centuries and the West Highland slabs seem to develop from them. Indeed there is a slab of this type at Keills in Knapdale. Little in the Lowlands however can compare with this flowering of sculpture in the West Highlands in the fourteenth and fifteenth centuries. Although sculpture adorns churches such as Melrose Abbey and Roslin Collegiate Church, and tombs like the mid-fifteenth-century series of knights and their ladies at Houston, Renfrew, Borthwick, Seton and elsewhere, it all recognizably belongs to a European tradition of art.

Fortunately not just stonework has survived from the Middle Ages in the Highlands. A few other valued pieces have as well, enough to demonstrate the abilities of wood carvers, jewellers and workers in bone, and attest to the sophistication of this Gaelic-speaking society. Pride of place must be given to the 'Queen Mary' Harp, a clarsach constructed about 1450 (fig. 3.10). It is decorated with foliage, interlace and animals comparable to work on the contemporary stone monuments. The strapwork cross design on the sound box and the animal head terminals on the fore-pillar, reminiscent of those on the Kilmichael Glassary bell shrine, hint at a more distant Scoto-Irish ancestry.

Two relic shrines, the Guthrie bell shrine (fig. 3.11) and the *Coigrich*, the shrine of St Fillan's crozier (fig. 3.12), show that fourteenth-century West Highland goldsmiths were competent in modelling figures – God and bishops on the former and a beautiful little bust of St Fillan on the latter. An interesting group of reliquary brooches has survived as well. The earliest is the Brooch of Lorne, long preserved by the McDougalls of Dunollie. It is of silver gilt and is an elaboration of the ring brooches popular in Scotland from the thirteenth century onwards. The flat ring is ornamented with silver filigree star designs alternating with eight tall collets containing pearls. The ring encircles a large capsule with scalloped outline surmounted by a hemispherical crystal. The capsule screws off and was presumably meant to contain a relic or memento of

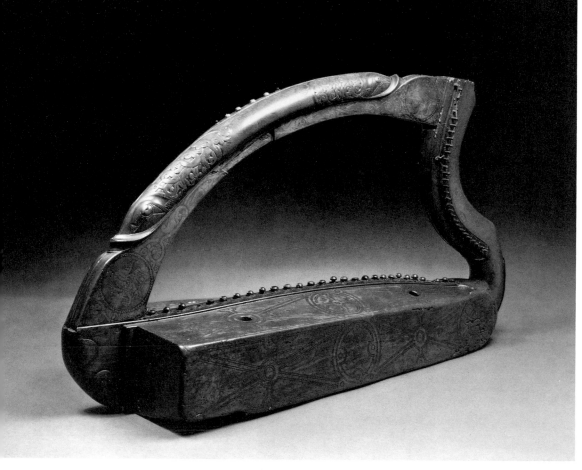

Fig. 3.10 *The Queen Mary Harp*, c. 1450
West Highland, hornbeam,
81.2 × 51 cm (32 × 20 in)
Said to have belonged to
Mary Queen of Scots
Trustees of the National
Museums of Scotland,
Edinburgh

Fig. 3.11 *Guthrie Bell Shrine*, 12th century and later
West Highland, iron, copper alloy, silver and gilt,
21 × 14 × 11.2 cm ($8\frac{1}{4}$ × $5\frac{1}{2}$ × $4\frac{3}{8}$ in)
Restored by John II, Lord of the Isles,
at the end of the 15th century
Trustees of the National Museums
of Scotland, Edinburgh

Fig. 3.12 *The Coigrich*, the
crozier shrine of St Fillan,
15th century,
incorporating earlier work
Detail of St Fillan, silver gilt,
rock crystal, 23 × 20 cm
($9\frac{1}{16}$ × $7\frac{7}{8}$ in)
Trustees of the National
Museums of Scotland,
Edinburgh

Fig. 3.13 *Lochbuy Brooch, c. 1500*
West Highland, silver gilt, rock crystal and river pearls, 12.1 × 6.8 cm ($4\frac{13}{16} \times 2\frac{11}{16}$ in)
Trustees of the British Museum, London

Fig. 3.14 Casket, 15th century
West Highland, whale bone, copper alloy, 13 × 22 × 11 cm ($5\frac{1}{8} \times 8\frac{5}{8} \times 4\frac{3}{8}$ in)
Trustees of the National Museums of Scotland, Edinburgh

some sort. The brooch is said to have been lost by Robert Bruce at the Battle of Dalry in 1306 when his cloak was torn from him by a dying assailant, but despite this picturesque tradition it probably dates from the later part of the fifteenth century. The Lochbuy Brooch and Ugadale Brooches, also long preserved by West Highland families, are closely comparable but slightly later in date. The Lochbuy Brooch has a plausible eighteenth-century inscription saying it was made about 1500 (fig. 3.13). A fine silver ring brooch of about 1500 from Mull is decorated with animals, foliage and black letter amuletic inscriptions (Edinburgh, National Museums). The engraving is beautifully enhanced with niello, a type of black enamelling. The technique was also executed about the same time on a panel on the Guthrie bell shrine (fig. 3.11) to record its renovation at the behest of John, son of Alexander, presumably John Lord of the Isles (died 1498).

Two caskets made of panels of whale bone bound with brass mounts are decorated all over with interlace patterns, and were probably used for holding jewellery or documents (fig. 3.14). Similar caskets are represented on some West Highland graveslabs.

Common to all this West Highland art is a love of decorative schemes that leave few surfaces untouched. Leafy scroll designs, interlace and animals (real or mythical), are the dominant motifs. There is little evidence that the style penetrated the Lowlands at this period or influenced craftsmen working there. In the Lowlands Late Gothic forms of decoration survived well into the sixteenth century.

Thus two traditions of Medieval Art developed simultaneously in Scotland, a Highland and a Lowland. In the sixteenth century the Scottish Court introduced the art of the Renaissance, a radically new style characterized by classical precedent and an interest in portraiture. James v's French marriages, his visit to France and the employment of French craftsmen all made its transference from that country inevitable. The Renaissance style first appears in the late 1530s in the courtyard façades of Falkland Palace with their pilastered buttresses, large windows and roundels con-

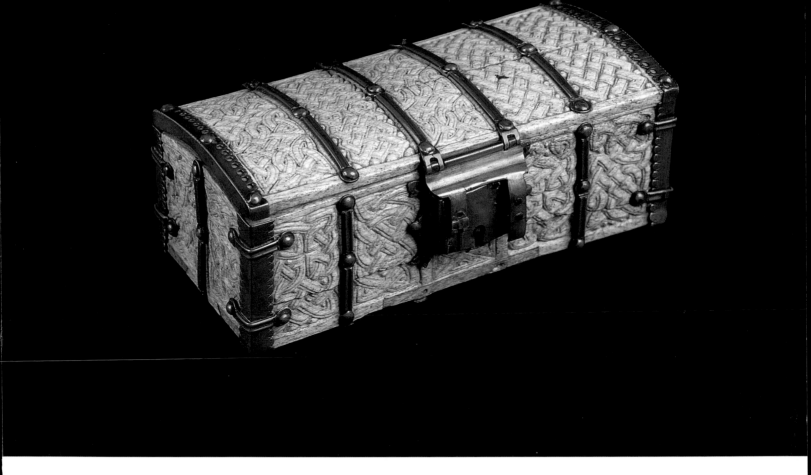

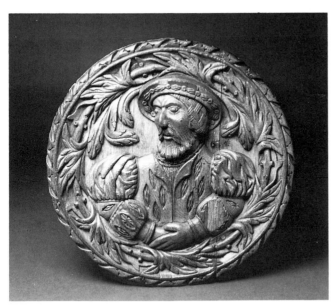

Fig. 3.15 *Stirling Head,* said to represent James V, *c.* 1540
One of several medallions from the ceiling of the King's
 Presence Chamber in the palace, Stirling Castle; carved oak,
 d. 71.1 cm (28 in)
Trustees of the National Museums of Scotland, Edinburgh

taining relief portraits of Roman emperors. It is also
evident in the contemporary palace block at Stirling
Castle from which some wood panelling survives as
well as most of the portrait roundels – the so-called
Stirling heads (fig. 3.15) – from the ceiling in the Pres-
ence Chamber. Framed by garlands or wreaths in classi-
cal style, the heads are a mixture of classical busts,
dancing putti and, perhaps modelled on court figures,
men and women dressed in contemporary costume.

The response of Scottish craftsmen and patrons to
the new style varied. Although he was the main sup-
porter of the French alliance, Cardinal Beaton chose the
Gothic style for the panels he commissioned (fig. 3.8),
perhaps in order to stress continuity with a past that he
hoped would not be invalidated by Protestant ideas.

As books, jewellery, furnishings and other objects in
the new style flooded into the country and were
adopted in court circles, many Scottish craftsmen
readily copied them. Some of their attempts inevitably
were crude but by the end of the century several
artisans, particularly in Edinburgh and Canongate,

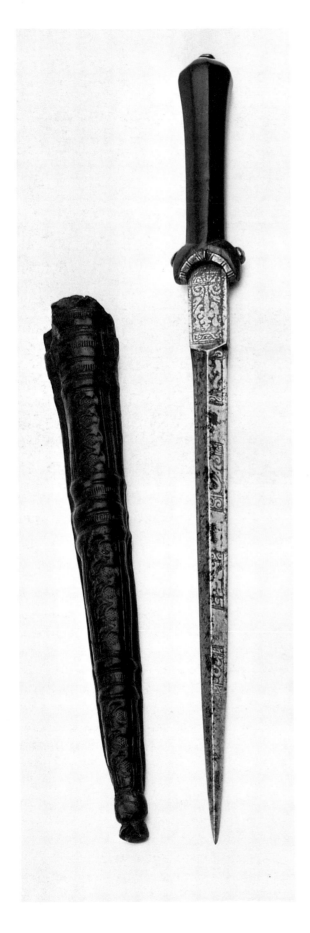

were producing first-class work in a distinctive Scottish Renaissance style. A real flowering of craftsmanship took place in the late sixteenth and early seventeenth century, manifested in painted ceilings, standing mazers, gold enamelled jewellery, dudgeon daggers (fig. 3.16) and snaphance pistols. Painting flourished along with the decorative arts; for example George Jamesone, a portrait painter of considerable ability, was successfully plying his business in the 1620s and 30s.

In the mid-seventeenth century, the withdrawal of patronage to London with the Court, civil war and religious disapproval contributed to the decline of craftsmanship in the Scottish towns and burghs, and throughout the eighteenth century much of it was very conservative in character. Remarkably the style developed in the fourteenth century continued in the Highlands and Islands throughout these centuries. The tradition of stone carving died away in the mid-sixteenth century but craftsmanship in metal, wood and other materials thrived. With the collapse of the Lordship of the Isles after the forfeiture of 1493 there was a power vacuum in the west and Highland art in the east was more dominant. Whereas most of the works from the medieval period were commissioned or owned by the top ranks in society, many of the finely decorated brooches, dirks, targes (shields) and powder-horns of the seventeenth century belonged to people further down the social scale. To call it folk art might imply that it was some sort of peasant phenomenon – hardly appropriate for a society that prided itself on its nobility. In fact some of the best examples were commissioned by clan leaders and lairds, like the horn of about 1600 at Dunvegan Castle which belonged to Rory Mor, chief of the MacLeods, or the long guns made for the Lairds of Grant in the seventeenth century (fig. 3.17). The stocks of these may have been the work of William Smith, clan armourer to the Grants.

The repertoire of design used by Highland craftsmen in the seventeenth century was still based firmly on foliage, interlace and animals. Imitation black letter inscriptions even appear on some late sixteenth- and seventeenth-century brooches giving the semblance of

Fig. 3.16 Dudgeon dagger, 1617
Edinburgh, wooden hilt, blade etched and gilt, l. 33.6 cm
(13¼ in)
Trustees of the National Museums of Scotland, Edinburgh

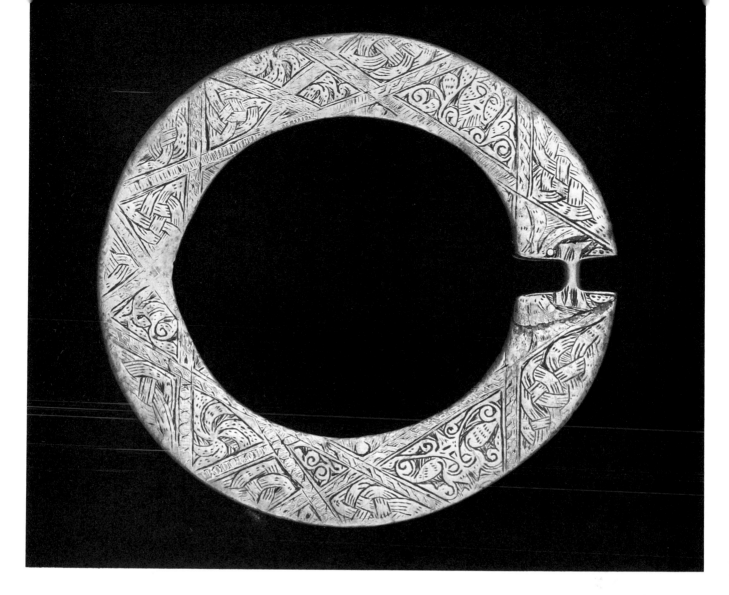

earlier inscriptions. The forms of many of the objects so lovingly decorated also reflect conservative values. The brooches, targes and dirks of these times were not at all different from medieval types. The weaving of multi-coloured cloth – tartan – was new, however; perhaps introduced no earlier than the sixteenth century.

Some awareness of the new Renaissance Art is evident; strapwork designs and grotesques as well as Highland designs ornament a late sixteenth-century silver brooch (fig. 3.18) from Rannoch Moor, and several seventeenth-century powder-horns also show a mixture of styles. Highland interlace, animals and foliage, especially as arranged in roundels and panels on the brooches (fig. 3.19) curiously parallel some Renaissance style art with its strapwork, grotesques and scrollwork and may have drawn strength from this happy coincidence.

Highland art seems to have had little influence on the craftsmen working in the towns and burghs. An interesting exception is the Highland-style spotted

Fig. 3.18 Brooch, found on Rannoch Moor, late 16th–17th century
Highland, silver, d. 10.9 cm ($4\frac{5}{16}$ in)
Trustees of the National Museums of Scotland, Edinburgh

animal heads that appear on the butt mounts of some early seventeenth-century pistols made in Dundee. On the other hand several Lowland craftsmen in the seventeenth and eighteenth centuries produced pistols and swords hilts for the Highlands. They were so successful that their products are often considered, wrongly, to be Highland, and their decoration Celtic. A good example of this are the all-metal pistols made by the gunsmiths of Doune on the edge of the Highlands in Stirlingshire (fig. 3.20). With no elements of Highland art about them at all, their decoration is solidly Lowland in character (although surprisingly antiquated) and best described as traditional. For instance one of the main scrollwork designs on the back of the grips of these mid-eighteenth-century pistols finds its closest parallel in bookbinding of over a hundred years earlier.

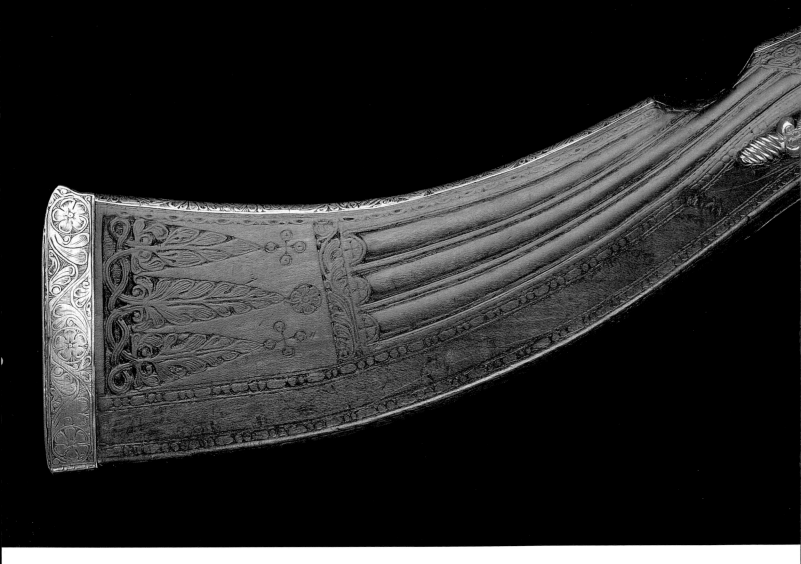

The quality and range of designs in Highland art had already degenerated before the end of the seventeenth century. There was an increasing tendency to simplify and produce more geometric forms. In the eighteenth century the Highland tradition, if somewhat diluted, was finally transmitted to Lowland workshops with the production there of attractive silver brooches (fig. 3.21). The earlier ones have recognizable animals, foliage and interlace; the later examples have geometric chequer patterns with distinctive anchor patterns in niello. Dirks, their bejewelled baluster-shaped hilts changing ever further from the simple interlace-patterned prototypes which inspired them (fig. 3.22) were being made in the towns in some quantity by the beginning of the nineteenth century, soon followed by those other essential pieces of Highland equipment,

Fig. 3.17 Sporting rifle, barrel dated 1667 and lock plate 1671
Possibly mounted by the Grants' armourer, William Smith; barrel marked IS and the lock IT; wooden stock with silver mounts, l. 154 cm ($60\frac{11}{16}$ in); Made for Ludovic Grant, 1st Laird of Grant
Trustees of the National Museums of Scotland, Edinburgh

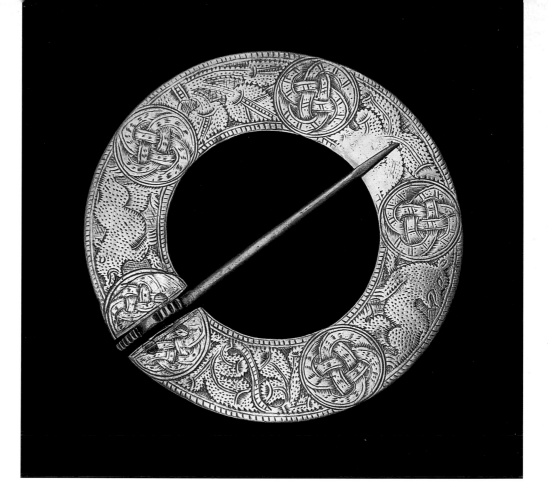

Fig. 3.19 Brooch, 17th century
Highland, brass, d. 13.5 cm ($4\frac{3}{8}$ in)
Trustees of the National Museums of Scotland, Edinburgh

Fig. 3.20 Pistol, *c.* 1750
Alexander Campbell, Doune; iron, silver inlay, l. 33 cm (13 in)
Trustees of the National Museums of Scotland, Edinburgh

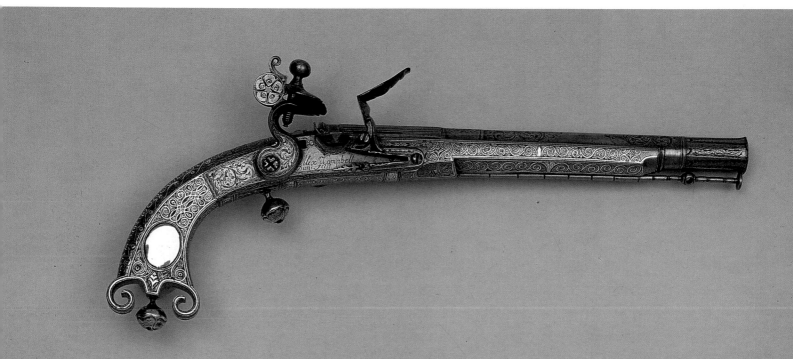

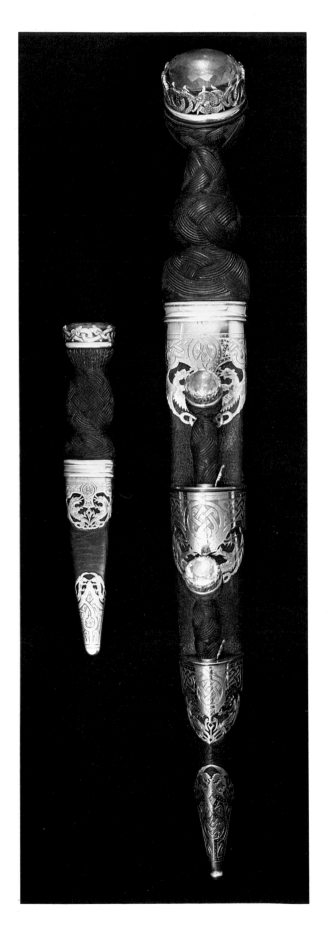

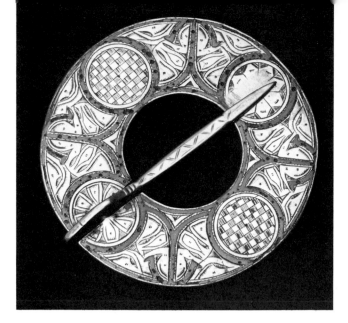

Fig. 3.21 Brooch, c. 1770
Silver, niello, d. 7.6 cm (3 in)
Trustees of the National Museums of Scotland, Edinburgh

Fig. 3.22 Dirk and Skene dhu, 1907–8
Sold by Scott Adie, London; hallmarks Young & Tatton,
 Edinburgh; wooden hilts set with citrines and silver mounts,
 l. 44.7 and 17 cm ($17\frac{9}{16}$ and $6\frac{11}{16}$ in)
Trustees of the National Museums of Scotland, Edinburgh

bagpipes and sporrans. Skene dhus (literally black knives) were invented to decorate the stocking tops of a more civilized breed of Highlanders who disdained having naked legs (fig. 3.22). Enormous lengths of tartan were woven in Lowland mills to supply the army, and George IV's appearance in a kilt at Holyrood in 1822 gave the royal seal of approval to Highland dress and, by association, the culture that had produced it.

While these developments might easily be dismissed as degenerate, a revival or nostalgia for a misunderstood past, perhaps it is more constructive to see them as the ultimate triumph of a long enduring tradition. Not even drastic and determined government measures in the eighteenth century to destroy Highland culture and root out Jacobitism had quite managed to deliver the death blow to this art. Ironically it was the army, that instrument of oppression in the Highlands, which kept alive many traditions in its eagerness to recruit Highlanders to the ranks. The tartan-clad image of the Scots that emerges in the nineteenth century and the so-called Celtic-style decoration, mixing and muddling much more than the motifs favoured by the medieval Highland craftsman, were not mere fabrications but were firmly rooted in the past. They were accepted by both Highlanders and Lowlanders as an expression of Scottish culture as a whole.

4

SCOTLAND'S ARTISTIC LINKS WITH EUROPE

JAMES HOLLOWAY

The earliest documents to mention painting in Scotland date from the very beginning of the fourteenth century. Too few survive to give anything like a clear view of the personalities and projects of the time, much less describe the influence of foreign artists on the Scottish scene. The earliest existing document to mention a Scottish artist by name, however, does in fact record an international transaction, albeit of the most insignificant kind. This is a payment to 'Richard of Dunfermline' in June 1301 for a journey to Newcastle-upon-Tyne to buy paints to be used in the decoration of the King's Chapel at Edinburgh Castle.

In the fifteenth and sixteenth centuries a little more is known because more documentary evidence and works of art survive. Scotland was apparently becoming more cosmopolitan, importing talent from France and the Netherlands, from England and Germany as well as employing her own native craftsmen. The country could support families of painters like the Scotts in Glasgow or the Binnings in Edinburgh, and herald painters such as John Workman, in addition to European artists like the Frenchman Piers who, for three years between 1505 and 1508, was employed by the king at Edinburgh and Stirling.

Although the royal family were the most lavish patrons, surprisingly, the greatest work of art in post-medieval Scotland was not paid for by the king or even a nobleman but was commissioned by a cleric with strong family connections in international trade.

Edward Bonkil, one of a family of rich city merchants, was the Provost of the Collegiate Church of the Holy Trinity in Edinburgh. His father and brother, both traded with the Netherlands; his brother also lived for a time in Bruges where he was a burgess.

In the late 1470s Edward Bonkil must have visited the Brussels studio of Hugo van der Goes, one of the greatest European artists of the time, since Bonkil's portrait, painted from the life, appears on one of the pair of organ shutters which the Provost ordered for his church in Edinburgh. Both the scale of the commission (two panels over six foot high, painted on both sides) and their superlative quality are exceptional. Open, they reveal on the one panel King James III and his son, the future James IV, with St Andrew facing, on the second panel, Queen Margaret and St George. When the panels are closed they show Edward Bonkil kneeling in prayer before a vision of the Trinity (fig. 4.1).

For over a hundred years, until James VI succeeded to the English throne at the beginning of the seventeenth century and took the Trinity panels south with him, Van der Goes's painting must have been the finest work of art in Scotland and an inspiration to Scottish artists of the Renaissance. The panels were not, however, an isolated phenomenon. There were other devotional works, prayer books and breviaries, like the Arbuthnott Hours and the Taymouth Hours (see figs 2.13 and 3.3), there were oil portraits such as that of Glasgow-born Bishop William Elphinstone (see fig. 2.17),

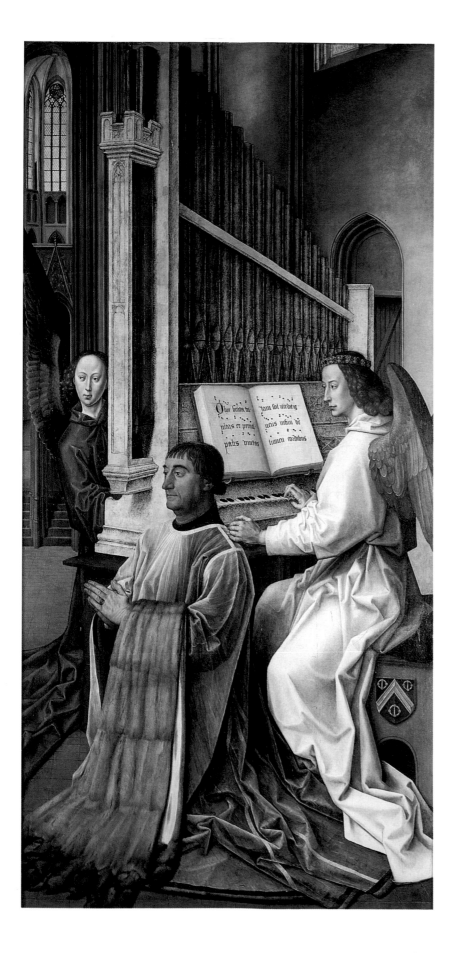

Fig. 4.2 *Falkland Palace and the Howe of Fife, c.* 1633
Alexander Keirincx (1600–52); oil on panel,
45.6 × 68.6 cm (18 × 27 in);
Painted for King Charles I
Scottish National Portrait Gallery, Edinburgh

Fig. 4.1 *Edward Bonkil and Two Angels, c.* 1478
A panel from the Trinity Altar-piece; Hugo van der Goes (active 1467, died 1482), Brussels; oil on panel, 202 × 100.5 cm
(79½ × 39½ in)
National Gallery of Scotland (on loan)
Reproduced by Gracious Permission of Her Majesty the Queen

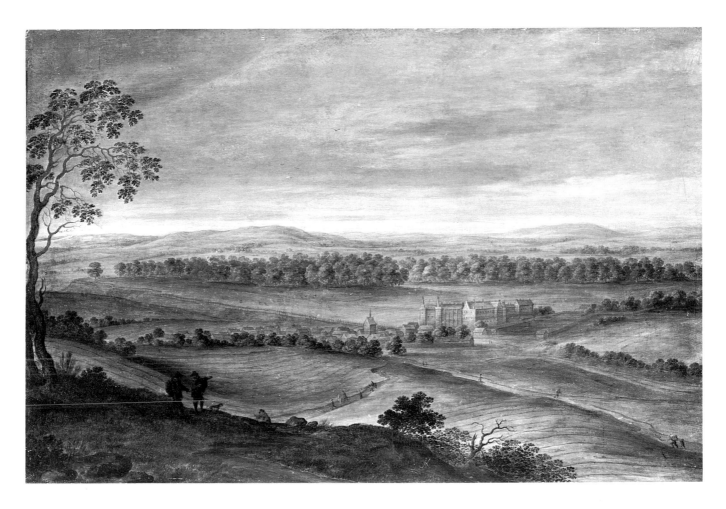

and there were fine buildings at Falkland (fig. 4.2) and at Roslin; all of which reflect the light of developments in continental Europe. They survive, while much more has been destroyed; yet a false perception has grown of Scotland as a backwater, a country which was bypassed by the Renaissance. Certainly the finest Italian or Flemish artists did not visit Scotland any more than they visited England or Denmark. Rather, Scotsmen and women like Mary, Queen of Scots or her chancellor, Lord Seton, were painted abroad and then returned with fine examples of continental painting.

Although not in the first rank of Renaissance portrait painters, the Dutchmen Arnold Bronkhorst, Adrian Vanson and Adam de Colone, who worked in Scotland between 1580 and 1628, were accomplished artists who could capture more than just a likeness. Bronkhorst is documented in Scotland from 1580, painting portraits

Fig. 4.3 *Lady Agnes Douglas, Countess of Argyll,* 1599
Adrian Vanson (active 1581–1602); oil on canvas,
 86.4 × 77.5 cm (34 × 30½ in)
Scottish National Portrait Gallery, Edinburgh

Fig. 4.4 *Lord Mungo Murray*, *c.* 1681
John Michael Wright (1617–94); oil on canvas,
224.8 × 154.3 cm (88½ × 60¾ in)
Scottish National Portrait Gallery, Edinburgh

for King James VI; he probably had arrived a few years earlier. Like the work of Adrian Vanson (fig. 4.3), who replaced him as court painter in 1584, Bronkhorst's portraits of the Stewart court are psychologically acute as well as decorative. To Vanson we owe the only known image of John Knox, the man whose sermons encouraged the destruction of much precious earlier art. Vanson was made a burgess of the City of Edinburgh and undertook to train apprentices, though when his own artist son, Adam de Colone, was of age he prudently sent him abroad to the Netherlands to complete his studies. By the time Colone was fully trained the Scottish court had left Edinburgh for London. This was a loss to Scotland for, while James and his son, King Charles I, employed Rubens and Van

Dyck at Whitehall, in Edinburgh there was no longer the magnet of court patronage to entice other foreign artists north. George Jamesone, optimistically but misleadingly given the soubriquet 'the Scottish Van Dyck', was one of the artists who remained. A prolific and often very sensitive painter, Jamesone, as his technique suggests, may at some time during his training have worked in the Netherlands or at least under a Dutch artist in Scotland.

It was Jamesone's own pupil, John Michael Wright, working in the second half of the seventeenth century, whose connections with Europe were stronger than any Scottish artist hitherto. Spending much of the 1640s in Rome, Wright in 1648 joined Nicolas Poussin and Velásquez as a member of the prestigious Academy of St Luke. As a Roman Catholic, Wright was well away from Britain in such troubled years. In the hardly more propitious 1650s Wright found employment with the Archduke Leopold, the Governor of the Spanish Netherlands. Again in the 1680s religious intolerance forced Wright from London. He went to Ireland where he painted the teenage son of the Marquis of Atholl, Lord Mungo Murray (fig. 4.4). Wright's portrait of the young Highlander, dressed in his national costume, was almost certainly commissioned by an Irish peer as a companion to another portrait Wright had previously painted of an Ulsterman in his native costume. Wright's prospects as a painter ebbed and flowed with the fortunes of the Catholic party in Britain. With the exile of James VII and II in 1688 Wright's world collapsed. In the words of a contemporary: 'His royal master being now gone, he soon found he has lost an extraordinary friend, and 'tis therefore from that time that he dated his own ruin.'

While the *coup d'état*, which saw James replaced by the Protestant King and Queen, William and Mary, wrecked the career of John Michael Wright, it led indirectly to the visit, residence and eventual nationalization of a talented Hispano-Flemish artist, John de Medina. His patrons were the Melville family: the Earl and his son David, Earl of Leven, were prominent supporters of the new dynasty (the son fighting with William through the south of England, the father created Secretary of State for Scotland by the new king). Melville and his son had sat to Medina in his London studio as had other prominent supporters of William and Mary, like Lord Portmore and the 1st

Duke of Argyll (fig. 4.5). The Melville family and, in particular, the friends of the Countess back in Scotland managed to persuade Medina to leave his Drury Lane studio and his wife and children for a brief spell in Edinburgh. So successful was the visit that Medina sent for his family and effects and settled in Edinburgh's Canongate where he remained until his death some fifteen or sixteen years later. Medina brought something new to art in Scotland – a confident up-to-date Baroque style that made the portraits of his Scottish competitors, John Scougal for instance, appear stiff and awkward. Medina's success was complete. He gained a near monopoly of the fashionable portrait business and ended his career a rich man with a knighthood, the first artist to be so honoured in Scotland, and the last until Raeburn in 1822.

While portraiture was Medina's main business he also introduced a type of painting that was a novelty

in the late seventeenth century, at least by an artist working in Scotland. Aiming at a growing collectors' market, Medina produced figure compositions with subjects drawn from the Bible or classical mythology. Already the merchant John Clerk of Penicuik had imported works of art to Scotland, some of which he kept for himself but most he sold for profit. At the end of the seventeenth century it was becoming easier for the richer Scottish families to acquire Old Master and contemporary foreign works of art. Medina's figure paintings, mostly small-scale pieces, appealed to this growing interest in collecting, an appetite for which was partly fed at auctions. In April 1702, for instance, a sale of seventy-seven lots took place in a house off Glasgow's Saltmarket. Described in the catalogue as, 'A fine collection of pictures, some fit for halls, staircases, chambers and closets', the majority were portraits, a few contemporary but mostly historical figures: Buchanan, Calvin, Luther, Seneca and Demosthenes. The remainder of the paintings were catalogued, not according to artist, but for which room they would be most appropriate: 'A large landscape for a staircase, A landscape for a doorpiece, A landscape for a chimney-piece.' Two paintings appear to be destined for a dining-room: 'A fine piece with a lobster and other shell-fish, A hare hanging by a leg very well painted'. The latter sounds like a description of a work by William Gouw Ferguson, a Scottish artist who made a career as a specialist in still life.

While Medina had been born in the Low Countries and settled in Scotland, so Ferguson made the same journey in the other direction. Since he was not a portrait painter, Ferguson was unable to find enough buyers for his work in Scotland. He needed better access to the larger continental markets and his solution was to settle in Holland, then the centre of the European art trade. A good businessman as well as painter, he maintained his contacts with his native country, sending back newly completed paintings to sell at auction, and very likely returning himself from time to time.

Fig. 4.5 *Archibald, 1st Duke of Argyll,* with his two sons John and Archibald, *c.* 1689
John de Medina (1659–1710); oil on canvas, 240 × 158 cm (91 × 57½ in)
Trustees of the Tenth Duke of Argyll

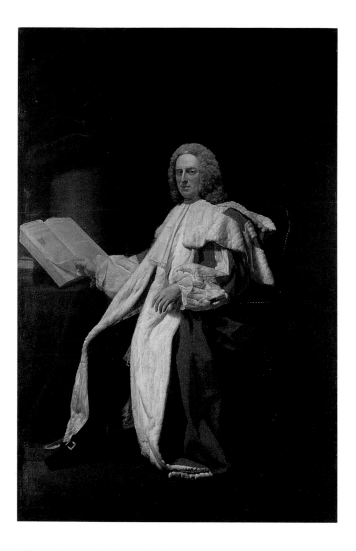

Fig. 4.6 *Archibald, 3rd Duke of Argyll,* 1749
Allan Ramsay (1713–84); oil on canvas, 238.8 × 156.2 cm
(94 × 61½ in); Painted for Glasgow Town Council
Glasgow Art Gallery & Museum

The auction rooms were one channel through which continental painting could find its way into Scottish collections. Another was for a Scottish artist, while training abroad, to buy paintings for re-sale in Scotland on his return. Such a painter-dealer was the Aberdeen-born William Mosman who partly financed his five-year study in Rome during the 1730s by acting as agent for several families in the north-east, the Urquharts and the Duffs in particular. Through Mosman's agency Scottish collectors were the first foreigners to employ Pompeo Batoni and they were the greatest foreign collectors of the work of his master, Imperiali. The Grants of Monymusk may have provided much of the £450 that John Smibert spent on Old Masters and

contemporary paintings in Rome during the early 1720s, far more money than he was able to earn as a painter. Smibert probably had some business arrangement with Andrew Hay, a former pupil of Sir John de Medina who had gradually given up portrait painting in favour of buying and selling works of art. One of the first European art dealers, he helped create a profession that soon became dominated by Scotsmen. Hay was assisted by the presence in Rome of a large expatriate Scottish community, mostly Jacobites, who commissioned paintings by such leading Italian masters as Trevisani and Masucci. Copies of Trevisani's portraits of the royal family or Antonio David's of the young princes, Charles and Henry, were very popular amongst Jacobite sympathizers in Scotland and Mosman or Hay was available to commission copies. Mosman spent so much of his time copying the work of David that even after his return home in the late 1730s his work retained the pastel colouring of the contemporary Roman school, differentiating it from the style of other British painters of the period.

Allan Ramsay was a fellow pupil of Mosman in Imperiali's studio. A far better painter, he was able to assimilate the lessons of his Italian mentors – composition from Imperiali, draughtsmanship from Batoni, colour from Solimena – with much greater facility than Mosman. After returning from his first visit to Italy, however, he still painted some pictures, like the two imposing full-length portraits of Dr Mead and of the 3rd Duke of Argyll (fig. 4.6), where the lessons of Solimena can be seen grafted on to a British stem. Ramsay revisited Italy in the mid-1750s, a visit he treated as a sabbatical. He returned to Britain in 1757 refreshed and better informed. He was now ready to reform his style by synthesizing the best elements of the work of his European contemporaries while remaining fully sensitive to the examples of the great seventeenth-century portrait painters. The portraits that Ramsay painted on his return for his patron the Prime Minister, Lord Bute (fig. 4.7), and the royal family are unsurpassed in the eighteenth century.

Fig. 4.7 *John, 3rd Earl of Bute,* 1758
Allan Ramsay (1713–84); oil on canvas, 239.4 × 147 cm
(94¼ × 57⅞ in); Painted for the Prince of Wales
Private Collection

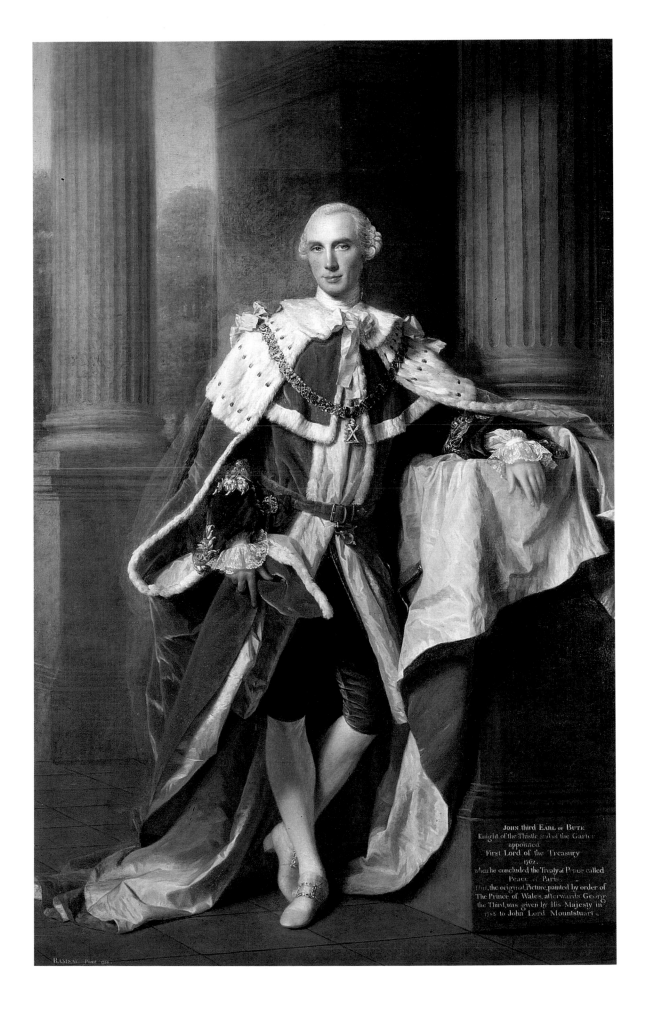

JOHN third EARL OF BUTE
Knight of the Thistle and of the Garter
appointed
First Lord of the Treasury
1762.
when he concluded the Treaty of Peace called
Peace of Paris.
That, the original Picture, painted by order of
The Prince of Wales, afterwards George
the Third, was given by His Majesty in
1782 to John Lord Mountstuart.

RAMSAY Pinxit 1758.

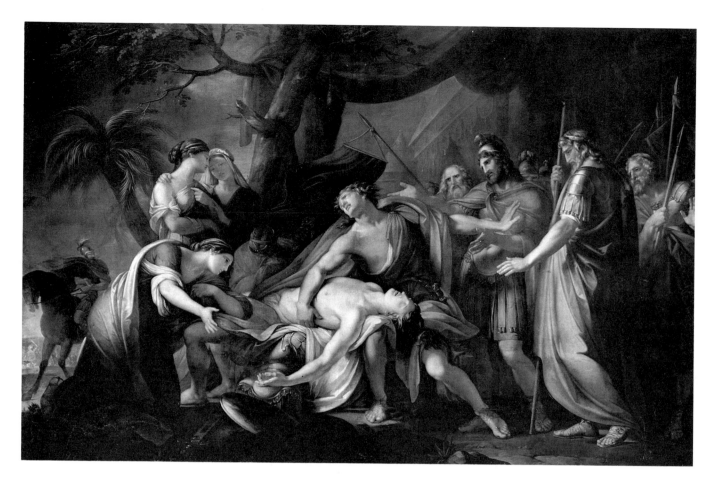

Fig. 4.8 *Achilles lamenting the death of Patroclus,* 1760–63
Gavin Hamilton (1723–98); oil on canvas, 227.3 × 391.2 cm
(99½ × 154 in)
National Gallery of Scotland, Edinburgh

Whereas the magnificent portraits of his contemporaries, Reynolds and Gainsborough, remained essentially British in style, Ramsay's later work was truly international.

'It is from Scotland that we receive rules of taste in all the arts', wrote Voltaire in 1762 and while the French philosopher may have had Ramsay in mind, he was probably thinking of the works of David Hume, Robert Adam and Gavin Hamilton as well. Hamilton, born in Lanarkshire, spent most of his life in Rome where he became a doyen of the British community in the city – a world famous painter, archaeologist and art dealer. Few of Gavin Hamilton's huge history paintings survive but their compositions are known today, as they were in his lifetime, from the engravings by Domenico Cunego that Hamilton went to considerable trouble and expense to procure. *Achilles lamenting the death of Patroclus* (fig. 4.8) was the second in a series of six paintings illustrating Homer's *Iliad*. Commissioned in 1760 by Sir James Grant of Grant, the painting was finished three years later and exhibited in London in 1765 en route to its final destination

in Scotland. Hamilton's early Homeric paintings and other works from classical history, like *The Oath of Brutus* (fig. 4.9) influenced painting in both Italy and France; Jacques Louis David, the greatest painter of the neo-classical movement, was particularly in his debt.

Hamilton was not the only Scot in Rome whose work was internationally regarded. Robert Adam (fig. 4.10), the friend and travelling companion of Allan Ramsay in Italy, transformed British architecture and design while the landscapes painted by Jacob More were collected by the Borgheses, the British royal family and the Pope (fig. 4.11). Even David Allan from Alloa won the coveted Roman art prize, the Concorso Balestra in 1773 (fig. 4.12).

Scottish artists in Rome in the eighteenth century formed a significant national group, larger proportionally than that of any other foreign country. In

addition, residents like James Byres and the Abbé Grant – men from Jacobite families – made careers for themselves in the city. Byres trained as an architect and studied painting under Anton Rafael Mengs, but he is better remembered for his activities as an art dealer and as a professional guide to the city. It was Byres who took Edward Gibbon around Rome; James Boswell

Mackenzie, the chief of the Clan, opened the doors of their Neapolitan palaces to welcome British visitors to the city (fig. 4.14). Their interest in the newly excavated classical antiquities of Pompeii and Herculaneum was more than a mere dilettante's pastime – their publications and scholarship fuelled the neo-classical movement across Europe.

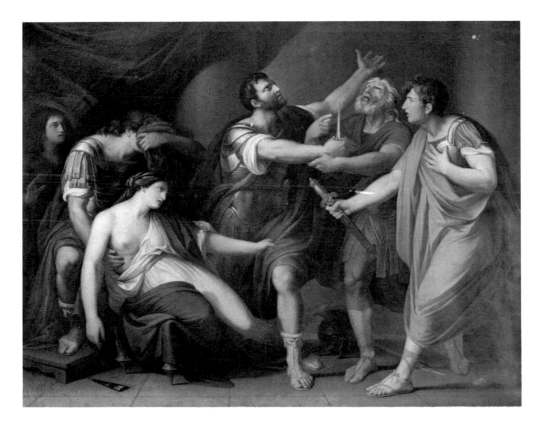

Fig. 4.9 *The Oath of Brutus*, 1763–64
Gavin Hamilton (1723–98); oil on canvas, 210.8 × 273 cm (83 × 107½ in)
The Theatre Royal, Drury Lane, London
Photo: Courtauld Institute of Art

Fig. 4.10 *Robert Adam*, 1792
James Tassie (1735–99); glass paste, h. 7.8 cm (3⅛ in)
Scottish National Portrait Gallery, Edinburgh

(fig. 4.13) was shown the sights by a fellow Scot, the painter, sculptor and collector, Colin Morison.

Second only to Rome as an artistic centre, Naples was the largest city in eighteenth-century Italy and, after London and Paris, the third most populous in Europe. From the middle of the century Naples, like Edinburgh, experienced a cultural and intellectual enlightenment and there were links between the two cities throughout the century. In 1710 the portrait painter William Aikman had visited the city and in the 1730s Allan Ramsay was Solimena's only British pupil. Later artists like David Allan, James Clerk and John Runciman all settled in Naples; Runciman, one of the most promising Scottish artists of the century, died there at the age of only twenty-four. At the hub of the British community was the envoy and plenipotentiary Sir William Hamilton. He and his friend Kenneth

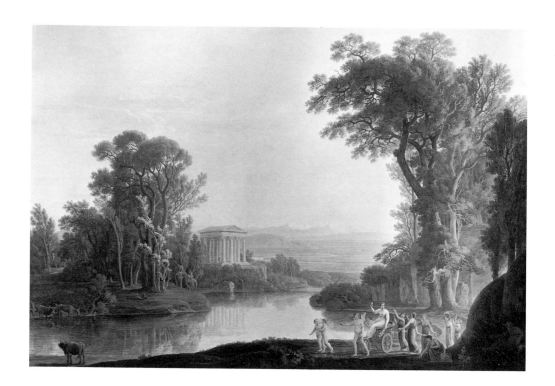

Fig. 4.11 *Morning*, 1785
Jacob More (1740–93); oil
on canvas, 152.2 × 203 cm
(60 × 80 in)
Glasgow Art Gallery &
Museum

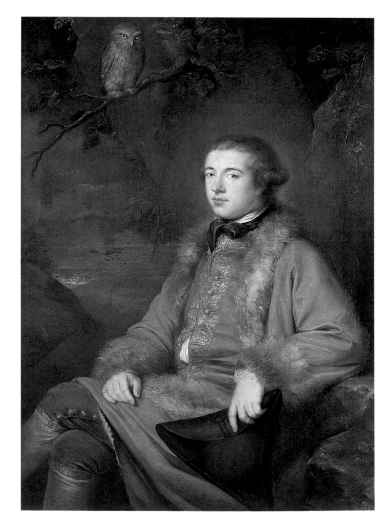

Fig. 4.12 *The Origin of Painting*, 1775
David Allan (1744–96); oil on panel, 38.1 × 30.5 cm (15 × 12 in)
National Gallery of Scotland, Edinburgh

Fig. 4.13 *James Boswell*, 1765
George Willison (1741–97); oil on canvas, 135.2 × 96.5 cm
(53¼ × 38 in)
Scottish National Portrait Gallery, Edinburgh

Fig. 4.14 *Kenneth Mackenzie, Lord Fortrose at Home in Naples,* 1771
William Hamilton, in the grey wig, plays the viola
Pietro Fabris (active 1768–78); oil on canvas, 35.5 × 47.6 cm ($14 \times 18\frac{3}{4}$ in)
Scottish National Portrait Gallery, Edinburgh

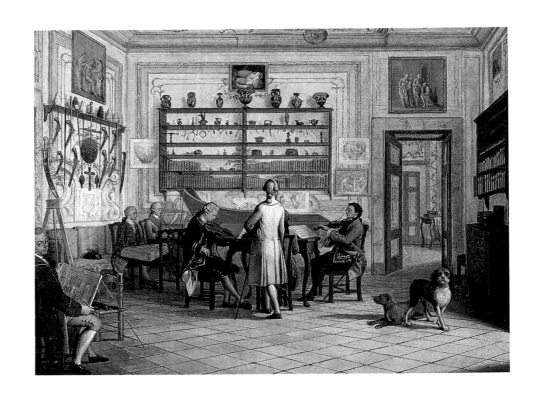

Fig. 4.15 *The Defence of Saragossa,* 1828
David Wilkie (1785–1841); oil on canvas, 94 × 141 cm ($37 \times 55\frac{1}{2}$ in)
The Royal Collection, London
Reproduced by Gracious Permission of Her Majesty the Queen

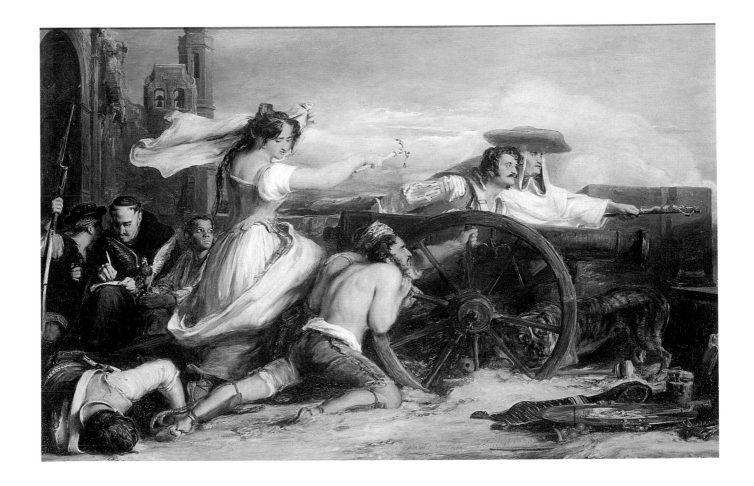

Fig. 4.17 *Athens from the East, c.* 1822
Hugh William Williams (1773–1829); watercolour on paper,
62 × 98 cm (24 × 38 in)
Glasgow Art Gallery & Museum

Napoleon's conquests in Italy shattered the Scottish communities there, forcing men like Sir William Hamilton into exile in Sicily and James Byres to return home to Aberdeenshire. During the early years of the nineteenth century, with Britain at war with France, the Continent was closed to Scottish artists. When at last they could cross the channel once more they were able to see the magnificent Old Masters in the Louvre, many looted by Napoleon from the churches and palaces of the Continent.

For most early and mid-nineteenth-century artists it was the work of painters of previous centuries, not their contemporaries, which influenced them. Van Dyck and Rubens were particular favourites with Andrew Geddes and William Simson; Titian and the Venetian school for Robert Scott Lauder and his pupils.

The work of Spanish painters was a revelation to many, since the school was hardly known outside Spain until the Napoleonic invasion released paintings onto the market. David Wilkie was an enthusiast, even choosing Spanish themes for his paintings (fig. 4.15). Indeed interest in Spanish art became very much a Scottish speciality. Sir William Stirling Maxwell's *Annals of the Artists of Spain* was the first and remained the definitive study of Spanish painting. Sir James Macpherson Grant, a young diplomat posted to Madrid and Lisbon, bought Spanish Old Masters for his castle in Banffshire. On his return home, no longer with the opportunity of adding Spanish works to his collection, he bought paintings from Scottish artists that most closely resembled the Spanish Old Masters. The artists David Roberts, John Phillip (fig. 4.16) and Arthur Melville all followed Wilkie to Spain where not only were they inspired by the landscapes and customs of the country, but also influenced contemporary Spanish artists.

Other artists went even further afield: Hugh William Williams to Greece (fig. 4.17) and Sir William Allan to Russia. Allan lived and dressed as a native enabling

him to travel far into the interior and bring back to Scotland, as early as 1814, paintings of Tartars, Circassians and Cossacks (fig. 4.18).

A few artists, however, were not interested in local manners or customs and looked less at the work of the great masters of the sixteenth and seventeenth centuries than at the paintings of their foreign contemporaries. One was William Dyce, in Rome in the mid-1820s. A friend of Frederick Overbeck and Schnorr von Carolsfeld, Dyce shared with them the clarity and spirituality of the German Nazarene style (fig. 4.19). James Drummond, Sir Joseph Noel Paton (fig. 4.20) and Sir William Fettes Douglas were also influenced by German art, the latter two in particular by the illustrations of Moritz Retzsch for Goethe's *Faust*. Scotland also attracted its share of visiting European artists.

Fig. 4.18 *Sir William Allan in Circassian dress*, 1815
Andrew Geddes (1783–1844); Etching with drypoint,
22.5 × 15.1 cm ($8\frac{13}{16} \times 5\frac{7}{8}$ in)
Glasgow Art Gallery & Museum

One was the Frenchman, Eugène Devéria, who made several extended visits to Edinburgh between 1849 and 1854, exhibiting work at the Royal Scottish Academy. Later in the century, in 1881, Telemaco Signorini visited Edinburgh and painted in the High Street, the Pleasance and in Leith. By then many of the most advanced Scottish artists had come under the spell of the Frenchman, Jules Bastien-Lepage. His influence, in subject matter, tone and technique was felt from Manchester to Melbourne. James Guthrie, E. A. Walton, Lavery, Roche and the other Glasgow Boys were amongst the most distinguished members of this truly international school (see figs 9.1, 9.2, 9.4 and 9.6). Not only was their style and technique continental, their audience was as well. The work of the Glasgow Boys was especially admired in the German-speaking countries of central Europe, particularly at the international exhibitions in Munich, Vienna and Budapest.

A friend of the Glasgow Boys, the dealer Alexander Reid not only bought and sold their work but also introduced a receptive Glasgow audience to the paintings of Whistler and the Impressionists. The best-known Scottish collector of the late nineteenth and early twentieth century was the shipping magnate, Sir William Burrell, whose collection (now owned by the City of Glasgow) is rich in the works of Crawhall and Degas, both favourite artists of Reid. Burrell was only one of a number of collectors of contemporary French and Dutch painting. There were other men and women the evidence of whose taste and generosity are reflected in the collections donated to the art galleries of Glasgow, Edinburgh and Dundee.

Based in the east rather than in Glasgow, the Scottish colourists Peploe, Cadell, Fergusson and Hunter also looked to France but to the south and the vivid, pulsating Mediterranean palettes of the Fauve painters of the years immediately preceding the First World War (fig. 4.21). In 1913 Stanley Cursiter, intrigued by the street scenes of the Italian Futurists, painted a remarkable group of canvases on the theme of modern urban life, using the city of Edinburgh rather than Milan as his locus. Cursiter's *The Sensation of Crossing the Street* (fig. 4.22), very similar to the work of Severini, was painted the same year that Boccioni created *Unique Forms of Continuity in Space*, the masterpiece of futurism. The following year war broke out and with death and destruction spreading across Europe the

Fig. 4.19 *Jacob and Rachel*,
1850–53
William Dyce (1806–64); oil
on canvas, 70.4 × 91.1 cm
($27\frac{3}{4}$ × $35\frac{7}{8}$ in)
Leicestershire Museums,
Arts and Records Service

Fig. 4.16 *La Loteria
Nacional, c.* 1863–64
John Phillip (1817–67); oil
on canvas,
129.5 × 167.5 cm
($50\frac{1}{2}$ × 66 in)
Aberdeen Art Gallery and
Museums, Aberdeen City
Arts Department

Fig. 4.20 *The Fairy Raid: Carrying off a Changeling – Midsummer Eve*, 1867
Joseph Noel Paton (1821–1901); oil on canvas, 90.5 × 146.7 cm (35⅝ × 57¾ in)
Glasgow Art Gallery & Museum

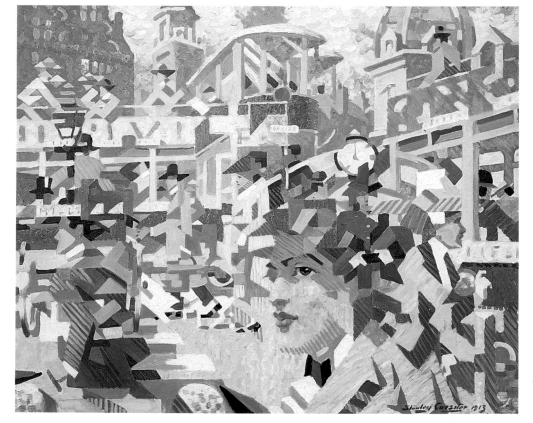

Fig. 4.22 *The Sensation of Crossing the Street*, 1913
The West End, Edinburgh
Stanley Cursiter (1887–1976); oil on canvas, 50 × 60 cm (19⅝ × 23⅝ in)
Collection of Mr and Mrs William Hardie, Glasgow

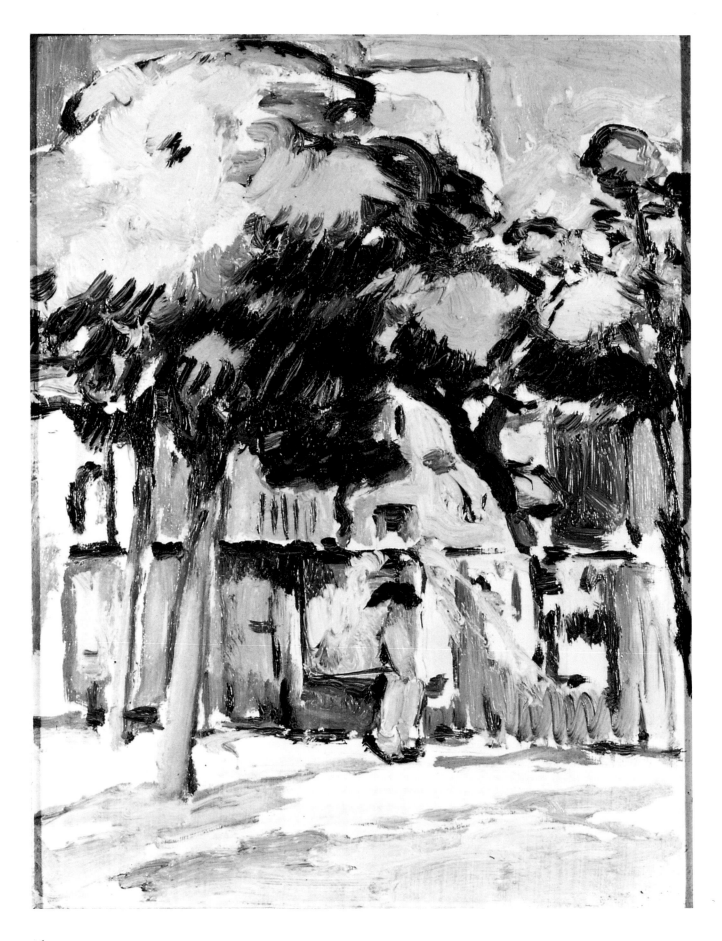

movement, which had extolled speed, change and violence, itself withered, while Europe staggered into the modern age.

Despite the two great wars the twentieth century has witnessed the countries of Europe moving closer together with political integration following a few decades behind cultural assimilation. While it is still as possible as ever to identify a distinctive Scottish school of painting, the ease and cheapness of travel, the frequency of international exhibitions, and film, television and magazines have brought an increased awareness of the developments of European contemporary art to the art schools of Scotland.

A positive step in fastening Scottish art securely to Europe was taken by the Scottish Arts Council in the mid-1970s when it rented, as it still does, a studio in Amsterdam for the use of its artists. This was official recognition that Scotland's artistic horizons lay well beyond either the Tweed or the Channel and an encouragement for Scottish artists to consider themselves as part of the European mainstream. At about the same time the Third Eye Centre opened on Sauchiehall Street in Glasgow, with an open-plan gallery space

much influenced by the Lanteren Centre in Rotterdam.

Many young Scottish artists have found it stimulating to live and work for a time in Europe. Since 1960, when Paolozzi was appointed Visiting Professor at the Hochschule für Bildende Kunst in Hamburg, Germany and German twentieth-century art has replaced France and the School of Paris as the dominant continental influence in Scotland. In 1967 John Bellany visited the terrible concentration camp at Buchenwald and that, and the influence of the painters of the Neue Sachlichkeit, altered and strengthened his art. More recently Margaret Hunter and Gwen Hardie have both studied under Baselitz in Berlin. The influence of Germany and of the countries of central Europe has been reinforced by the pioneering exhibitions, most notably of Joseph Beuys, organized in Edinburgh by Richard Demarco.

The lively environment created by artists, their dealers, the public galleries and the Scottish art schools has fostered the unprecedented international success of a great many young artists. All the signs indicate that the enriching ebb and flow of cultural exchange between Scotland and Europe is likely to continue.

Fig. 4.21 *Verville-Les-Roses,* 1910–11
Samuel Peploe (1871–1935); oil on cardboard, 35.6 × 27 cm (14 × 10⅝ in)
Scottish National Gallery of Modern Art, Edinburgh

5

SCOTTISH DESIGN AND THE ART
OF THE BOOK 1500–1800

JOHN MORRIS

Printing was first introduced into Scotland at the instance of the Church of Rome and under royal patronage. An Edinburgh merchant, Walter Chepman, imported 'ane prent with all stuff belangand tharto, and expert men to use the samyne' as the Patent of Privilege of 1507 reports, for the purpose of printing Bishop William Elphinstone's *Breviary of the use of Aberdeen*. His master, James IV, was very much a Renaissance prince, within the limits imposed by the real poverty of his kingdom. He employed gunsmiths to cast great guns like Mons Meg, shipwrights to build great ships like the *Great Michael* and, at a more economical level, a printer to print his laws, the chronicles of his realm, and occasional verse for him. Walter Chepman and his partner Androw Myllar printed the *Aberdeen Breviary* and a number of books of Scots verse by William Dunbar and the other court poets. If they printed laws and chronicles these have not survived, though both were mentioned in the patent. Their books are provincial French in appearance but this is hardly surprising. Androw Myllar had learnt his trade in Rouen, the type was Norman and even the devices used by the partners were copied from French designs.

When James died with the flower of his nobility on Flodden Field, his artillery was dragged away to England, his flagship, the *Great Michael*, was sold to the King of France, and Scotland was without a press until his infant son, James V, came of age. While his father's taste ran to artillery, shipbuilding and literature,

James V was careful with his money. However, he did appoint a royal printer, Thomas Davidson. There was nothing very original about the type or design of Davidson's books though he used a handsome woodcut of the Scottish royal arms (fig. 5.1) on the title pages of his edition of the Acts of Parliament and of the Scots translation of Hector Boece's *History of Scotland*. After James V's death in 1542, Thomas Davidson disappears from the record; his wife soon afterwards married an Edinburgh merchant called George Hopper.

In 1546, the Scottish Reformation started in bloodshed. The Cardinal Archbishop of St Andrews, Cardinal Beaton, had the Scottish reformer George Wishart burnt at the stake for heresy and was himself murdered by an enraged Protestant mob. Although John Knox and the other reformers were banished, the movement continued with increased momentum and, when Knox returned in 1559, and the Parliament in 1560 abolished the authority of the Pope, Puritanism became not only a major force in Scottish politics, but rapidly pervaded all aspects of everyday life. Books had a place of special importance in the Scottish Reformation. Calvin and his disciple John Knox placed great stress on Scriptural authority in matters of liturgy, manners and morals, and the Bible as the source of this authority was the one cultural influence that could not be questioned. To understand the Bible and to live in accordance with its teaching was to be the whole end of man, and education therefore was the most important

occupation next to preaching the word. Education needs books and, from the time of the Reformation, Scotland was never without books, particularly catechisms and school textbooks.

If the Reformation ensured the importance of printing in the cultural life of the country, it also ensured the relative austerity of the printed word. The work of the first two printers under royal patronage was decorated with woodcuts: the Last Judgement, biblical and battle scenes all occur in the handful of books they printed. For the rest of the sixteenth and the first half of the seventeenth century most books had decorated initials and lines of ornament at the beginnings and ends of chapters, but no illustration. While Bassandyne's Bible, published in 1579, did have an engraved map of Canaan, and diagrams to explain the construction of Noah's ark and Solomon's Temple, these

Fig. 5.2 Initial from Laud's Prayer Book, *The Book of Common Prayer for use in the Church of Scotland,* Edinburgh, 1637
6 × 6 cm ($2\frac{3}{8} \times 2\frac{3}{8}$ in)
Trustees of the National Library of Scotland

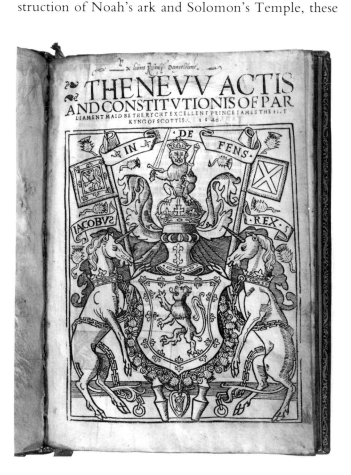

Fig. 5.1 Woodcut arms of Scotland from *The new actis and constitutionis of Parliament maid be the Richt Excellent Prince Iames the Fift Kyng of Scottis,* Thomas Davidson, Edinburgh, 1540
22.3 × 17.9 cm ($8\frac{7}{8} \times 7\frac{1}{16}$ in)
Trustees of the National Library of Scotland

Fig. 5.3 Michael Livingstone's *Patronas redux,* Edinburgh, 1682
Bookbinding in red morocco with onlays of black and citron morocco by the binder of Sir Thomas Murray's *Acts,*
18.2 × 13.8 cm ($7\frac{3}{16} \times 5\frac{7}{16}$ in)
Trustees of the National Library of Scotland

Fig. 5.4 Woodcut at the head of *A new song. Tune of Lochaber no more*, Edinburgh, *c.* 1700
4.6 × 4.9 cm ($1\frac{3}{4} \times 1\frac{7}{8}$ in)
Trustees of the National Library of Scotland

the book, of which a number survive, are beautifully bound in red morocco leather, and are among the best of seventeenth-century Edinburgh work though the binder, like the printers, may well have been a Dutchman (fig. 5.3). A Scottish vernacular influence in the printing of books in Scotland at this date is not easy to detect, though there is a clumsiness in the work of the more popular printers which makes it readily recognizable. There is however a naive grace about some of the woodcuts that decorated the tops of broadside ballads. With blocks showing a drinker, a hunter, or a man and a woman, the woodcuts are broad and purely decorative (fig. 5.4), rather than illustrative. If they had shown an incident from a particular ballad, it would have been less easy to reuse them. Some continued to be used until the 1840s decorating the chapbooks that early in the eighteenth century replaced broadsides as the medium for popular ballads and prose tales. Interesting too are the thick black mourning borders found on verse elegies. They are often engraved with skulls, crossbones, coffins, spades and tears, in much the same style as contemporary tombstones, although printed examples seem not to date much later than 1720.

Copperplate engraving was not much used as a medium for illustrating books in Scotland in the seventeenth century. When Captain John Slezer, a Dutchman, published *Theatrum Scotiae*, containing fifty-seven views of towns and buildings in Scotland in 1693, he brought over a Dutch artist to draw the views, arranged for them to be engraved in Holland and had them printed and published in London. The plates for Thomas Ruddiman's edition of James Anderson's *Selectus Diplomatum & Numismatum Scoticae*, 1739, were engraved, and probably printed in England, and those for William Adam's *Vitruvius Scoticus* were engraved by an Englishman, Richard Cooper, who had settled in Edinburgh in 1730. On the other hand, Alexander Nisbet had a number of plates engraved between 1700 and 1722 in preparing his *Display of Heraldry*, and all the engravers he employed were Scots.

In the eighteenth century, the printing trade con-

embellishments were to the greater glory of the Lord, not primarily for the delight of man. After the Scottish Reformation, Scottish printing became more English than French in appearance as Protestant Scotland looked more to Protestant England than to Catholic France, and welcomed printers from England like the Huguenot Thomas Vautrollier and the Puritan Robert Waldegrave. The accession of James VI to the throne of England in 1603 at once confirmed this trend and removed the court from Edinburgh, with the King and many of the nobility, so that Scottish printing became for a time provincial, and official printing aped the English in its style and ornaments. Not only did the printing of Laud's Prayer Book of 1637 resemble that of its English counterpart, though having some interesting initials (fig. 5.2), but the bindings of the special copies were imitated from the London bindings of the period.

The initials used in the 1681 edition of Sir Thomas Murray's *Acts of the Scottish Parliament*, printed by the Dutch company of David Lindsay and his partners, Kniblo, Solingen, Colmar and Gunter, are saved by their vigour from being merely copies of those used by the English King's Printers. The special copies of

tinued to develop side by side with that of England. More pride was shown in the quality of the work, though, at first, in order to improve it, printing presses, workmen and printing types had to be imported from Holland. The situation was no better in England. When Cambridge University set up its printing house at the end of the seventeenth century, it also had to import its type from Holland. There were founders in England casting type, but no type cutters, designing and cutting punches and striking matrices, until William Caslon set up in business about 1725. The superiority of his type was immediately recognized in Scotland, where it was widely used until Alexander Wilson and John Bain started their type foundry in St Andrews in 1742. Thereafter native type gradually superseded the foreign article. By about 1760, when Bain returned from Ireland, most of the type used in Scottish books was of

native manufacture. This did not of course mean an immediate and radical change in the appearance of printed books. The type cut while Bain and Wilson were in partnership up until 1749, and afterwards by Wilson alone, is not singular in any way, but represents a graceful recutting of the conventional Roman and Greek letter forms. Although exhibiting some small innovations, it has nothing unusual about it except its great elegance. In 1760, Bain introduced a new kind of letter form with heavy upright strokes (fig. 5.5) which is entirely original, though possibly owing something to Baskerville's type. This was used for several decades in Scotland, and even somewhat in England and America (Alden 1942 and 1951), before being forgotten.

The partnership of the brothers Robert and Andrew Foulis in Glasgow produced some of the most elegant

Fig. 5.5 'Strong' type from Henry Fielding, *The history of Tom Jones,* 3 vols, Edinburgh, 1767
John Bain (1713?–90); 10 lines = 3.3 cm ($1\frac{5}{16}$ in)
Trustees of the National Library of Scotland

Fig. 5.6 Title page from the fourth edition of *The meditations of the Emperor Marcus Aurelius Antoninus* printed at the Foulis Press, Glasgow, 1764
16 × 10 cm ($6\frac{5}{16} \times 3\frac{15}{16}$ in)
Trustees of the National Library of Scotland

books of the eighteenth century. They used Wilson types and paid great attention to the layout of their books, particularly the title pages, which encouraged emulation among the best printers in the rest of Scotland. Not all Foulis title pages were greatly superior to contemporary work elsewhere. It was the attention paid to layout that in the best of their work, particularly the Latin and Greek classics of their second decade of activity, where the additional spacing between letters, the sensitive use of capitals, and the banishment of lower-case letters altogether, produced an effect which was truly classical (fig. 5.6) and new. The spacing of the text too, not only gave it a spaciousness and elegance, but also improved its readability (fig. 5.7).

Scotland was becoming recognized as a centre for printing in the British Isles, partly because of the excellent work done by the printers of Glasgow and Edinburgh, partly due to the reprinting in Edinburgh of most of the books published south of the border. Some

modern bibliographers have been outraged by this so-called piracy, but it should be remembered that most of it was perfectly legal, and certainly as far as books for distribution in Scotland quite legitimate. A number of these books were illustrated with locally-produced engravings, but though reasonably competent, there was nothing particularly Scottish about them. Of more importance, and more Scottish in feeling were the aquatints David Allan made for the Foulis brothers' edition of Allan Ramsay's *The Gentle Shepherd* in 1788. Like the poem they illustrate, they are both realistic and romantic (fig. 5.8). David Allan had learnt the aquatint process from the English painter–engraver Paul Sandby who had been employed on the military survey of the Highlands after the Jacobite Rebellion of 1745. Towards the end of the century, Scotland had many excellent engravers of all kinds, many of whom produced work of some artistic interest. David Deuchar, a seal engraver by trade, published many copies of the work of the greater Flemish engravers, as well as portraits and caricatures that are characteristically Scottish. His only book, apart from a collection of his engraved works, was a *Dance of Death*, after Hollar, rather than directly after Dürer. John Kay

Fig. 5.7 Two pages of Wilson type from the Foulis Press edition of *Boethius,* Glasgow, 1751
Alexander Wilson (1714–86); 19.5 × 29.3 cm (7 $\frac{11}{16}$ × 11 $\frac{1}{2}$ in)
Trustees of the National Library of Scotland

Fig. 5.8 'Jenny and Roger' from Allan Ramsay, *The Gentle Shepherd,* printed by A. Foulis, Glasgow, 1788
David Allan (1744–96); aquatint, plate size 26.7 × 20.7 cm (10 × 8⅛ in)
Dundee University Library

Fig. 5.9 Jacques Bassantin, *Astronomique discours,* Lyons, 1557
Bookbinding in brown leather tooled in gold and painted in white, red and green enamel, 42.5 × 31 cm (16¾ × 12⅜ in);
Made for Lord George Seton
Röhsska Konstlöjdmuseet, Gothenburg, Sweden

in Edinburgh, as well as his well-known caricature etchings, occasionally supplied portraits of some quality for books.

Bookbinding in Scotland at first followed closely the International Gothic styles of northern Europe, and later the early French gold-tooled tradition. The very earliest bindings that are identifiably Scottish are the Hayes Manuscript, signed by the binder 'Patricius Lowes me ligavit' (Patrick Lowes bound me), dating from not later than 1480 and arguably earlier, the Dunfermline Court book of 1488 (Mitchell 1955), and the Glasgow Rental of 1509. All are decorated with small tools impressed into the leather without gold, as they would have been anywhere else in Europe at that date.

From the middle of the sixteenth century hundreds of books survive bound with the arms of Scottish churchmen and noblemen stamped in gold on the sides. In contrast only a handful of contemporary gold-tooled bindings are known to have been done in England. Gold tooling was a recent novelty in Western Europe and these bindings must from their appearance be the

work of a French tool cutter and a French binder or binders. W. S. Mitchell argued that they were imported ready-bound (Mitchell 1955) and showed that the boards of one of the group contained waste French manuscript, but their number must throw some doubt on this, and documentary evidence shows the presence of a French bookbinder Jhonn de Moullings, who died in Edinburgh sometime before 19 March 1567. Books were undoubtedly bound in France, however, for Scottish patrons, since many such survive, from the humble to the very grand. Scottish patronage could on occasion be very lavish indeed. While on an embassy

Fig. 5.10 Simon Schard, *Germanicarum rerum quatuor chronographi*, Frankfurt, 1566
John Gibson (fl. 1581); Bookbinding in vellum tooled in gold, 34.5 × 20.7 cm ($13\frac{9}{16} \times 8\frac{1}{8}$ in); From the library of James VI
Trustees of the National Library of Scotland

1581, and who may have been binding for him earlier (fig. 5.10).

Scottish bookbinders did not evolve a national style until the third quarter of the seventeenth century. Some had experimented with onlays (patches of coloured leather) like their contemporaries in England, decorated the edges of the leaves with flowers and a religious text in black and red on or perhaps under the gold, and used floral tools on the sides to make an overall pattern that has been justly compared to a Persian carpet. A more enduring style however was the placing of pairs of tools along a centre spine to provide what became known as a herringbone binding. The pattern seems to have evolved in the 1670s. The standard herringbone (fig. 5.11) was rather stiff and stylized with a central frame often wide and elaborately figured, and a herringbone inside the frame made with a single pair of tools. Outside the frame the corners have subsidiary herringbones in which the elements are graded like the branches of a Christmas tree and the sides of the frame have pyramids of fishscale ornament.

Such is the standard herringbone, but by 1720 the frame was often abandoned, making for much greater freedom of treatment. The lengths of the ribs of the herringbone may alternate. In other cases the frame instead of disappearing took on a free-drawn scalloped or arabesque form (fig. 5.12). One of the characteristics of herringbone bindings was the great variety in style and indeed in competence. Later bindings instead of a large number of small tools had a small number of larger decorative units. The favourites among these new tools were rather large and heart-shaped or half-pear-shaped with the outline filled with a network of fine lines. The hearts have pine-cone-like objects in their centres a little like Christmas tree baubles. These large tools were quicker to apply than the small ones and were used on many rather routine bindings. Scottish bindings were also characterized by their use of elaborate decorative endpapers. At first these were of Dutch marbling, combed to patterns in milky red and blue, but later showed all the gaudiness of German papers printed in gold and stencilled in colour.

Since every head of family in the country of any standing took his own bible to the kirk every Sunday, and as an article of dress these books reflected the standing of their owners, it is not surprising that there is a vast corpus of eighteenth-century Scottish decorated

to France, in 1557, Lord George Seton commissioned two elaborate bindings on copies of the work of an expatriate Scot, Jacques Bassantin's *Astronomique discours*, one for the French king (Paris, Bibliothèque Nationale) and one for his own library (fig. 5.9). These were among the most elaborate French bindings of the period. By the 1580s bookbinding was well established in Scotland. The ordinary books from James VI's library were marked with a handsome block of the royal arms in a border of thistle heads and the work was being carried out in Edinburgh, probably by John Gibson, who was appointed bookbinder to the King on 29 July

bookbindings, or that it should vary greatly in its competence. Many of these bindings were on books given as presents – another motive for elaborate decoration – some were given to children, and many are on presentation copies of medical theses or the legal theses that all advocates had to present when they became members of the Faculty of Advocates. The majority perhaps were on bibles or the Book of Common Prayer presented to young women on the occasion of their marriages. Some had on the edge of the leaves the verse from Proverbs 12:4, 'A vertuous woman is a croun to her husband'. The Bible was seen as the focal point of the family in Scotland, and family and kinship had always been important to the Scots. A good number of these bibles had the names of their owners written in, or their initials impressed in gold, usually on the inside of the front board, either at the edge on the leather or in the centre of the paste-down. The grander specimens frequently had a red morocco label, sometimes with just a name, but often with a date or a donor's inscription. In many of them was written a record of the dates of births and deaths of the family children. Ownership of a bible was the first requirement of respectability. Among the laws of the Chapmens' [pedlars'] Societies of Stirling and Fife, for instance, it was enacted that members should each have a pocket bible, and those that could not read it should learn. That these books were taken to church is demonstrated by the number of the pocket-size ones that were bound in two volumes, of which the first volume only survives. The second volume, which contained the New Testament and The Whole Book of Psalms in Metre, was the volume which received more use.

In the early eighteenth century the herringbone style of bookbinding was joined by the wheel binding. This in its most rigid and conventional form had a centre wheel with a scalloped circumference and spokes of ornamental form like sceptres. Above and below a rectangular panel formed the base for a triangle usually of fishscale ornament. The corners were filled with Christmas tree herringbones (fig. 5.13). Though by its nature the form of the wheel binding was more rigid because the wheel occupied about a third of the available surface of the sides, the binders managed to achieve a remarkable variety. Wheel bindings were most exciting when the more rigid conventions were relaxed and the binder allowed his imagination to inform his

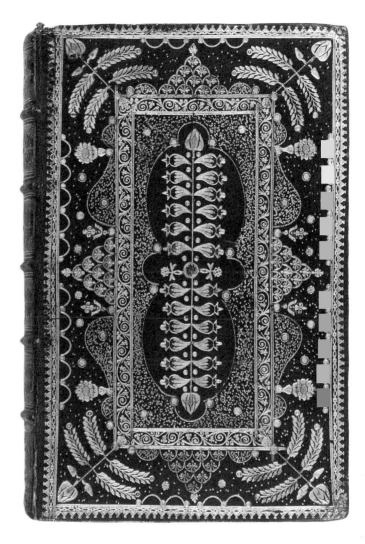

Fig. 5.11 *The Book of Common Prayer*, Oxford, 1716
Herringbone binding in black morocco tooled in gold,
20 × 12.5 cm ($7\frac{7}{8}$ × 5 in)
Trustees of the National Library of Scotland

treatment. Some contained unlikely elements like a hare hunt and crowns, and the accompanying tools might include horns of plenty and cherubs.

English styles in binding only gradually made any impact on the binders of Edinburgh. They were certainly aware of what was being made elsewhere, but the demand seems to have been for the native herringbones and wheels, with their endpapers of dutch gilt paper. In the 1750s and 60s, a binder known as the 'naturalistic and floral' binder was producing some excellent work of high technical standard and great charm of decoration, both in the asymmetrical use of foliage and flower elements, and in the use of green

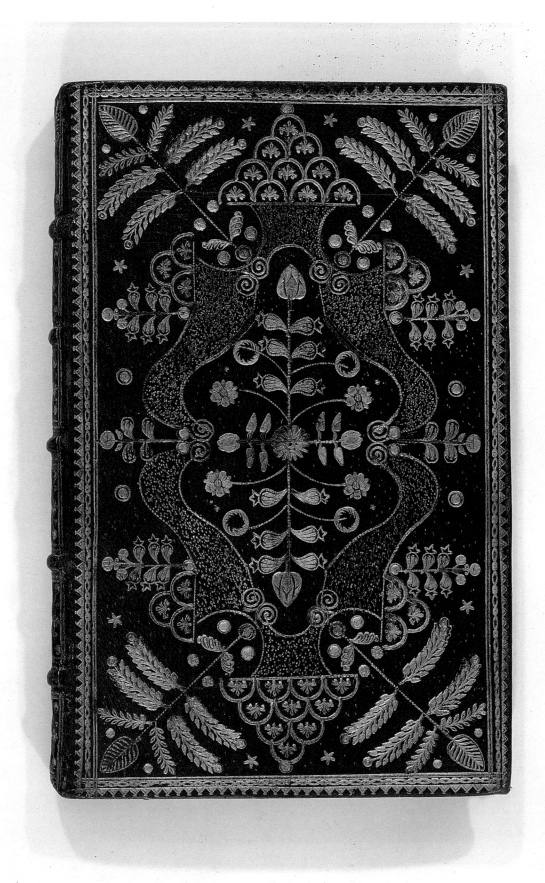

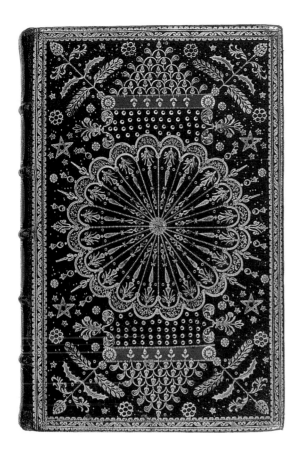

Fig. 5.12 (OPPOSITE) James Freebairn, *L'Eloge d'Ecosse, et des dames écossoises*, Edinburgh, 1727
Herringbone binding with an arabesque frame in black morocco tooled in gold, 18.7 × 11.8 cm ($7\frac{3}{8} \times 4\frac{5}{8}$ in)
Trustees of the National Library of Scotland

Fig. 5.13 *The Holy Bible*, 2 vols, Oxford, 1750, bound with *Psalms of David in Metre*, Edinburgh, 1746
Wheel binding in black morocco with a small red onlay, 21.7 × 13.5 cm ($8\frac{9}{16} \times 5\frac{5}{16}$ in); Label 'Robert Ingles 1755 given by Ann Wightman his grandmother'
Trustees of the National Library of Scotland

Fig. 5.14 (BELOW LEFT) A blank book formerly on William Ward, *A new treatise or The method of breeding and training horses*, Edinburgh, 1776
Bookbinding by James Scott of Edinburgh (d. 1786) in red morocco, 21.5 × 13.1 cm ($8\frac{1}{2} \times 5$ in)
Trustees of the National Library of Scotland

Fig. 5.15 John Jackson, *Eldred . . . a tragedy*, Edinburgh, 1782
Bookbinding by James Scott of Edinburgh (d. 1786) in stained calf, 21.4 × 13.1 cm ($8\frac{1}{2} \times 5\frac{1}{8}$ in)
Trustees of the National Library of Scotland

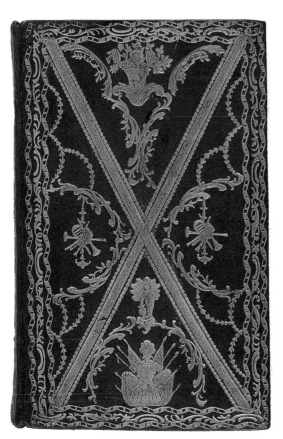

leather, vellum onlays, enamelled colour and marbled morocco. He bound at least two copies of a pocket-size edition of *Terence* printed in 1758 in green morocco with vellum onlays and touches of colour. The two are of entirely different designs: the one in the National Library of Scotland with a central onlay of white vellum, while that in the Röhsska Konstlöjdmuseet, Göteborg has an overall diamond pattern with some of the diamonds in vellum (Nilsson 1922, 8). On both copies the vellum has flowers painted in colour.

The naturalistic and floral binder had no imitators,

and his bindings though charming had no permanent effect on Scottish binding. This was not true of James Scott, one of only three eighteenth-century Scottish binders who regularly signed their work. His appearance brought the European baroque to Edinburgh, and in his hands it was almost a creed. He declared himself in a letter to the Society of Antiquaries of Scotland who had just appointed him their binder 'To be at the head of my Proffession as a tradesman, has been and still Shall be the Study of my Life; however much that ambition may hurt me as to Money matters' (Loudon

Fig. 5.16 John Hagart,
Disputatio juridica,
Edinburgh, 1784
Edinburgh Thesis binding in
green morocco,
24 × 18.5 cm (9$\frac{1}{2}$ × 7$\frac{1}{4}$ in)
Trustees of the National
Library of Scotland

1980). His work fell roughly into two styles, those that obtained their effects from using baroque tools on red or green morocco (fig. 5.14), and those in which the most complex effects were obtained by selective marbling or staining of calf (fig. 5.15). The baroque tools include swags, trophies, baskets of fruit, figures, crinkly and asymmetrical rolls, shellwork from grottoes, and sometimes twisted and garlanded pillars impressed from elaborate rolls. He did indeed 'hurt himself as to money matters'. His personal history in Edinburgh is one of debt, indeed of bankruptcy. Binders were not among the better-paid artisans in Edinburgh at the time, and the quality of work he produced was unlikely to be adequately remunerated. When he died in 1786, he left a son to carry on the business, but more important he had made an alternative style of binding available to the traditional binders of Edinburgh, one that they could use, abuse, and combine with the herringbone and the wheel binding to produce new and imaginative compositions.

For a time the two styles existed side by side and, if some herringbone bindings could only be called degenerate, and some binders massed baroque tools in a manner that was heavy-handed and unintelligent, some extremely elegant designs in both styles resulted. The period from 1775 to 1820 saw a great flowering of invention among the Edinburgh binders, the two fashions interacting to stimulate each other. While the wheel binding freed itself from some of the more constricting conventions, the baroque binding was able, for instance, to take the border and central diamond, and by the use of shellwork rolls and floral swags make something altogether less formal, prettier if a little sentimental (fig. 5.16). The early years of the nineteenth century saw a gradual adoption by Scottish bookbinding of international styles, and all that remained of the eighteenth-century movement is great technical expertise, a certain robustness in construction and a willingness to innovate. For example, an Edinburgh thesis of 1802 (fig. 5.17) shows an interpretation of the wheel binding, without spoke tools, or scalloped edge, but nevertheless a satisfying design.

Scotland was beginning to become a part of the larger world, artistically as in other ways. Distances were becoming shorter and, with the new century, Scots were taking their place in the European art scene. The Adam brothers, Walter Scott, the Edinburgh Reviewers, Wilkie and Raeburn, were in a real sense European, as Adam Smith and David Hume were in the realm of political thought. Economically too, Great Britain was becoming a single country, and industrialization brought alliances in printing and publishing which produced at the same time wider horizons and a greater artistic unity.

Fig. 5.17 William Laing, *Disputatio juridica,* Edinburgh, 1802
Edinburgh Thesis binding in red morocco, 23.6 × 18.3 cm
($9\frac{5}{16} \times 7\frac{3}{16}$ in)
Trustees of the National Library of Scotland

THE EIGHTEENTH-CENTURY INTERIOR
IN SCOTLAND

IAN GOW

Although we are much closer to the Georgian period than to medieval times and many eighteenth-century buildings survive in Scotland, it is not easy to visualize how their rooms originally looked. Our great country houses are overlaid with the spoils of nineteenth-century prosperity and we would have to wish away many splendid objects and picture collections in order to reconstruct their original appearance. In humbler homes almost nothing survives *in situ* while many items like curtains and carpets have completely disappeared. There are no record drawings of Scottish eighteenth-century domestic interiors. The practice of making perspective views does not seem to have arisen until the start of the nineteenth century. Although portraits often introduced domestic details, these were intended to reflect the accomplishments of the sitter rather than show an actual room. In conversation pieces of interiors, the settings are often fanciful and the objects depicted are included to contribute to the story-line rather than add verisimilitude to the scene. Our picture of eighteenth-century interiors has therefore to be built up from fragmentary information supplied by bills and inventories seen alongside the surviving archaeological evidence. If we make this imaginative effort the mental picture that emerges is a rewarding one and often unexpectedly colourful.

During the eighteenth century interior design was regarded as a branch of architecture. This is reflected in the way architects presented their designs for dec-

oration to their patrons. Whereas today we would automatically draw a perspective sketch, architects at this period preferred elevations of the four walls arranged round the plan to create a diagram of a room known as a 'section' (fig. 6.1).

Classical architecture had been introduced to Scotland by Sir William Bruce (*c.* 1630–1710) who combined an interest in architecture with a political career. In his designs he used the language of classical architecture with a concern for grammatical correctness that was new to Scotland. Earlier designers had viewed this language more as a quarry for decorative enrichments.

From 1671 he rebuilt Holyrood Palace for Charles II after it had been grievously damaged in the Civil Wars. The courtyard façade shows the classical orders correctly superimposed and the same discipline is followed through in its interiors, which were to be highly influential. The key to the Palace lies in the long line of state rooms, comprising the royal apartment on the first floor approached by a splendid stone staircase. Panelling was the most important feature of the interior schemes and this too was subjected to a new sense of architectural order. Pairs of oak pilasters, raised on pedestals, frame the most important chimney-pieces. The panelling around each room followed the same division into column and pedestal. The doors were carefully paired to give symmetry and aligned to provide an impressive vista along the first floor of the Palace.

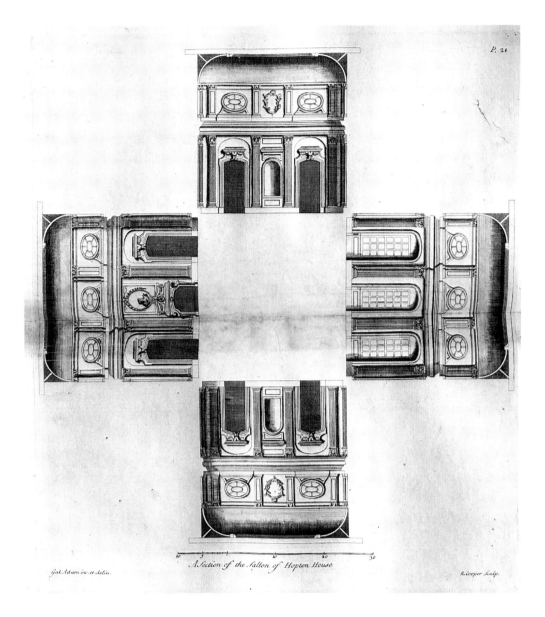

Fig. 6.1 Design for the
Great Dining Room at
Hopetoun House
William Adam (1689–
1748); Engraving from
Vitruvius Scoticus, c. 1730;
51.8 × 69.5 cm
($20\frac{1}{2}$ × 48 in)
The Royal Commission on
the Ancient and Historical
Monuments of Scotland,
Edinburgh

A nineteenth-century view of the Council Room at George Heriot's Hospital in Edinburgh displays many of the attributes of Bruce's interiors and it was fitted up in 1690 by craftsmen well versed in his style (fig. 6.2). The Heriot's interior is unusually lavish in its carved detail and Bruce rarely had the opportunity to create such decorative effects. There was always to be difficulty in luring the best craftsmen to work in Scotland and the resulting sparing use of ornament, which was confined to the most important elements in the scheme such as the chimney-piece, underlines the formal architectural effect. At Holyrood, Bruce was fortunate to secure the services of a particularly skilled pair of English plasterers, Houlbert and Dunsterfield, but outside the royal works there was little to match

its excellence. The state rooms at Holyrood were completed with a cycle of decorative painting by Jacob de Witt, giving them an unusual urbanity and degree of polish.

The grandeur of Holyrood set a new standard and soon every landowner strove to equip his house with a grand state apartment so that his most important guests were provided with the necessary setting for ceremonial display. Although all are similarly decorated with the usual paired pilasters framing the chimney-piece the sophistication of the final product reflected the calibre of the available craftsmen. Bruce took care to secure the best for his masterpiece, Kinross House, which he built for himself in 1686 from the profits of political office. Other patrons were often less

fortunate in the execution of their state apartments and despite borrowing many features from Holyrood, the new wing which the Earl of Glasgow added about 1700 to his ancient towerhouse, Kelburn Castle, lacks Bruce's control and its classical detail has an engaging naivety. The simplicity of its plan, however, shows the

Fig. 6.2 Perspective view of the Council Room of George Heriot's Hospital, Edinburgh
R. W. Billings (1813–74); Engraving from *The Baronial and Ecclesiastical Architecture of Scotland, 1845–52*
The Royal Commission on the Ancient and Historical Monuments of Scotland, Edinburgh

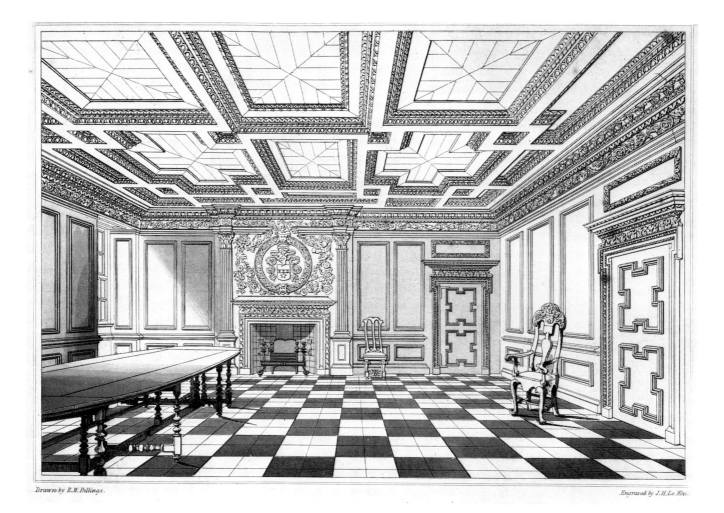

Drawn by R.W. Billings. Engraved by J.H. Le Heu.

components of the standard Scottish state apartment with unusual clarity (fig. 6.3). The Great Stair with balusters copied from Holyrood led from the entrance hall up to the first floor. The first room in the suite, the Great Dining Room, was always the largest and was well lit by pairs of very large sash windows which were then a recent innovation. This led through into the smaller Drawing Room which opened into the State Bedroom. Adjacent to this was a more private Dressing Room with access to service stairs and a bedroom, sometimes in a mezzanine, for a servant who slept near his master.

Bruce's interiors were outclassed only by those of a

younger architect, James Smith. Bruce, a gentleman amateur architect, relied on collaborators to draw up his ideas but Smith had been trained as a mason, which gave him a much greater control over the details of his buildings. Smith also seems to have had the opportunity to travel in Italy which gave his architecture remarkable assurance in its profiles and expressive quality. His finest interiors were at Hamilton Palace and possessed a noble simplicity.

The plan of Melville House (*c.* 1700) displays Smith's interest in bilateral symmetry and these experiments with Palladian plans were to bear important fruit in later English architecture through the influence he

Fig. 6.3 Plan of the state apartment of Kelburn Castle
Dr Thomas Ross (1849–1930); Illustration from David
 MacGibbon and Thomas Ross, *The Castellated and Domestic*
 Architecture of Scotland, 1887–92
The Royal Commission on the Ancient and Historical
 Monuments of Scotland, Edinburgh

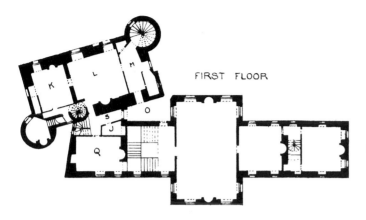

Fig. 6.4 The State Bed at Melville House, 1697
Maker unknown; Photograph 1925
The Royal Commission on the Ancient and Historical
 Monuments of Scotland, Edinburgh

exerted on Colen Campbell, a young Scottish architect who made his career in London.

This disciplined interior architecture often provided the background for surprisingly lavish contents because they could be more readily imported from the centre of the luxury trades than craftsmen. For an impression of how very splendid Scottish rooms could be, the present marriage between Bruce's decoration in the Royal Apartment at Holyrood and the princely furniture supplied from London during the late 1680s for the Duke and Duchess of Hamilton's apartments elsewhere in the Palace is instructive and easily studied because the rooms are open to the public. A pair of sumptuous beds in damask and cut velvet with elaborately trimmed upholstery are partnered by tall backed japanned chairs. These beds were made for display and possibly played a political role in impressing the rank of their owners on supporters and rivals. An equally grand bed, now at Blair Castle, is said to

have come from the Duke of Atholl's apartments in Holyrood Palace. This concentration of grand furniture in the aristocratic lodgings of the Canongate may relate to the assemblies of the Scots Parliament in the years before the Union of the Parliaments in 1707. The most celebrated of the Scottish state beds is that from Melville House (fig. 6.4) which is now displayed in the Victoria and Albert Museum in London.

William Adam was to become the most important architect in Scotland after 1707. Details of his early training remain obscure but he was rapidly entrusted with some of the most important architectural projects of the period. His interest in interiors is demonstrated by nine plates which he had engraved from the late

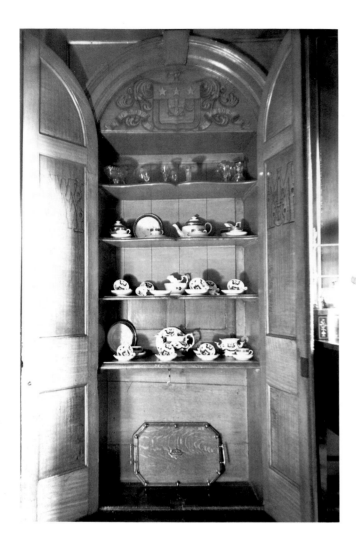

Fig. 6.5 Buffet niche at Murrayfield House, Edinburgh,
c. 1750
Architect unknown
Photo: The Royal Commission on the Ancient and Historical
 Monuments of Scotland, Edinburgh

1720s for the sumptuous book illustrating his designs, *Vitruvius Scoticus*. The key to his houses also lay in their state apartments and, although they followed in the mould established by Bruce for Holyrood, Adam brought to them a new emphasis on magnificence. At Hopetoun, which he remodelled from 1723, the thrust of the new State Apartment necessitated a huge new façade. The scale of these rooms may have been to display the fine picture collection which was acquired for the house at this time.

Although William Adam, like Bruce, articulated his interiors with the classical orders, his approach is quite different. Not only did he favour giant orders, omitting

the pedestal employed by Bruce, but he also liked to dispose pilasters all round his rooms, rather than merely on either side of the chimney-piece as his unexecuted design for the Great Dining Room at Hopetoun from his *Vitruvius Scoticus* shows (fig. 6.1). In Scotland the Great Dining Room was to remain the largest and grandest room in the State Apartment and its size was possibly a reflection of the disposition of the dinner tables. This emphasis on the display of the table is confirmed by the prominence in Scotland of the buffet niche from the 1720s. This was provided with shaped shelves for the display of plate and glass and they can be found in quite modest houses. A late example at Murrayfield House, a villa near Edinburgh of about 1750, unusually retains both its shelves and panelled doors (fig. 6.5).

William Adam was as much an entrepreneur as an architect, with the capacity to execute his designs as a general contractor. His handsome chimney-pieces demonstrate the importance of his marble works. In his state apartments the marbles often became more exotic as they progressed to the State Bedroom and his chimney-pieces often employ contrasting coloured marbles to show off their details to advantage. His favourite form had an integral chimney-glass framed in matching marble slips.

Adam's fondness for interior grandeur which reflected his façades was expressed in his introduction of stucco decorations to Scotland, displacing the earlier fashion for panelling. At first he had great difficulty in luring competent stuccoists from England. Samuel Calderwood, who was the first to join the Adam firm's payroll, proved a disappointment. In Joseph Enzer, however, William Adam found a soul mate who shared his sense of brio. Their masterpiece is the Great Dining Room at the House of Dun, near Montrose, where an astonishing array of objects and textures has been imitated in stucco and some of the features burst into three dimensions. The architectural framework of Adam's rooms always retains its integrity, however, and at Dun the Corinthian pilasters and cornice remain untouched by the tumbling forms (fig. 6.6). After Enzer's death in 1743, the Clayton family were to become William Adam's most important stuccoists. Their work is marked by a fondness for naturalistically modelled flowers. One of their finest ceilings, executed in 1731, has been newly restored at Chatelherault, the

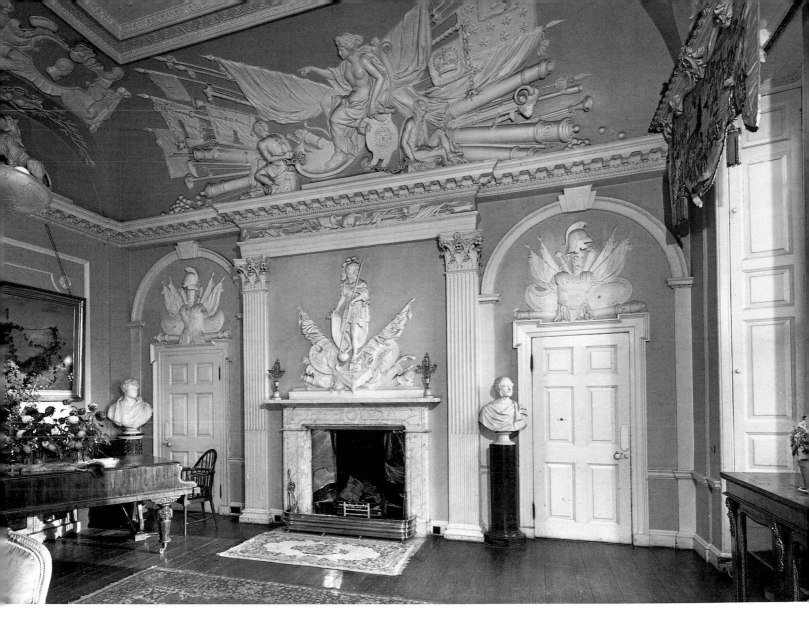

Fig. 6.6 The Great Dining Room at the House of Dun,
 c. 1735
William Adam (1689–1748) with plasterwork by Joseph Enzer
The Royal Commission on the Ancient and Historical
 Monuments of Scotland, Edinburgh

Duke of Hamilton's hunting lodge on his Lanarkshire estates, which was designed to act as an eye-catcher from Hamilton Palace. The ornaments are so deeply projecting that they suggest these schemes must have relied purely on the relief of light and shade rather than colour to bring the white plasterwork to life.

William Adam also liked to use decorative painting extensively in his interiors. Today we are familiar with isolated classical landscapes over chimney-pieces and doors but originally, as the accounts show, such panels were only a component of elaborate schemes involving decorative effects like marbling and graining. At Mavisbank, which was designed as a villa near Edinburgh for Sir John Clerk of Penicuik in 1723 and is

now a sorry ruin, the rooms were named from their primary colour schemes executed by the painter, Robert Norie. A few of the rooms had monochrome landscapes in the fields of their painted panels. Adam's houses must have been as iridescent as the frescoed salons of Italian villas although nothing but fragments of their painted decorations survive today.

Adam does not seem to have designed furniture. A surviving set of letters describing the fitting up of a new bedroom for the Duchess of Hamilton at Holyrood in 1740 show Adam taking the leading part in controlling the activities of the craftsmen to the extent that he was responsible for the overall look of the room. The Duchess's new blue damask bed was set in an alcove, a fashion promoted by Adam. The windows were transferred from one side of the room to the other and mirror-fronted secretaires were inserted in the old window openings. Two pier tables supported by eagles were supplied and they must have been like those

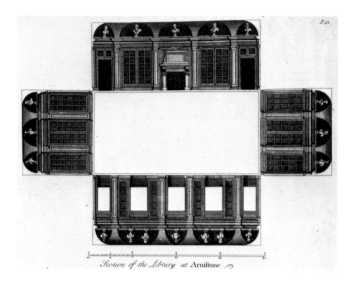

Section of the Library at Arniftone

Fig. 6.7 Design for the Library at Arniston House, *c.* 1730
William Adam (1689–1748); Engraving from *Vitruvius Scoticus,*
c. 1730; 51.8 × 35.5 cm (20½ × 14 in)
The Royal Commission on the Ancient and Historical
Monuments of Scotland, Edinburgh

shown on the engraved billhead of Francis Brodie, the cabinet-maker favoured by Adam. In this correspondence Adam shows particular concern for the way the furniture was to be set out. During this period furniture was disposed around the perimeter of the room when not in use and Adam showed an unusual concern to place his chairs and sofas with architectural precision.

The Library at Arniston is the most intimate of the rooms illustrated by Adam in his *Vitruvius Scoticus* (fig. 6.7). The awkward spacing of its windows arises because it is situated on the attic floor, as was common in Scotland, directly behind the pediment of the principal façade. Adam arranged his pilasters to cope with the differential spacing and ingeniously gained extra height by breaking his cove up into the roof-space. Although the walls shown in the engraving are expressed as four flattened elevations, the arcading in the coving which links the pilasters demonstrates that Adam could think in three dimensions. The carefully spaced busts show his feeling for sculptural enrichment. This organic approach is also shown in his inventive plans. Although each room has an individual internal symmetry, they are fused into highly imaginative arrangements where both a state apartment and comfortable family rooms (conveniently relieved by corridors and jib doors for servants' access) are accom-

modated on the same floor. Adam seems to have had little interest in the bilateral symmetry pursued by James Smith at the expense of comfort. These abilities ensured that Adam dominated Scottish architecture until his death in 1748.

The mid-eighteenth century proved to be a watershed in Scottish design. In the years following Adam's death there was a greater convergence between Scottish and English taste. After the Union of the Parliaments, which concentrated power in London, the upper classes became familiar with metropolitan fashions and it was less unusual for English architects to supply designs for Scottish buildings. Amisfield House, which stood outside Haddington until it was demolished in the 1930s, exemplified this trend. Francis Charteris employed Isaac Ware, an orthodox English Palladian architect, to design the house, but it seems to have been built by Scottish workmen without Ware's supervision. Similarly it was natural for the Duke of Argyll, who spent much of his time in London, to ask another English architect, Roger Morris, to design his revolutionary 'modern' Gothic castle at Inveraray in 1744 although William Adam was awarded the contract to build it in this remote spot in the west of Scotland. This architectural exchange, however, was very much two-way; Scottish architects exerted an equal influence on English taste.

Both Colen Campbell and James Gibbs were Scots who became the leading architects in England in the early eighteenth century and achieved a wide influence through their publications. Campbell's *Vitruvius Britannicus*, the first volume of which appeared in 1715, was in a tradition of view books showing country houses designed by the author and other contemporary architects. It was prefaced by a strongly worded tract decrying baroque architecture and extolling the virtues of the neo-Palladian style. James Gibbs's *Book of Architecture* (1728) not only contained his designs for churches and country houses but also included many details of ornaments and chimney-pieces that were widely copied. Both these publications inspired William Adam's *Vitruvius Scoticus*. He took care to secure the best engravers to execute the plates but in spite of his careful preparations the volume did not appear in his lifetime although the loose sheets must have circulated.

The mid-century was also a time of stylistic confusion and other styles challenged the classical tradition

and provided other choices for interior decoration. Today there are very few rococo interiors in Scotland but a great many highly decorated rooms must have existed in the town houses of Edinburgh and Glasgow which were demolished during nineteenth-century improvements. The finest rococo room in Scotland is probably the Drawing Room at Marchmont House. Reflecting the owner's Francophile tastes, the room has a highly imaginative chimney-piece with sunburst rays of marble whose wavy top precisely fits an especially made curvaceous gilt chimney-glass framing a painting.

The Scots played an important part in the development of the neo-classical style. Robert Adam (1728–92), William's second son, became the most famous of all the Scottish artists who gathered in Rome during the 1750s to further their knowledge of classical antiquity. Scotland was to provide too narrow a canvas for a designer of his abilities and on his return home in

1758 he established his practice in London. Soon his Scots surname became synonymous with architectural elegance throughout the world. Adam's experimental rethinking of the British interior required the kind of unlimited budget that only the wealthiest English patrons like the Duke and Duchess of Northumberland could provide, but he was careful to maintain his Scottish connections. A number of these Scottish schemes were to remain unexecuted like his early design for the Library at Craigiehall near Edinburgh (fig. 6.8) but Scotland has some fine Adam rooms. The most characteristic is perhaps the library at Mellerstain in the Borders (fig. 6.9) with its elegantly attenuated figures

Fig. 6.8 Design for the Library at Craigiehall, 1766
Robert Adam (1728–92); pen and Indian ink wash,
35.5 × 47.5 cm (14 × 18¾ in)
The Royal Commission on the Ancient and Historical
 Monuments of Scotland, Edinburgh

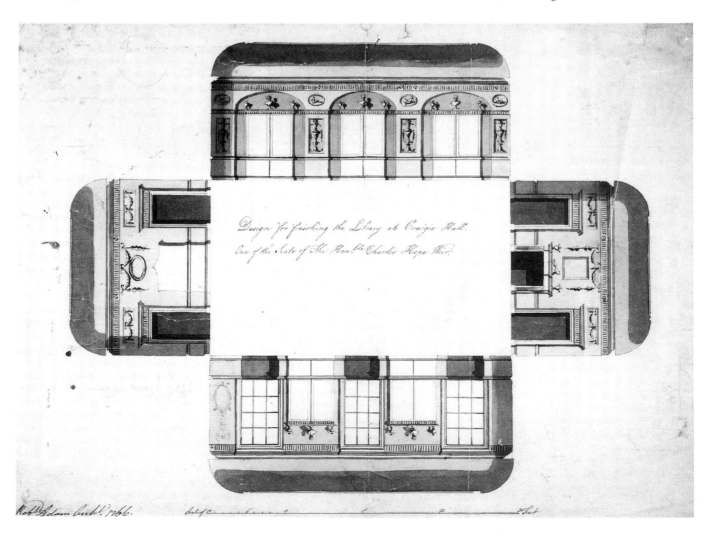

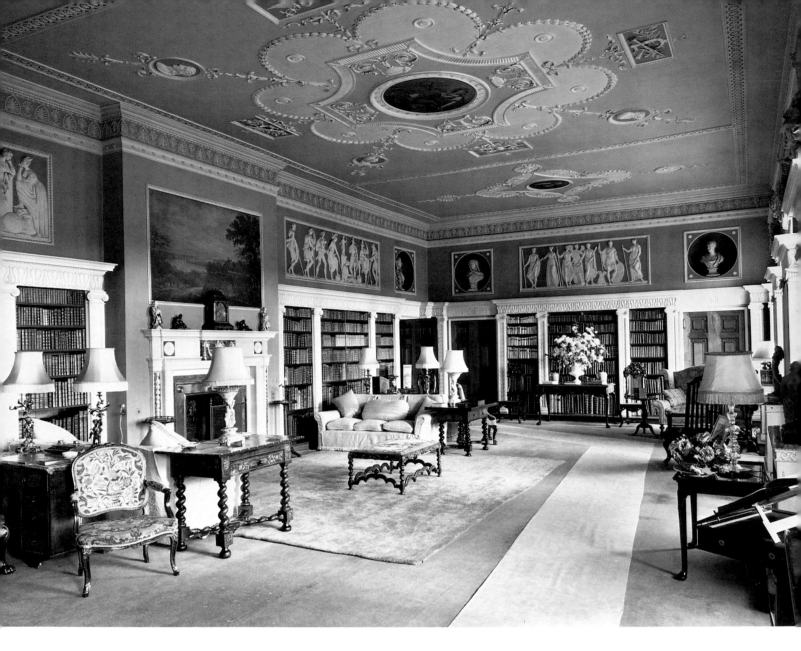

Fig. 6.9 The Library at Mellerstain, *c.* 1775
Robert Adam (1728–92)
Photo: The Royal Commission on the Ancient and Historical
 Monuments of Scotland, Edinburgh

in the bas-reliefs over the inset bookcases and roundels containing busts. At Culzean Castle, on a dramatic site overlooking the sea in Ayrshire, Adam was able to realize a particularly fine sequence of rooms opening from the grand oval staircase at the centre of the house which, surprisingly, seems to have been an after-thought. The exteriors of these houses are in the castle style because Adam's Picturesque taste deemed this as more suitable for the rugged Scottish landscape than the classical ornaments reserved for their interiors. The most beautiful Adam room in Scotland is the Saloon at Yester, near Gifford, which is a team effort because both generations of the family helped to design it. For

once, a great cycle of decorative painting was fully realized. William Delacour was employed to fill the great wall-panels with Italianate landscapes showing classical monuments amid pine trees which have a Tiepolo-like lightness of touch appropriate to a stage designer (fig. 6.10).

Decorative painting remained a characteristic feature of the Scottish interior throughout the eighteenth century. The best-known room is perhaps the Great Dining room at Blair Castle where, from 1766 to 1778, the artist Charles Steuart filled the wall-panels with realistic paintings of local, rather than imaginary, scenery. This marked the beginning of a new awareness of the beauty of the Scottish landscape. The most important painted room in Scotland was at Penicuik House (south of Edinburgh) and had a ceiling painted by Alexander Runciman in 1772, inspired by the romantic Gaelic tales of Ossian. Many more modest

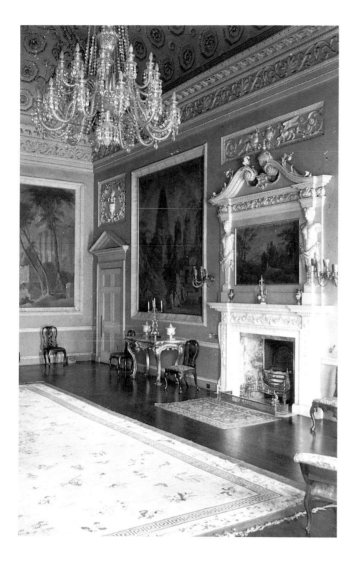

Fig. 6.10 The Saloon at Yester House
William Adam (1689–1748) and Robert Adam (1728–92) with
 paintings by William Delacour, 1761
Photo: The Royal Commission on the Ancient and Historical
 Monuments of Scotland, Edinburgh

Scottish houses had painted decorations by competent house-painters who strove to imitate more gifted artists. A design for an unidentified room (Edinburgh, National Gallery of Scotland) shows how pretty some of these neo-classical rooms must have been but little survives today although fragments sometimes come to light. A very attractive scheme was recently discovered in a tenement flat in Leith Walk, Edinburgh, which bore traces of blue birds supporting garlands of flowers.

The second half of the eighteenth century was marked by the development of a larger middle-class market for relatively inexpensive luxury goods made possible by the industrial revolution. This can be seen in the transformation of Scotland's towns, with the New Town of Edinburgh as the most celebrated example. The New Town contained houses by the first architects of the day such as Sir Laurence Dundas's town house in St Andrew Square by Sir William Chambers, the King's architect, or 8 Queen Street, for which Robert Adam even supplied designs for the chair covers. The majority of the houses, however, were the product of builders who had modelled their detailing on these fine exemplars. Neo-classical taste favoured an understated interior with simplified cornices where the white painted ceilings and woodwork were offset by plain walls washed in clear pale colours. The variety of colours can be studied in the surviving ledger of the house-painter, William Deas, who ben-

Fig. 6.11 Set of colour sample cards (sent to Mr Vans Agnew
 of Barnbarroch House by a Glasgow house-painter), c. 1810
Historic Buildings and Monuments: Stenhouse Conservation
 Centre

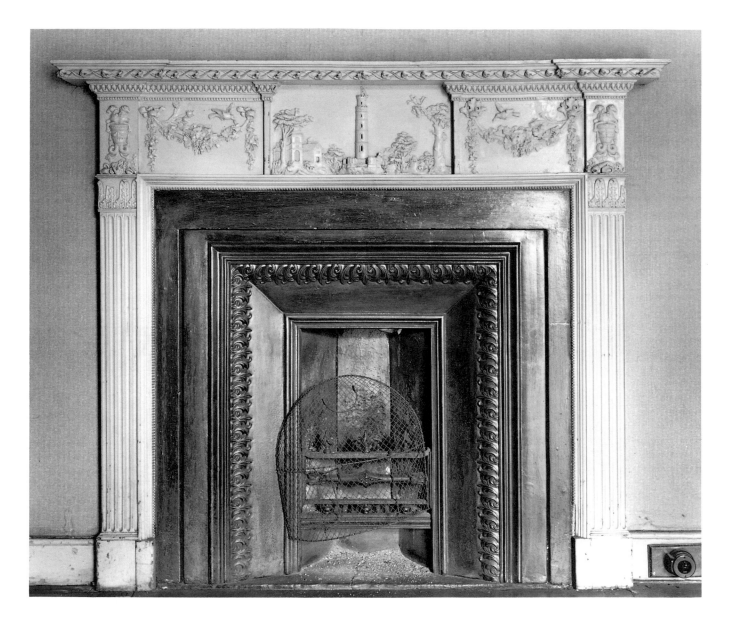

Fig. 6.12 Chimney-piece at Ravelston House, Edinburgh
with a tablet depicting the Nelson Monument on the Calton
Hill, *c.* 1810
Maker unknown; painted pine and composition
Photo: The Royal Commission on the Ancient and Historical
Monuments of Scotland, Edinburgh

efited from the expansion of the New Town. (His ledger, with the first entry in 1774, is now in the Scottish Record Office.) A unique set of colour cards survives from the early nineteenth century when they were sent by a Glasgow house-painter to Mr Vans-Agnew to assist him in the choice of paint colours for Barnbarroch House in Wigtonshire (fig. 6.11). They show the contemporary preference for clear shades of distemper colours.

The repetitive ornaments admired by neo-classical designers lent themselves to cast plaster friezes and ceiling ornaments which displaced the livelier direct modelling of stucco. James Nisbet seems to have been the leading plasterer in the New Town of Edinburgh and some of his best work can still be seen in the Assembly Rooms of 1786 in George Street. The most attractive of all the architectural features of the New Town are the series of wooden chimney-pieces with applied cast composition ornaments. Their maker is not known but an Edinburgh provenance is suggested by a group bearing tables depicting a local scene, the Nelson Monument on the Calton Hill (fig. 6.12). The finest are ornamented with seaweed and shells and appear to be cast from life. Although much admired

today they seem to have been regarded at the time as a cheap substitute for a marble chimney-piece and they were used in bedrooms and lesser public rooms.

During the late eighteenth century there was an important government initiative to improve Scottish design. The Board of Manufactures, which had its origins in the Treaty of Union, had been voted sums of money to encourage manufactures in the hope of relieving the impoverished state of the Scottish nation. Recognizing that these products were mainly humble domestic goods like textiles with no intrinsic value, the Board's Commissioners soon realized that the only means of rendering them more attractive for export lay in improving the standard of design. To this end they established a Drawing Academy in Edinburgh in 1760 which was geared to training young tradesmen in the rudiments of design. Although the school suffered various vicissitudes, considerable progress had been made by the late eighteenth century when the artist, David Allan, was the Master. Allan had a particular feeling for interiors as the details of many of his portraits and conversation pieces demonstrate. His painting, *The Connoisseurs* (fig. 6.13), has the usual stage-set room with scanty architectural detail but the contents are rendered convincingly and relate to the fashionable furnishings of the period. The handsome press with its broken pediment in the background of this painting is almost identical to an actual piece of mahogany furniture by Deacon Brodie, the son of William Adam's cabinet-maker (Edinburgh, National Museums of Scotland). When earlier portrait painters had introduced domestic furnishings they had tended to invent fanciful pieces to give a more artistic effect but Allan was one of the first Scottish painters to record such realistic domestic details. This is especially noticeable in his illustrations to both Allan Ramsay's rustic poetry (see fig. 5.8) and also to Robert Burns' poems.

David Allan was one of the few masters of the Board of Manufactures' Drawing School who took his duty of supplying designs as models for his pupils seriously. His taste can be seen in the appliqué panels bearing griffins and vases of flowers worked by Lady Mary Hogg who had been given drawing lessons by Allan (fig. 6.14). The completed panels were installed in Robert Adam's new drawing room at Newliston House outside Edinburgh. Allan had been the star pupil at another earlier educational establishment, the Foulis

Academy in Glagow, where design for industry (particularly the burgeoning printed linen workshops in the west of Scotland) had been included among the aims of the city's merchants who financed its brief flowering.

Sadly, it is not possible to assess the impact of the Board's attempts to raise the standard of Scottish design. Although the written records in Scottish Record Office are extensive and are replete with information on many aspects of manufactures, there are not only very few visual records but also hardly any artefacts which have a secure Scottish provenance. Almost the only drawing which can be connected with the Board's Academy is a fragment of a carpet design which the young artist Alexander Nasmyth submitted when he applied for a place at the school (fig. 6.15). Nasmyth went on to become a celebrated landscape painter and therefore the calibre of his design is probably exceptional. This fine drawing is a reminder of the importance of the Scottish carpet industry during this period although very few examples survive. 'Scotch' carpets were exported to England where their success was probably due more to their cheapness (resulting from their flatwoven construction) rather than from the merits of their design. A late nineteenth-century photograph of the President's Room at Culloden House, which was designed about 1782, provides a rare illustration of one of these woven carpets with its small-scale repetitive geometric design (fig. 6.16).

Many other areas of Scottish design remain equally mysterious. The firm of Esplin and Forbes, for instance, printed wallpapers in Edinburgh during the late eighteenth century but none of their work has as yet been identified. The best documented Scottish firm was the Carron Ironworks which was also the country's largest industrial enterprise (see fig. 7.1). Although they are popularly supposed to have supplied much of the outstanding ironwork in Adam's grandest English commissions, their surviving letter books reveal a different story. The company liked to make very long runs of the same object rather than individual luxury items. Customers with one-off requests were frightened away by a high quotation for cutting the mould unless they happened to be shareholders, since it was company policy to indulge their commands to keep them sweet. Cast-iron stove grates were exactly the kind of items which suited their mass manufacturing ambitions and

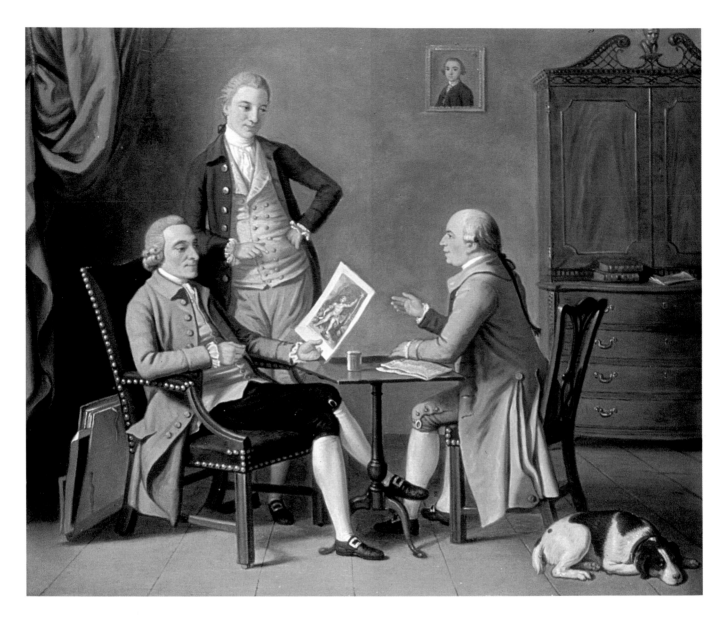

many English houses had Carron grates. Although these are in elegant neo-classical styles, their ornamentation was limited by the practicalities of the casting process and any unnecessary frippery was strongly discouraged.

A clear picture of Scottish rooms at the beginning of the nineteenth century emerges because artists suddenly took up the perspective view with enthusiasm. Since some rooms remain old-fashioned, particularly in institutions, it is occasionally possible to gain an insight into the eighteenth-century domestic scene. William Douglas's drawing of the *Chaplain's Room at Trinity College Hospital, Edinburgh* (fig. 6.17) dates from as late as 1845 but the incumbent, the Rev. John Sime, was an enthusiastic antiquarian who deliberately retained

Fig. 6.13 *The Connoisseurs, c.* 1780
David Allan (1744–96); oil on canvas, 86.4 × 97.8 cm
 ($34 \times 38\frac{1}{2}$ in)
The National Gallery of Scotland, Edinburgh

Fig. 6.14 Design for an appliqué panel for the Drawing
 Room at Newliston House, *c.* 1790
David Allan (1744–96); pencil and watercolour, 12 × 18.5 cm
 ($4\frac{3}{4} \times 7\frac{1}{2}$ in)
The National Gallery of Scotland, Edinburgh

Fig. 6.15 Design for part of a carpet submitted for entrance
 to the Board of Manufactures Drawing Academy, 1774
Alexander Nasmyth (1758–1840); gouache, 15 × 32.5 cm
 ($6 \times 12\frac{3}{4}$ in)
The National Gallery of Scotland, Edinburgh

Fig. 6.16 The President's Room at Culloden House showing
a 'Scotch' carpet
Photograph from *Sale Catalogue*, 1892
The Royal Commission on the Ancient and Historical
Monuments of Scotland, Edinburgh

the fashions of earlier times. With the exception of the gas-mantle and the chimney-shelf which supports it, nothing in the room can be later than about 1780. A handsome set of curvaceous rococo chairs have been lined up stiffly around the walls following eighteenth-century practice. A small table has been pulled up near the window for reading. The draw-up curtains show how sparingly textiles were used in early interiors and give a very architectural effect revealing the panelled window surrounds. The fitted carpet shows a taste for comfort and its small-scale neo-classical coffered design

would have been suitable for a woven rather than knotted technique, so it may be a 'Scotch' carpet. The sparse pictures have been grouped to make maximum impact as a pattern. The fully stuffed chair looks only marginally more comfortable than the others. The walls are plain painted and unrelieved by wallpaper patterns.

If the Chaplain's Room looks back to an earlier and very formal way of life, Alexander Carse's painting of *The Drawing Room at Midfield House*, 1807 (fig. 6.18), looks forward to nineteenth-century fashions and has the distinction of being the first view of an actual room in Scottish art. Midfield was a delightful cottage ornée set in attractive countryside to the south of Edinburgh with fine views over the Pentland Hills and therefore a note of informality might be expected. The furniture arrangement is very different from that of the

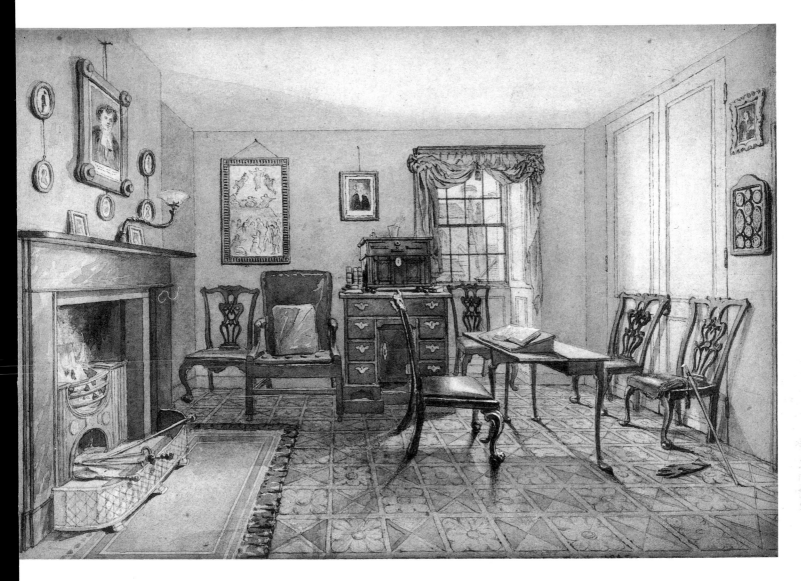

Fig. 6.17 *The Chaplain's Room at Trinity College Hospital,*
 Edinburgh, 1845
William Douglas (dates unknown); sepia, 30.5 × 35.5 cm
 (12 × 14 in)
By kind permission of The Company of Merchants of the City
 of Edinburgh
Photo: Royal Commission on the Ancient and Historical
 Monuments of Scotland, Edinburgh

Chaplain's room and the pieces have been pulled away
from the walls to wherever they would prove most
useful creating informal groupings. The couches,
inspired by the new enthusiasm for Greek rather than
Roman antiquity, allowed for more relaxed postures
as the Campbell family here demonstrate, a change also
reflected in the ladies' simple dresses. Although the
pictures remain sparse there is a new taste for lavish
window draperies and the statuary in such a small room
strikes a theatrical note. Entirely new types of light,
portable furniture were invented and popularized in
response to the banishment of formality. The new taste
for the Picturesque, to which we owe this painting,
undermined the long established classical tradition.

These changes, which must have been paralleled in
many homes throughout Scotland, stimulated Scottish
craftsmen to new invention and more extravagant
effects. Improvements were encouraged by com-
petitions and prizes were offered by the Board of
Manufactures. The established firms vied with each
other to produce ever more elaborate domestic fur-
nishings and painted decorations. By the middle of
the nineteenth century Scotland had been transformed
from an importer to an exporter of decorative art and
the biggest firms of house-painters, carpet-manu-
facturers and furniture-makers of Edinburgh and

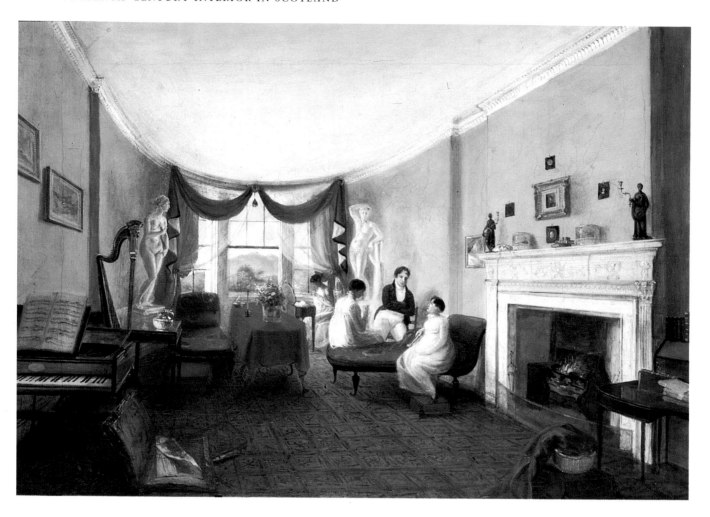

Glasgow competed for English contracts with a success that the Board of Manufactures could scarcely have imagined. Scotland's outstanding contribution to interior design was to come in the nineteenth century but this transformation owed much to the cumulative effect of the relatively modest innovations made during the eighteenth century.

Fig. 6.18 *The Drawing Room at Midfield House*, 1803
Alexander Carse (*c.* 1770–1843); oil on canvas, 38 × 51 cm
 (15 × 20 in)
Private Collection
Photo: Royal Commission on the Ancient and Historical
 Monuments of Scotland, Edinburgh

7

INDUSTRIAL DESIGN IN SCOTLAND
1700–1990

JOHN HUME

For the past seventy years or so industrial design has meant for most people the styling of the coverings for working objects as in motor cars, radios and washing machines, or the design of products whose virtues are all on the surface, like textiles, crockery and furnishings. This essay takes a wider view, looking at design constraints, the development of accepted styles, and how the acceptable then becomes conventional and proves a challenge to the innovator. As the whole spectrum of industrial design would be unmanageable, eight subject areas have been selected, which reflect the dominance of particular industries in Scotland over nearly three centuries. These are discussed roughly in the order in which they became prominent, and provide a conspectus of some of the main themes to be addressed in a study of Scotland's distinctive contributions not only to industrial design, but to the history of design in general.

Iron Founding

Iron smelting came to Scotland late in European terms. Although charcoal-fuelled blast furnaces were in use in the Highlands from the early seventeenth century, they were small in scale, and the bulk of their produce seems to have been intended for conversion into wrought iron. One early eighteenth-century fireback survives (now at Taynuilt, Bonawe Ironworks), which is much simpler in design than contemporary Dutch or English examples. The Carron Company revolutionized iron

smelting in Scotland. Founded in 1759, the company aimed to smelt iron with coke on a scale unprecedented in Scotland and unusual in Britain. From the iron thus produced the company made cast-iron goods of a wide range of types, including hemispherical sugar-boiling pans, cast-iron guns and domestic ironware (fig. 7.1). The firm's concern with quality led them to commission designs from Robert Adam. Later in the eighteenth century Carron's example was followed by others, but its range and quality of products remained unrivalled until, in the first decade of the nineteenth century, the Shotts Iron Company began producing architectural ironwork both at Shotts and in their Edinburgh foundry. An important part of their output consisted of railings and balconies for the Edinburgh New Town as well as water pipes and gutters. These products were repetitive to a high degree, calling for better technique and management of green sand moulding, which involved using a mixture of sand, coal-dust and a little water that would take an impression strong enough to resist the flow of molten iron into the mould. The invention of the cupola furnace for remelting pig iron was important in helping to produce good, uniform castings. In Scotland, Georgian architectural ironwork was simple, sometimes severely so. The Victorians, however, quickly developed a taste for elaborate cast-iron work. In this they were immensely aided by the introduction in the 1830s of the hot blast process for iron smelting which,

Fig. 7.1 Fire grate, early 19th century
Attributed to the Carron Company, Falkirk; cast iron,
100.3 × 96.5 × 30.5 cm (39$\frac{1}{2}$ × 38 × 12 in)
Glasgow Museums & Art Galleries, Pollok House

when used with Scottish iron ores, produced cheaply a quality of iron which was very fluid when melted. With this process all parts of even complicated moulds could be filled producing castings of unrivalled fineness and surface finish. That such castings were mechanically weak was of secondary importance to purchasers. By making wooden patterns and using them to make iron ones, long sequences of repetitive castings could be made. These techniques were applied with great vigour in foundries throughout central Scotland.

In Glasgow two firms emerged as leading producers of rainwater goods, sanitary ironware and, most publicly, ornamental ironwork. Gates, railings and cresting (ironwork for roof ridges), were produced as architectural embellishments, and whole buildings were made of cast iron, including bandstands, pavilions and public lavatories. Walter MacFarlane's Saracen Foundry, established in 1850s, was the first in the field, and remains the most famous, but George Smith &

Company's Sun Foundry (1870) rivalled it in bold and effective design. MacFarlane's catalogues give some idea of the inventiveness of the firm's designers and the vast range of products supplied (fig. 7.2). Other companies in Kirkintilloch, Falkirk and Bo'ness also made ornamental work, and a few still do, on a limited scale.

The other important branch of the 'light castings' side of the trade was located primarily in Bonnybridge, with outliers in Larbert, Falkirk and Glasgow. This produced stoves and ranges, originally coal-fired, later gas and electric. Lane & Girvan, Smith & Wellstood (who still make stoves), and McDowall, Steven & Co. were all important manufacturers. As with ornamental work the variety produced was remarkable: everything from tiny stoves for yachts to massive cookers for hotels, liners and hospitals. The continued success of these large companies (until pressed steel superseded cast iron as a major constructional material) suggests that their designs were most acceptable in the market place. Their products, along with those of the ornamental iron foundries, rarely, if ever, aspired to the highest aesthetic standards of the time. However, they epitomize a level of Victorian middle-class taste, and exemplify the virtuosity both of designers and moulders in producing castings of extraordinarily fine quality. Comparison with the products of Coalbrookdale, the leading English producer (on display in the museum there), suggests that the Scottish firms were more confident in new design, expressing a new Victorian aesthetic rather than copying classical and Gothic models. Like it or loathe it, one must respond to classic Scottish Victorian ironwork.

Textile Manufacture

In contrast to iron founding, textile manufacture has throughout the world a very ancient history. Before the eighteenth century Scotland's textile output seems to have had little refinement, but from the later seventeenth century attempts were made to improve quality. In the later eighteenth century the silk and

Fig. 7.2 Canopied fountain, c. 1880s
Walter MacFarlane & Co, Saracen Foundry, Glasgow; cast iron, h. 340 cm (133$\frac{7}{8}$ in), d. 185.6 cm (73$\frac{1}{8}$ in)
Trustees of the National Museums of Scotland, Edinburgh
Photo: Crowther of Syon Lodge

linen industries of the west of Scotland were renowned for quality, but it was not until the early and middle nineteenth century that truly distinctive Scottish textiles made their mark on British and foreign markets. These may be divided roughly into hand-produced textiles for the luxury trades, and machine-produced textiles for less wealthy customers. In the first category are Paisley shawls, Ayrshire embroidery, and more recently, 'designer' knitwear. In the second are most woollen cloths, printed cotton textiles and fine linens. The Paisley shawl is a good example of a luxury product first produced to compete with Indian, and later French, competition but securing through fine design and quality of craftsmanship such a reputation that shawls woven in other areas have been attributed to Paisley. (For example, the pine motif, originally from Kashmir, has been firmly linked to that town.) Like so many textile innovations, the Paisley shawl fell out of fashion, and its manufacture on any scale ceased in the 1870s.

Ayrshire embroidery (or tambouring) was in its day as celebrated as the Paisley shawl, and Ayrshire christening robes are still cherished in some families. This industry developed from the weaving of plain muslin cloth, made in the west of Scotland on both hand and power looms from the early nineteenth century. Some decoration could be introduced into plain muslins in the loom, but the patterns produced in this way were repetitive, and so for a more individual product Ayrshire drawn-thread embroidery became popular. Glasgow-based manufacturers 'put out' muslin and thread to households throughout Ayrshire, where young girls were trained to the painstaking skill involved. The embroidered goods were then brought back to central warehouses where they were washed and ironed ready for sale. The industry collapsed in the later 1850s owing to changes in fashion: the bankruptcy of a few large firms being a factor in the failure of the Western Bank in 1857. The designs of Ayrshire white work are usually complex, bearing some relation to bobbin lace design, and indeed the effect of the work is dependent on the richness of pattern and texture in monochrome. In contrast, the complexity of the Paisley shawl results from two-dimensional coloured patterning, and texture is important for smoothness rather than variety of surface.

A third important textile product was calico print-

Fig. 7.3 Calico printing pattern, c. 1850-90
United Turkey Red Co. Ltd, Alexandria; watercolour
Glasgow Museums & Art Galleries, People's Palace

ing, a technique copied from the Far East and used in linen printing in the eighteenth century. Initially the pattern was applied by hand, using hand-cut wooden blocks, sometimes with metal inserts. The invention of the rotary textile printing machine, a Scottish innovation, allowed mass production of multi-coloured decorative fabrics. As with Ayrshire embroidery this was a way of decorating a plain surface, but as with the Paisley shawl, colour and pattern were its most important design features. Since main markets for printed goods had been developed in India and further east, changes in design were necessary. Fastness to light and washing were important considerations: hence the use of Turkey Red dyeing, using the natural dye madder (imported from the Mediterranean) with various chemicals called mordants, to produce a range of colours from reds through browns to blacks. The technique of Turkey Red dyeing was brought to Scotland from France in the 1780s, and the use of mordants was greatly extended by Scottish chemists to give a richer variety of colours.

The aesthetic of Turkey Red designs was linked strongly to the Far Eastern markets for which they were intended. Designs were normally bold, with

in Glasgow and Renfrewshire. Capital-intensive in nature, the industry become highly competitive in the later nineteenth century. By the early 1900s, closure of works following amalgamation with English producers had all but ended large-scale production.

Today fine textiles are locally important in Scotland and Borders woollens (fig. 7.4) and tweeds made in the Borders and in the Western Isles have deservedly high reputations for quality and style. Elegance is their hallmark in contrast to the complicated patterns of many Victorian textiles.

Marine Engineering

While ornamental cast iron and decorative textiles reflected popular taste, corporate expectation determined other aspects of industrial design. Marine engineering is the first example, since the marine steam engine was effectively a Scottish invention. In 1801,

Fig. 7.4 Knitted sweater, 1990
Pringle of Scotland, Hawick; cashmere
Pringle of Scotland, Hawick

Fig. 7.5 Drawing of a Napier side-lever marine engine for the paddle steamer *Admiral*, 1840s
Designer: Robert Napier & Sons, Glasgow; ink and wash on paper, 40 × 50 cm ($15\frac{3}{4} \times 19\frac{5}{8}$ in)
Glasgow Museums & Art Galleries, Museum of Transport

effective use of bright colours (fig. 7.3). These fabrics seem to have had little appeal to home buyers, but they demonstrate the role of exports in Scottish industrial development from the late seventeenth century. This is one of the few export markets in which the taste of indigenous peoples, rather than that of émigré Europeans, dictated design. The valley of the Leven between Dumbarton and Balloch became the greatest centre of calico printing in Scotland but there were also outliers

the *Charlotte Dundas* was fitted with what was arguably the first direct-acting steam engine of any type anywhere and in 1812, the *Comet* was fitted with the pioneer of the first successful type of marine engine, the side-lever engine. The side-lever engine type was in fact developed by James Watt's English partnership, Boulton & Watt, for use on land, but being self-contained and with a low centre of gravity it was ideally suited to paddle propulsion, and after the *Comet*

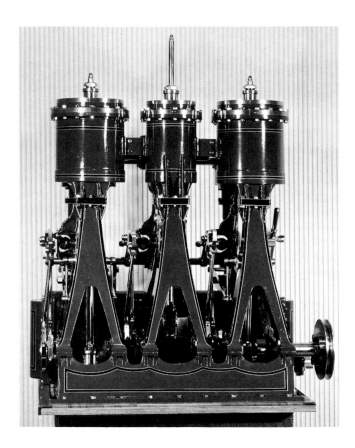

Fig. 7.6 Three-cylinder compound marine engine for the
ss *Orient*, 1879 (model)
John Elder & Co., Glasgow; cast and wrought iron, brass;
Scale 1:12
Glasgow Museums & Art Galleries, Museum of Transport

powered most steamships for about the next thirty years or so. The little *Comet II* engine demonstrates early nineteenth-century engine design in a simple and basic form, the shape of its elements being dictated by the techniques of forging, casting, turning, screwing, and filing available to its maker. Nothing here is ornamental; fitness for purpose shines through the design, as does craftsmanship.

Many of the pioneers of marine engineering fell by the wayside, but the cousins David and Robert Napier and the firms set up by former employees, such as Randolph, Elder & Co. and J. & G. Thomson, came to dominate the top end of the market in marine engines from the 1840s. Rugged reliability was essential for safety at sea as well as economy in operation, and Napier engines certainly possessed it. Robert Napier however became something of an aesthete as well, and the engineering virtuosity of his design staff, led by David Elder, was complemented by a desire to intro-

duce elegance into what was the most potent machine of its day. The drawings of Napier engines (fig. 7.5) and David Kirkaldy's superb drawing of the *Persia* illustrate this concern for artistic expression in a space ill-lit and not generally on view to passengers.

In 1853 David Elder's son John invented compounding (the use of high-pressure steam in two stages) to give economy in operation, and the firm he established with the great millwright Charles Randolph quickly gained a reputation for advanced technology. The Elder three-cylinder compound engine model (fig. 7.6) exemplifies a developed engine of this type. Ornament has been discarded as unnecessary and indeed irrelevant, but judicious proportioning and fitness for purpose in an engine that was at the forefront of contemporary technology produced a machine of compelling elegance. In a highly competitive field, economy of operation and maintenance were important, but appealing design and good finish were sales points too. The commissioning of this model demonstrates that kind of concern and pride, combined with proper respect for an engine's function as the heart of a ship, which is still found in today's giant diesel engines.

For the first fifty years of the marine engine's existence the Clyde was at the forefront of innovation. Both triple and quadruple expansion engines were pioneered on the river, and it was the combination of the Scotch boiler and triple expansion engine that really opened up the freight trade of the world to British steamship owners. When in the 1890s and early 1900s the steam turbine and the diesel engine were adapted to marine use the Clyde builders quickly took them up. The first turbines for passenger ships, second and then first-class liners, were built between 1901 and 1907 and two of the first marine diesel engine works in the world were built on the Clyde just before the First World War. The role of the Clyde designers was less distinctive than it had been in the design of reciprocating steam engines since the international licensing of patents led to a degree of uniformity of practice throughout the world which subdued the Scottish input. Today, however, marine engines of large size are still being made in Scotland, and the fitness for purpose that characterized the products of the earliest designers is still there.

Shipbuilding

Shipbuilding is, apart from the distilling of whisky, the industry most closely associated with Scotland. There were few branches of shipbuilding in which Scotland has not excelled. This dominance arose from the early lead in steam navigation secured by Scots inventors and entrepreneurs. William Symington's first steamboat on Dalswinton Loch was barely a success, but the steam tugs he built for the Forth & Clyde Canal in 1801–02 were not only technically successful but highly influential, stimulating Robert Fulton to introduce the world's first commercial steamboat on the Hudson River in 1807 and Henry Bell of Glasgow to build Europe's first commercial steamship, the *Comet*. The *Charlotte Dundas* (fig. 7.7), was a true prototype, intended not for series production, but to demonstrate practicality. Her design incorporated existing wooden boat technology and new designs of boiler and direct-acting steam engine. The *Comet*, which was intended for passengers, had more style. Steamships built for the sheltered waters of the Clyde and later for cross-

Channel and coastal service developed an aesthetic of lean hulls with sharp prows, prominent, decorated paddle-boxes and tall funnels painted in distinctive colours, usually with black tops to camouflage smoke stains. Vessels designed for longer routes were fitted with sails to increase speed.

The *Sirius*, a Scots-designed vessel, was the first steamship to cross the Atlantic using her engines all the time and Samuel Cunard came to Glasgow to inaugurate the first regular liner steamship service across the Atlantic. The *Acadia*, one of that pioneering group, had the funnel colours of the Napier family, since Robert Napier had provided the engines and some of the finance, and had contracted for the wooden hulls for these ships. Napier's engine works and his iron shipyard continued to supply ships to Cunard for

Fig. 7.7 *Charlotte Dundas*, 1803 (model)
Designer: William Symington (1763–1831); Maker: R. W. Clark, Glasgow; Scale 1:24
Trustees of the National Museums of Scotland, Edinburgh

Fig. 7.8 RMS *Umbria*, 1884 (model)
John Elder & Co., Glasgow; Scale 1:48
Glasgow Museums & Art Galleries, Museum of Transport

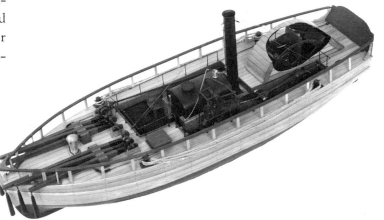

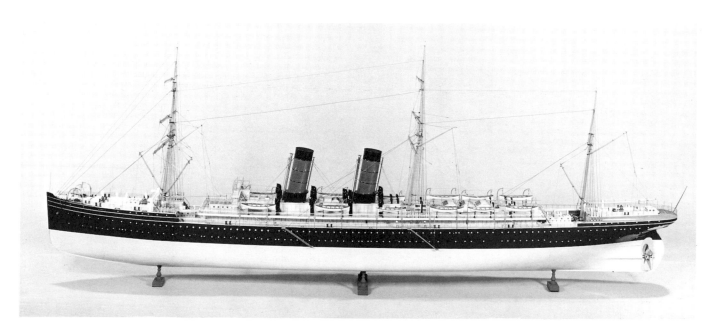

more than twenty years; and the *Persia* of 1855, the largest ship of her day, represented the acme of the paddle-propelled first-class transatlantic liner. Her choice as a subject by the draughtsman David Kirkaldy and the beauty of his treatment are strong evidence for the esteem in which this ship was held at the time. Her design represents that balance of practical necessity, desire to please the passenger and a kind of nobility that the Clyde above all other shipbuilding centres emphasized in its ships. The firms of J. & G. Thomson and John Elder & Co. (later the Fairfield Shipbuilding and Engineering Co.) inherited Napier's connections and built almost all the first-rate and many second-rate Cunarders until the *Queen Elizabeth II* (1969). The

Umbria illustrates the end of one phase of liner design (fig. 7.8). This vessel and her sister ship *Etruria* were the last compound-engined first-class transatlantic liners and the last Cunarders with auxiliary sail. The design of their successors, the *Campania* and *Lucania*, began a tradition of functional cleanness and balance that was carried right through to the *Queen Mary* and *Queen Elizabeth*. Underlying the visual strength of these designs was a theoretical foundation based on the calculation of ship stresses pioneered by W. J. McQuorn Rankine of Glasgow University, on the refinement of hull form by David Napier and John Scott Russell and on test-tank experiments on merchant-ship hull designs first used by William Denny & Bros of Dumbarton.

Fig. 7.9 Container ship
 Taihe for the China Ocean
 Shipping Co., Shanghai,
 1989
Maker: Govan Shipbuilders;
 Gross tonnage 35,963,
 speed 19 knots, l. 224.9 m
 (737 ft $11\frac{3}{8}$ in)
Photo: Courtesy Kvaerner
 Govan Ltd and Ralston
 Photography

The use of iron, then steel for hull construction were Clyde innovations. In accommodation, too, the Clyde innovated, with J. & G. Thomson introducing the saloon running up through several decks in the *City of Paris* and *City of New York* in 1889.

Among the other ship types in which the Clyde made notable contributions were fast estuarial and Channel steamers. In the latter William Denny & Bros set standards of speed and appearance that others could only imitate. In the less glamorous field of dredgers and other harbour craft the Clyde and Cart were pre-eminent and in the design of clipper ships and of steel bulk-carrying sailing vessels Scotland was remarkably successful. The balance in appearance mentioned in

Scope for originality in design has diminished over the years as ease of construction, strict suitability for purpose and an international aesthetic have gripped shipbuilding. The surviving Clyde yards, notably Kvaerner-Govan and Yarrow Shipbuilders, now produce vessels which are of the highest quality and in which so far as practicable the best traditions of restrained elegance in design are maintained (fig. 7.9).

Railway Locomotives

Scotland pioneered the first use anywhere in the world of a steam locomotive on a public railway in 1818, on the Kilmarnock & Troon line, but it was not until 1831 that the first steam locomotive was built by a Scottish

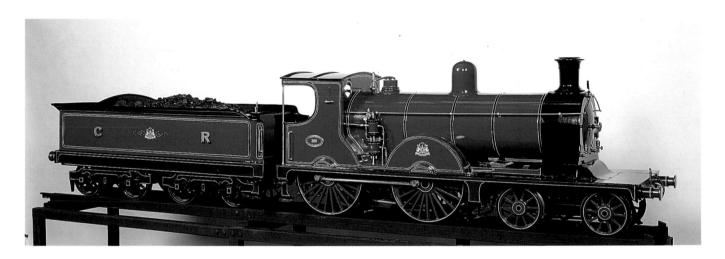

Fig. 7.10 Caledonian Railway locomotive *Dunalastair II*,
4–4–0, No. 769, 1897 (model)
Designer: J. F. McIntosh, Caledonian Railway, Glasgow;
 Maker: Caledonian Railway, Glasgow; Scale 1:6
Glasgow Museums & Art Galleries, Museum of Transport

Fig. 7.11 Locomotive, *Blue John*, built for Blue Circle
 Industries in Hope, Sheffield, 1990
Maker: Hunslet-Barclay Ltd, Kilmarnock
Hunslet-Barclay Ltd, Kilmarnock

connection with ocean liners was carried through not only into obviously graceful sailing ships but also into hopper barges, sewage sludge boats and even bucket ladder dredgers!

company, Murdoch & Aitken of Glasgow. This, for the Monkland & Kirkintilloch Railway, was of the type invented by George Stephenson in about 1814, and was already obsolete. Though engineers in

Glasgow and Dundee tried alternative layouts for the machinery of locomotives, Robert Stephenson and R. & W. Hawthorn in England evolved the first successful main line types. In prolonged service, however, these insider-cylinder locomotives proved unreliable, and Alexander Allan, a Scot working in England, developed an outside cylinder layout which became characteristic of Scottish practice for nearly half a century. This style was mechanically superior and introduced a cleanness of appearance that became a hall-mark of Scottish locomotive design.

At about the time Allan invented his layout, another outside-cylinder style was being developed by Patrick Stirling. He used this for locomotives on the Glasgow & South Western Railway, and developed it further when he moved south of the Border to the Great Northern Railway. Its finest application was in his very beautiful and successful 'Eight Footers' of 1870 and later. Patrick Stirling's brother James preferred inside-cylinder locomotives, but, like his brother, favoured domeless boilers, which remained characteristic of the family's designs and those of their school until the early years of this century. Some of their locomotives carried external simplicity of design almost to the ultimate.

The other notable indigenous Scottish school of design began with Allan-type locomotives on the Highland Railway which were modified by William Stroudley before he moved south in 1869. Stroudley's pupil Dugald Drummond introduced locomotives on the North British and Caledonian railways which combined robust simplicity with great beauty of external treatment. Niceties of chimney, dome and cab design combined with balancing of components to create real masterpieces. Drummond himself enlarged and expanded both passenger and freight locomotives as did his successors on the Caledonian (fig. 7.10) and North British railways and later on, his brother on the Highland and Glasgow & South Western railways, producing continuity of design for nearly fifty years. (It also found its way on to the London & South Western Railway.) Locomotives of basic Drummond design were the last British Rail steam engines in service in Scotland in the late 1960s.

The success of a steam locomotive is dependent on its ability to raise steam, to use that steam efficiently, and to run reliably and with minimal costs for maintenance. In these terms the classic schools of locomotive design in Scotland were eminently and fairly consistently successful. Only when the original concepts were stretched too far did serious failure occur, as in the case of some of the larger Caledonian locomotives.

Scotland was also a notable builder of locomotives for export. In 1903, when the North British Locomotive Company Ltd was formed by amalgamating the three Glasgow builders, it was the largest privately-owned locomotive-building firm in Europe. Many, if not most, of the locomotives built by this concern and its predecessors were designed by their clients or by consulting engineers. The model of a South African Railways 15F locomotive exemplifies a client-designed locomotive but the style is similar to that adopted by Glasgow designers from the 1920s until the end of new steam locomotive construction in the late 1950s.

Numerous industrial locomotives were also constructed in Scotland, both by the larger firms and occasionally by smaller companies. The dominant concern was Andrew Barclay's Caledonia Foundry, Kilmarnock (now Hunslet-Barclay), whose standard steam designs were robust, effective and distinctively handsome. Today Hunslet-Barclay are still building fine diesel industrial locomotives which in their neat outlines echo the tradition from which they stem (fig. 7.11).

General Engineering

The choice of high-public-profile products for the bulk of this essay has been deliberate, for where public consciousness exists design will take account of it. In general engineering few people actually saw the products, but the way in which they were sold, through catalogues and brochures, meant that the design-consciousness of the potential client often had an effect on external treatment. As in the case of marine engineering, aesthetically-pleasing components will often result from the judicious use of materials, but their assembly into a harmonious whole requires a sense of proportion and balance. The model of a Rigby steam hammer shows a machine in which engineering necessity and care in design have blended to produce a satisfying and effective product (fig. 7.12). Hammers of this type and style were made for some seventy years, and used all over the world. Another area of general engineering in which the west of Scotland specialized was the manufacture of machine tools. Local firms such

as Craig & Donald and Thomas Shanks & Co. (both of Johnstone) led the world in making shipbuilding tools such as bending rolls, punching and shearing machines and heavy machines for making parts for the largest marine engines. In the building of these, manufacturers combined utility with neat, even graceful, design, softening the impact of the great bulk of many of the devices.

Other notable Scottish general engineering products have included steam driving engines and winding engines, steelworks plant equipment, sugar and rice machinery, and stone quarrying and sawing equipment. In all these fields one can quote firms whose engineering expertise produced well balanced designs. Today firms such as James Howden & Co. Ltd and Anderson Longwall turn out superbly designed and constructed products, notably tunnelling (fig. 7.13) and coal cutting machines, of greater sophistication than their predecessors, but with the same attention to combining fitness for purpose with pleasing appearance.

Fig. 7.12 Rigby steam hammer, late 19th century (model)
Glen & Ross, Glasgow; Scale 1:6
Glasgow Museums & Art Galleries, Museum of Transport

Fig. 7.13 Channel tunnel boring machine being erected in the Scotland Street works, Glasgow, of James Howden & Co., 1988
Photo: Courtesy James Howden & Co., Glasgow

Motor Cars and Aviation

Scotland now has no indigenous motor car production but in its day the country was a notable producer. In the 1890s Arrol Johnston's sturdy and effective dogcarts had a level of reliability unusual at the time, and Alexander Govan's Argyll Motor Company in Alexandria had the largest European motor-car plant when it was completed in 1906. The 1907 Argyll is a typical product of this short-lived concern (fig. 7.14). Albion built motor cars in its early days, but by the First World War the company was concentrating on commercial vehicles, earning a first-class reputation that has carried the Scotstoun works into the 1990s as a Leyland-DAF axle assembly plant. The government-sponsored Linwood car plant during its troubled existence did not produce indigenously-designed vehicles.

Aero-engines were built in large numbers in Scotland during both World Wars. During the First World War the engines constructed were partly of Scottish design. The build-up to the Second World War brought Rolls Royce to Scotland, and jet engine manufacture and repair followed as large piston engines waned in popularity. An aero-engine today is not designed to be judged by aesthetic standards, but in its refinement of engineering and sophisticated use of high-technology materials it is almost unrivalled. In contrast, the modern civil aircraft is closer to the ocean liner in its design philosophy. Scotland's history of aircraft design is, like that of motor car manufacture, patchy. Although William Beardmore & Co. Ltd during and after the First World War tried to produce distinctive, innovative designs, they found few customers. In the 1950s the Prestwick Pioneer, product of Scottish Aviation, was one of the first Short Take Off and Landing (STOL) aircraft, and had some commercial success but in recent years the Handley Page Jetstream aircraft, now in series production at Prestwick, has been ordered in large numbers. Subsequent modifications have kept the design up to date in a way characteristic of much of the history of engineering in Scotland (fig. 7.15).

Fig. 7.14 Argyll motor car, 1907
Argyll Motor Co. Ltd; l. 360 cm (141$\frac{3}{4}$ in), w. 156 cm (61$\frac{3}{8}$ in), h. 165 cm (65$\frac{3}{8}$ in)
Glasgow Museums & Art Galleries, Museum of Transport

Fig. 7.15 Jetstream aircraft Super 31 and 41, artist's
impression, 1980s
British Aerospace plc
British Aerospace, Prestwick, Ayrshire

Other distinctively Scottish contributions to industrial design

Three almost symbolic artefacts suggest the breadth of
Scotland's contribution to industrial design. The first
is the malt whisky pot-still. Pot-stills are characteristic
of brandy and rum production, and no doubt of other
spirit distillations, but Scotch whisky has become such
a world-renowned industry, and one in which the
production process has been so much glamorized that
the whisky still has connotations all its own. Early stills
were riveted; today they are welded. Originally all
were coal-fired; now they are generally gas or steam
heated. There is little standardization, as befits an indus-
try producing whiskies with a wide variety of dis-
tinctive flavours. The whisky still, however, is an object
combining to a high degree aesthetic appeal and prac-
tical utility: its graceful forms influence directly the
flavours of the whiskies produced. Attempts to increase

its effectiveness by simplifying and brutalizing its
design have in general been abandoned. The 'cult
object' aspect of the still is winning.

Second, the fishing boat: Scotland's wooden herring
drifters, developed towards the end of the nineteenth
century from smaller craft, were probably the most
numerous and effective vessels of their kind ever built.
Herring caught by the fleet, cured in Scotland or else-
where, fed much of northern Europe. The boats
produced were simple, robust (they had to be) and
with a beauty almost solely derived from fitness for
purpose (fig. 7.16). Their descendants are beamy, trans-
om-sterned vessels, still being built of wood, and still
highly efficient fishing machines. Now equipped with
engines, not sails, and with sophisticated fish-finding
and navigating equipment, they continue to embody
the strength and ability to cope with mountainous seas
of their predecessors.

Third, the bicycle: Scotland has had a specialist
bicycle making industry, but never a major mass-pro-
duction plant. It was, however, Kirkpatrick MacMil-
lan, a Dumfriesshire blacksmith, who made the first
known bicycle. A clumsy thing it is, but MacMillan

Fig. 7.16 'Fife' herring drifter, *Morning Star,* 1904 (model)
Designer: Gordon, Rosehearty, Aberdeenshire; Maker: D.C.
 Peebles, Cellardyke; Scale 1:24
Trustees of the National Museums of Scotland, Edinburgh

Fig. 7.17 Copy of first bicycle, 1842
Gavin Dalzell, Lesmahagow, after Kirkpatrick MacMillan's
 1840 precedent; wood and iron, $217 \times 60 \times 112$ cm
 ($85\frac{7}{16} \times 23\frac{5}{8} \times 44$ in)
Glasgow Museums & Art Galleries, Museum of Transport

took the toy hobby horse, and began the process of converting it into the world's most efficient means of manpowered locomotion. The replica in Glasgow's Transport Museum (fig. 7.17) is of the oldest bicycle in the world, made using basic hand woodworking and ironworking techniques. It represents a simple, direct, thoughtful and original approach to a problem.

Conclusion

This attitude is an effective way of describing the evolution of industrial design in Scotland since the eighteenth century. Discounting international influences, in part at least, one can distinguish in Scotland a coherent, balanced approach to industrial design. This is born out of the rational side of the Scottish character, most clearly and publicly seen in the late eighteenth-century 'Age of Enlightenment', but a persistent feature of Scottish art, architecture and literature, as well as of industry, and embodied in Scottish religion. A certain morality – a sense of rightness – runs through everything mentioned in this essay. In the light castings and textiles sections, the morality is aspiration to the best in design and quality, a recognition that only the best is good enough for a particular market, together with a philosophical attachment to the idea of 'the good'.

In the case of the heavy industries the aspiration to

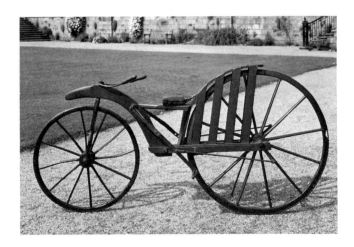

the best is coupled with the exigences of operational requirements. The object, be it ship, component of ship, locomotive or tool, has to work and work consistently and reliably, which introduces firmly the concept of fitness for purpose. Aspiring to the best and fitness for purpose are two vital components in first-class design. But a third, related factor is that of balance, of holding not at rest, but in tension, the parts of a design. At its best, Scottish design, in a wide range of fields and over a long time, has had that vital element turning the basic into the good and the good into the true, the enduring. When meretriciousness creeps in, remember this.

SIR WALTER SCOTT AND NINETEENTH-CENTURY PAINTING IN SCOTLAND

LINDSAY ERRINGTON

It was not until the late eighteenth century that literary and imaginative subjects began to emerge in Scottish painting alongside the mass of commissioned portraits and decorative pieces designed as parts of interior schemes for houses.

The catalogues of the first public exhibitions held in Edinburgh from 1808 to 1813, by the Associated Artists, show that those artists who wished to paint or draw imaginary scenes were looking for support to literary sources, especially to Shakespeare, and to the Scottish writers Robert Burns, James Thomson, author of the poems *The Seasons*, and James Beattie, author of *The Minstrel*. Significantly, in the very first exhibition there was also an illustration to Sir Walter Scott's recently published poem *The Lay of the Last Minstrel* and in the second to his poem *Marmion*. He had, as yet, published no novels, but in 1821, when exhibitions of the work of living artists were resumed in Edinburgh under the auspices of the Royal Institution, the first exhibition contained an illustration to Scott's second novel *Guy Mannering*.

National pride undoubtedly played a part in the artistic utilization of Scott's work. His treatment of Scottish history and daily life would have given his following of artists confidence in the intrinsic value of such subjects, whilst the wide circulation of his poems and novels meant that illustrations to these would be readily understood by the general public. Towards the end of the nineteenth century, when such close relations

between painting and literature were being called in question, and when the advanced artist preferred his picture to be estimated on its visual qualities alone, without reference to any text or story, a certain stigma began to attach itself to the illustrator of Scott. Far from benefiting painting, his example as a writer was now considered to have damaged it and to have encouraged painters off their proper visual course into a kind of bastard art that was neither painting nor literature.

Such reactions generally entail vast over-simplifications. The role Scott's example and writings played in the development of nineteenth-century Scottish painting is unfortunately far too complex to be covered in a single essay, more especially since he was personally acquainted with a number of important artists. One aspect, however, which can be shown to be false, is the prevalent belief that Scott invariably led and that the visual artists always followed obediently behind him like a troupe of dogs at heel.

If one attempts to characterize the complex interaction between painting and literature in Scotland at the beginning of the nineteenth century it is not as some might think, a parasitic, nor even a symbiotic one, but a synergetic relationship which was emerging. This relationship was dramatically expressed by Scott at the conclusion of his first novel, *Waverley*, in the descrip-

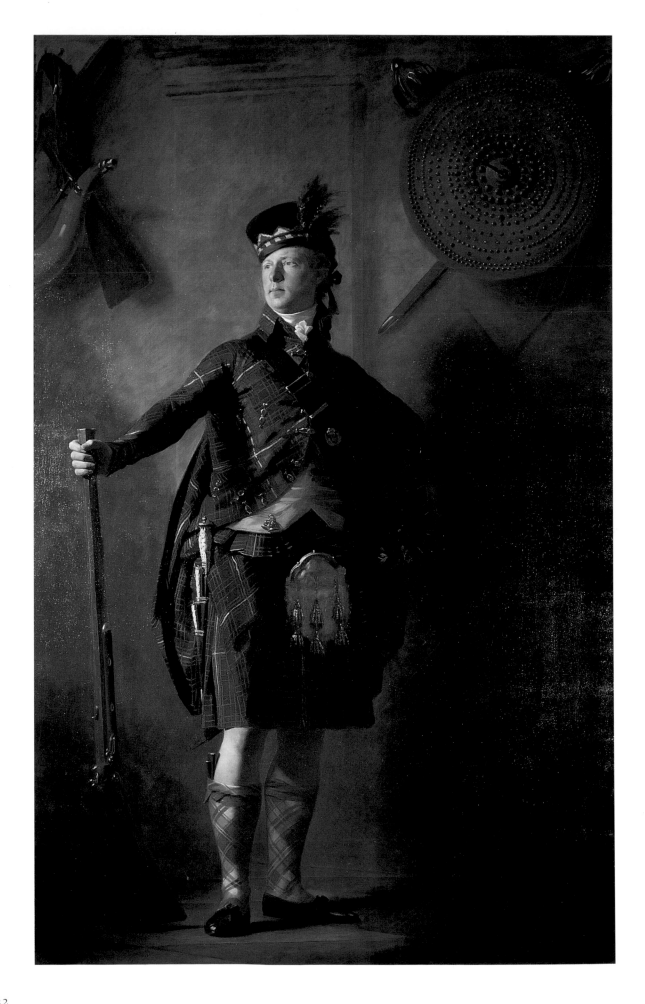

tion of an imaginary full-length, double portrait by a carefully un-named 'eminent London artist': 'A large and spirited painting, representing Fergus MacIvor and Waverley in their Highland dress; the scene a wild, rocky, and mountainous pass ... Raeburn himself', added Scott, '(whose Highland Chiefs do all but walk out of the canvas) could not have done more justice to the subject.'

By some freak of chance Sir Henry Raeburn has become so established in our minds now as the supreme specialist in tartan chieftainship that Scott's remark does not arrest the reader's attention as it should. In fact Raeburn did not often paint Highland chiefs, and even less often in tartan. His clientele was mainly drawn from the Edinburgh intelligentsia, wealthy merchants, the Lowland gentry, and various ranks of army officer. Scott's reference here is almost certainly to one specific picture which would, as exhibited – and probably painted – in 1812, have been still fresh in his mind in 1813 when after an interval of some years he resumed work on his interrupted novel (fig. 8.1). In this portrait of *Alastair Macdonell of Glengarry*, festooned in tartan, and bristling with weapons, Raeburn does indeed, by clever exploitation of pose and lighting, effectively project the sitter – or rather stander – out into the spectator's own space. It has long been asserted that the sitter, the eccentric, violent and anachronistically-minded chief, who deliberately modelled himself into a throwback to his more primitive feudal forbears, was the living original for Scott in delineating the fictitious character of Fergus MacIvor. This may indeed be true since the two men knew each other well, but it may also, and perhaps more interestingly, be true that it was Raeburn's 1812 depiction of Glengarry with all its romantic, military and historical resonances, that crystallized for the writer certain lineaments in his subject, and that his written compliment to Raeburn's art was intended as a record of and tribute to this influence.

Fig. 8.1 *Colonel Alastair Macdonell of Glengarry, c.* 1812
Henry Raeburn (1756–1823); oil on canvas, 241 × 150 cm
(95 × 59 in)
National Gallery of Scotland, Edinburgh

Fig. 8.2 *Sir Walter Scott,* 1822
Henry Raeburn (1756–1823); oil on canvas, 76.2 × 63.5 cm
(30 × 25 in)
Scottish National Portrait Gallery, Edinburgh

Much of Scott's writing has a strong pictorial character, a fact which was recognized instantly on the first appearance of *Waverley. The Scots Magazine*'s reviewer, for example, repeatedly resorted to the language of visual criticism when describing his reactions to the book, one of those he thought 'which undertake to *delineate* national manners ... the *picture*, however, is *drawn* with a masterly hand ... An opportunity is thus given to *paint*, not only what the Highlands were sixty years ago, but in some degree what all Europe was, at the distance of three centuries', and he called the account of Waverley's entrance to the village of Tully Veolan, a '*picture of still life*' (my italics throughout). Scott himself was convinced, according to Ballantyne, that 'the success of his book was to depend on the characters much more than upon the story'.

Raeburn also, beginning rather earlier than Scott, in the last three decades of the eighteenth century, and working on to overlap with Scott in the first two decades of the nineteenth, has been held to have succeeded in a similar task, the writing down of national manners and history through the human face and character. The already mentioned complexity of the interaction between painting and literature is apparent here, for if Scott, employing visual description and

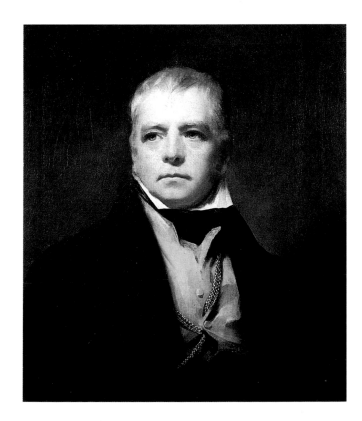

direct allusion to various artists by name, sought the assistance of painting in his novels, so also our view of Raeburn's *oeuvre* is strongly conditioned by our knowledge of contemporary literature and history.

'In the days before railways and the Disruption', the critic R. A. M. Stevenson boldly began in his posthumously published essay (1901) on Raeburn, 'Scotland was something else than a division of England.' 'Individuality', he continued, 'generally stamped a Scot as one who came from a country rich in men of character. Indeed character was widely appreciated throughout Scotland as the bed-mould of genius . . . Raeburn was organised to perceive character, and he acquired the art of showing its bodily signs with rare simplicity and energy. Scotland offered him a perfect glut of subjects.' Appraisals like this, combined with the fact that Raeburn had his own Gallery collection of his portraits of distinguished contemporaries, have served to make it seem as though he had done far more than simply issue a succession of separately commissioned likenesses in an efficient and business-like way. Retrospectively it began to look – especially after the major collecting together of Raeburn's portraits in the 1876 loan exhibition – as if the artist had, rather, compiled a purposeful, cumulative and comprehensive study of the whole upper social order in Scotland during a period of nearly half a century, concluding neatly enough, with a portrait of Scott himself (fig. 8.2). Lord Cockburn's published *Memorials* cover much the same period and include some of the same personalities as sat to Raeburn. These *Memorials* catch Scottish society in a phase of rapid change when the earlier personalities, reviewed by memory, had assumed a heroic, or at least Titanic character – for some of these personalities were grotesque.

In effect, Raeburn was converted from a portraitist, straightforwardly working to commission, into a thoughtful and critical observer of society, a historical painter, who provides us with the essence and the key figures of his age, together with a penetrating analysis of Scottish character. The nineteenth-century will to view him like this, as somehow working towards a controlled end which would summarize Scotland and its society, may not now tell us much about Raeburn, but it provides an illuminating commentary upon the purposes and preoccupations of many later nineteenth-century Scottish artists.

In Scott's third novel, *The Antiquary*, the most relaxed and possibly the most enjoyable of them all, the concern with character and the manners of a period is paramount. The novel deals with the passage of time, with the relation between past and present, with the way people perceive the more remote past as well as their own personal pasts, and with why and how their memories contain the things they do. It is, to pursue the pictorial comparison, painted like a landscape rather than written like a book – a well populated landscape, which ordinary people, their characters, strengths and foibles depicted with consuming interest, cross and re-cross on their daily business, meeting, parting, re-encountering, their contacts together cumulatively revealing ever more aspects to their personalities. In this book texture is more important than linear sequence, contrast and comparison matter more than the development of a plot. Scott seems to have become aware when writing it of two conflicting states of mind, two opposed perceptions of time – the experience of enjoying the examination of life in all its ramifications as it is lived, and the experience of pursuing an onward account where one event supports the next as in a ladder. In his preface, he disingenuously proclaimed a preference for the first mode. 'I have been more solicitous to describe manners minutely than to arrange in any case an artificial and combined narrative', he claimed, for he had found that the two could not be united.

This essentially pictorial approach is maintained throughout the book by set pieces of description and occasional direct pictorial allusions. A close relationship is established also between people and the landscape they occupy, both being seen as holders of memory. The fragmented mind of the oldest person, the terrifying Elspeth of the Craigburnfoot, with her scraps of ballads on ancient battles, her guilty memories of her youth, and her obliviousness towards events in the immediate present, finds a direct counterpart in the surrounding landscape: 'I wad say . . . that auld Elspeth's like some of the ancient ruined strengths and castles that ane sees amang the hills. There are mony parts of her mind that appear, as I may say, laid waste and decayed, but then there's parts that look the steever, and the stronger, and the grander, because they are rising just like to fragments among the ruins o' the rest. She's an awful woman.' Such an analogy between

the ageing mind and a ruined fortress, rests on the perception of the real ruined fortress in the actual landscape as a concrete embodiment of selectively decayed communal memory, and it might serve as the motto for much Scottish landscape painting in the nineteenth century, and in particular for the work of that expert in decaying castles, and friend of Scott, the Rev. John Thomson of Duddingston (fig. 8.3).

Scott's importance for the national school of painting throughout the century can scarcely be overestimated, and perhaps the least debt painting owed him is also the most obvious – he provided the artist with innumerable subjects. More important by far are the alternative modes of perception of time and character which he offered the painter, and it is possible to see most nineteenth-century Scottish artists, whether they practised history painting, genre painting, or landscape as, in some measure, working out Scott's vein of thought in another medium.

The individual searching for a convincing account or explanation of his own personality and its possible future development, might take the advice of a fortune-teller who would scan the lines of character formed in his hand, or he might adopt a psycho-analytical approach and delve into his buried memories of events which had occurred in earliest childhood. The Scottish artist was faced, in his search for national personality and identity, with a similar choice, viz either the study of present human character, which might be assumed to be perennially recurrent or constant within a national group, or the evocation of what had at one particular time taken place in history. Although artists tended to range themselves into specialities, so that one associates William Allan, Thomas Duncan and David Scott with history (figs 8.4, 8.5 and 8.6), or David Wilkie, John Phillip and the brothers John and Thomas Faed with genre and character study, the pull of these opposing methods could be exerted on the work of a single artist. Wilkie is an excellent example. Until 1822 his paintings nearly all belonged to the category of genre, but the vigorous oil sketch for the painting of Knox preaching

Fig. 8.5 *The Martyrdom of John Brown of Priesthill,* 1844
Thomas Duncan (1807–45); oil on canvas, 132.1 × 208.3 cm (52 × 82 in)
Glasgow Art Gallery & Museum

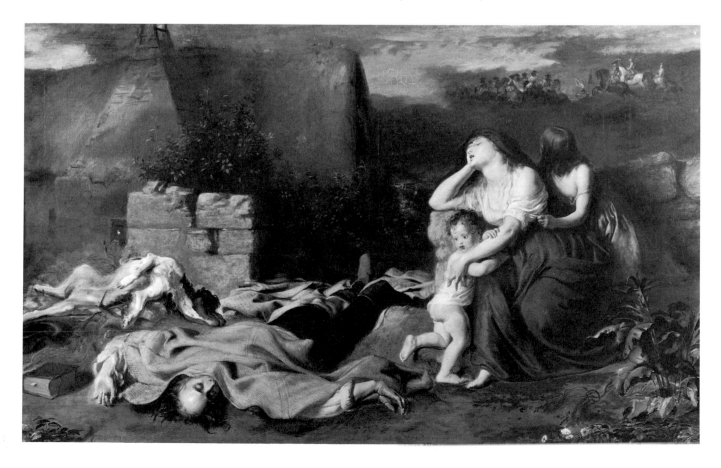

Fig. 8.3 *Fast Castle from
 Below, c.* 1824(?)
John Thomson (1778–1840);
 oil on canvas,
 76.2 × 105.4 cm
 $(30 \times 41\frac{1}{2}$ in)
National Gallery of
 Scotland, Edinburgh

Fig. 8.4 *The Murder of
 Rizzio,* 1833
William Allan (1782–1850);
 oil on panel,
 102.9 × 163 cm
 $(40\frac{1}{2} \times 64$ in)
National Gallery of
 Scotland, Edinburgh

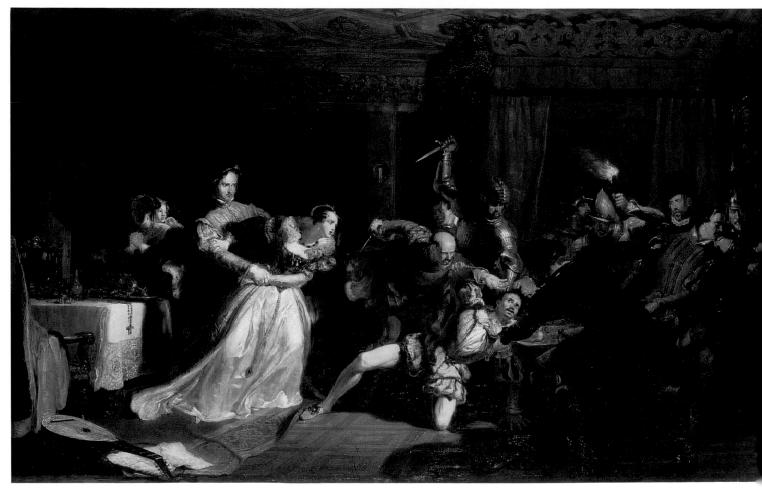

at St Andrews, executed in 1822, shows him stepping over the boundary to try something else (fig. 8.7).

Both his *Preaching of Knox* and his *Penny Wedding* (fig. 8.8) belong to a phase of his career when his stated declaration was that he wished to make his pictures more 'Scottish'. He seems, at this point, to have been highly receptive to influence from Scott, whose portrait he had painted in 1817 (fig. 8.9), and these two modes of apprehending time, through manners or through historical narrative could, of course, both have been discovered in the Waverley novels.

Fig. 8.6 *Sir William Wallace*, 1843
Central element of a triptych
David Scott (1806–49); oil on canvas, 101 × 78.1 cm
($39\frac{3}{4} \times 30\frac{3}{4}$ in)
Paisley Museums and Art Galleries, Renfrew District Council

Fig. 8.8 *The Penny Wedding*, 1818
David Wilkie (1785–1841); oil on panel, 64.4 × 95.6 cm
($25\frac{3}{8} \times 37\frac{5}{8}$ in)
The Royal Collection, London
Reproduced by Gracious Permission of Her Majesty the Queen

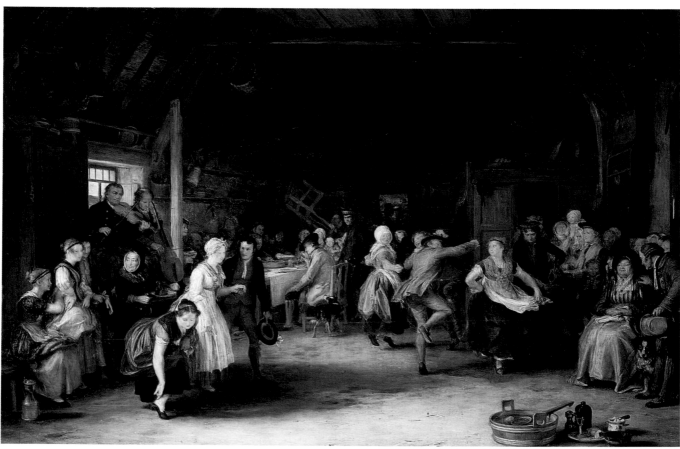

Fig. 8.7 *The Preaching of Knox before the Lords of Congregation 10 June 1559*, 1882 (sketch)
David Wilkie (1785–1841);
oil on panel,
49.5 × 62.2 cm
($19\frac{1}{2}$ × $24\frac{7}{16}$ in)
Petworth House, West Sussex
Photo: The National Trust Photographic Library

Whilst the single artist might waver between the choice of manners and of history, the categories themselves occasionally became confounded, so that what seems, in George Harvey's work, straight history, can turn out, as we shall shortly see, to be genre and manners, whilst an obvious genre scene like Wilkie's *Penny Wedding*, or its offspring, Phillip's *Presbyterian Catechising*, and *Baptism in Scotland* (fig. 8.10), are really history pictures – or are so at least insofar as costume is concerned.

Perplexed by the apparent evaporation and vanishing of a peculiar Scottishness that he believed had once characterized speech, dress, customs and behaviour, and threatened by the conviction that all these areas had become subject to English takeover bids, the artist retreated to the last period at which he was sure Scottish society had still preserved its uncontaminated uniqueness. This retreat tended to be to that period spanned by his own early childhood and the orally transmitted recollections of parents or grandparents. Scott's first two novels are located at spaced intervals within this zone, in, as he wrote, 'the age of our fathers ... [and] ... that of our own youth', and so too are Wilkie's *Penny Wedding* and Phillip's *Baptism*, whilst R. A. M. Stevenson, in his already quoted essay on Raeburn, located the key period correspondingly

further forward, in Raeburn's (and of course, Wilkie's) lifetime, 'before railways and the Disruption'. Inevitably the individual regarded change as having come, with a rush, in his own lifetime. Further back, like distant landscape seen from a moving vehicle, everything looked more stable, and Scottish culture and manners, especially rural culture and manners, could seem to have existed forever in a static haven outside the warring tide of history. History is change, causation, development, and in the *Preaching of Knox* Wilkie deliberately selected the moment most pregnant with national change, whereas in *The Penny Wedding* he showed what he supposed had always been done.

Phillip's portrayals of Scottish religious and folk life were created with a southern public in mind, and were first exhibited in London. Like Wilkie's *Penny Wedding* they are set in the previous century, and they share its apparently nostalgic sentiment. They also exude a certain coyness and whimsy, a slightly excessive charm, as if Phillip were all too consciously purveying what an English viewer expected of Scotland. In this they contrast with the more austere and heavy-handed reconstructions of Covenanting scenes by George Harvey, which were not sent to London, but were reserved for visitors to the Royal Scottish Academy.

The extraordinary conviction and sincerity of Har-

Fig. 8.9 *The Abbotsford Family* (Group portrait with Sir
 Walter Scott), 1817
David Wilkie (1785–1841); oil on panel, 28 × 37.6 cm
 (11 × 14$\frac{13}{16}$ in)
Scottish National Portrait Gallery, Edinburgh

vey's Covenanting scenes (fig. 8.11) goes far to redeem
what crudities of draughtsmanship and arrangement
they contain. Indeed a certain quality of naivety, almost
at times of ineptitude, which stamps them, becomes,
in this context, a positive virtue. It is as if the artist was
so concerned with the truth, with the plain tale, and
the harsh fact, that aesthetics could only interfere with
his messsage. His truth is, curiously enough – given that
these are historical scenes – not the truth of historical
accuracy, but of physiognomy. His costumes are a fair
attempt at rendering seventeenth-century dress, but it
is his faces, raw-boned, weathered, lined, the faces of
shepherds, farmers and hillmen in any age, the faces
undoubtedly of individual models discovered by
Harvey in his own day, that stick in the viewer's
memory. From childhood to old age, from hind to

laird, the microcosm of a whole society is there, gath-
ered by a national crisis, in an uncompromising land-
scape, and staunch to some unrelenting ideal of national
behaviour. Out of the historical event, Harvey has
conjured, most unexpectedly, the genre study of
manners and character – a study moreover with a
peculiar applicability to his own day and the debates
which were to lead to the great 1843 crisis of the
Disruption in the Scottish Church. His picture thus
records not merely what was once in the seventeenth
century but what still is in the nineteenth, for the artist
and his public, the essence of Scottish character.

Whereas the painters of the earlier nineteenth
century – especially those such as Wilkie, William
Allan and Thomson of Duddingston, who had all
known Scott personally – tended to work in a similar
spirit to that of the author but to avoid illustrating any
historical episodes actually described by Scott, many
of the next generation of artists regarded Scott's poems
and novels as a vast pool of illustratable texts. James
Drummond's *Porteous Mob* (fig. 8.12) is an extremely
accurate and specific depiction of the account Scott

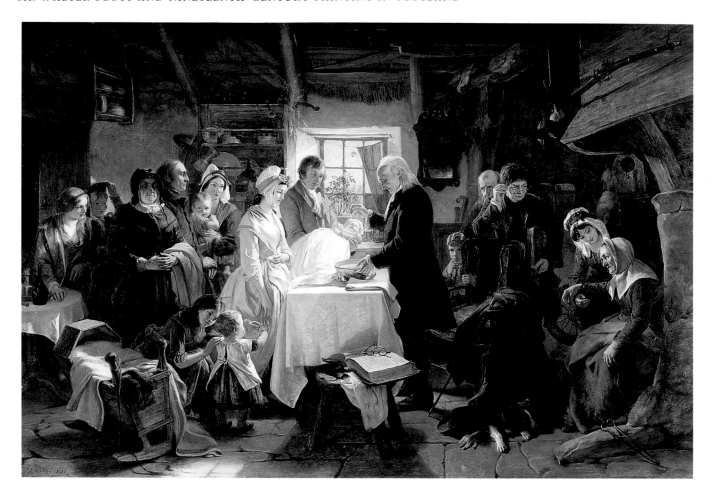

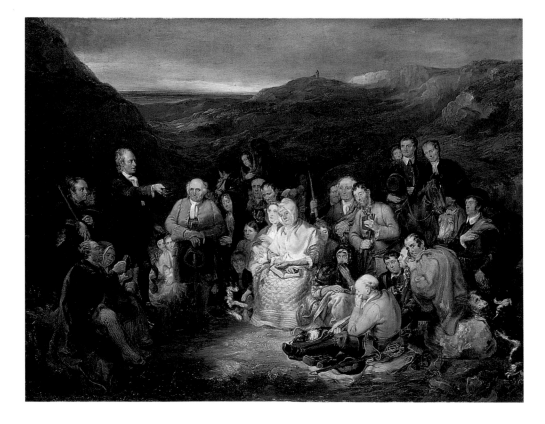

Fig. 8.10 *Baptism in Scotland,* 1850
John Phillip (1817–67); oil on canvas, 105 × 145 cm (41 × 61 in)
Aberdeen Art Gallery & Museums, Aberdeen City Arts Department

Fig. 8.11 *The Covenanters' Preaching, c.* 1830
George Harvey (1806–76); oil on panel, 82.6 × 106.7 cm (32½ × 42 in)
Glasgow Art Gallery & Museum

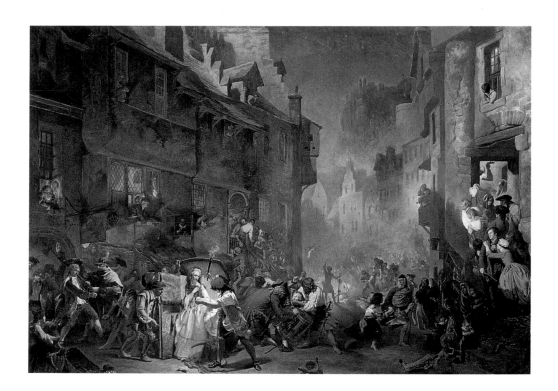

Fig. 8.12 *The Porteous Mob, 1855*
James Drummond (1816–77); oil on canvas, 112 × 143 cm (44 × 60 in)
National Gallery of Scotland, Edinburgh

Fig. 8.14 *The Queen of the Swords* (study), *c.* 1876–77
William Quiller Orchardson (1832–1910); oil on canvas, 47.3 × 80.6 cm (18⅝ × 31¾ in)
National Gallery of Scotland, Edinburgh

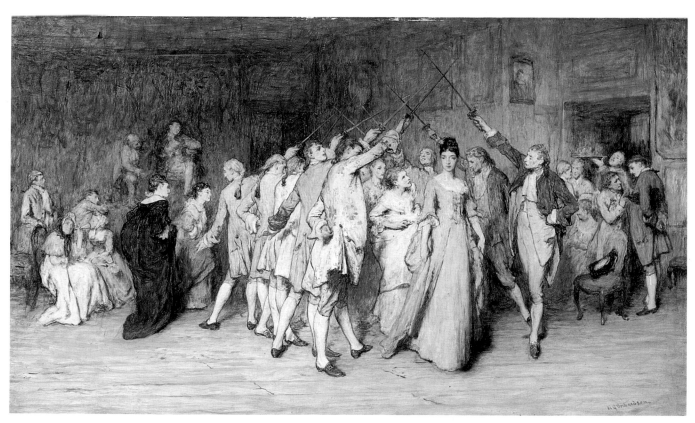

gives of the lynching of Captain Porteous, near the beginning of *Heart of Midlothian*. Such an account was well suited to Drummond's own antiquarian tastes, providing him with an opportunity to make a visual reconstruction of a vanished, eighteenth-century Edinburgh. Others, in particular Robert Scott Lauder, looked to Scott for the kind of chivalric glamour and romance which seemed lacking in the contemporary world. On the whole it was Scott's medievalizing novels which Lauder preferred to illustrate, and Scott's heroines whom he preferred to the heroes. A dream-like quality pervades his *Gow Chrom and Glee Maiden* (fig. 8.13), as they glide along in the twilight, but Scott's *Fair Maid of Perth*, which provides the excuse

for this attractive dream, is a much tougher novel than Lauder would have us suppose. The polarities of violence and pacifism, courage and cowardice, male and female moral values, around which Scott arranged his story, are indeed all too familiar to the twentieth-century film-goer from watching *High Noon*.

Lauder's taste for colour, for texture, for the handling of paint and for beauty of arrangement, were transmitted to his pupils, John Pettie, William Quiller

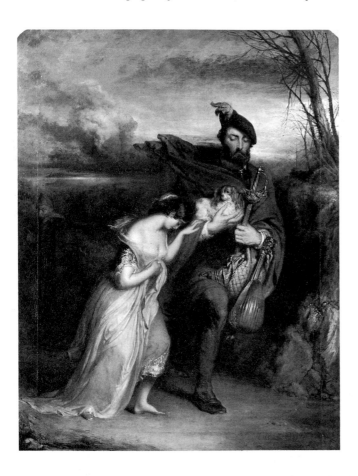

Fig. 8.13 *The Gow Chrom reluctantly conducting the Glee Maiden to a place of safety*, 1846
Robert Scott Lauder (1803–69); oil on canvas, 111.2 × 86 cm $(43\frac{3}{4} \times 33\frac{7}{8}$ in)
National Gallery of Scotland, Edinburgh

Orchardson, George Paul Chalmers and William McTaggart. Like their master, Pettie and Orchardson continued – for a time at least – to illustrate Scott. Yet what is one to make of Orchardson's *The Queen of the Swords* (fig. 8.14) or Pettie's episode from *Peveril of the Peak* (fig. 8.15)? The first is not a convinced or convincing portrait of old Scottish manners and charac-

ter, nor does the second reconstruct anything but the most trivial of historical events, significant and alarming to no one but a pair of children. Both pictures leave one with the impression that the artists had resorted to Scott almost out of convention, and had found in his stories handy, but quite unimportant, props for their private tastes in colour and design.

The perception of national history, the exploration of national character, and the encouragement of an intimate relationship between painting and literature, which were the three powerful mainstays of Scottish art during two thirds of the nineteenth century, began to buckle and collapse in the work of Lauder's pupils, as confidence in the validity of these supports was eroded. The impact of Continental ideas which derided national distinctions in painting, and placed abstract aesthetic qualities of colour, tone, or brushwork above narration and character description, was one of the main erosive forces. George Paul Chalmers' agonies with his unfinished *Legend* (fig. 8.16), commenced in 1864, repainted, set aside, started again and again scraped out so often, finally passing to the Scottish National Gallery on his sudden death, still unresolved and inconclusive, still an attempt to seize some incommunicable quality, were of course mainly personal difficulties peculiar to Chalmers' self-doubting and melancholic nature. Nevertheless, over and above this, it is possible from a present day vantage point to understand that the artist was not only the victim of his own temperament but, more cruelly, the victim of the altering artistic aspirations of his period, which rendered the various components of this picture incompatible with each other. A simple scene of rural genre in a duskily picturesque cottage with an old crone and a circle of listening, apprehensive children – a late descendant in fact of Wilkie's *Blind Fiddler* – should not have defeated an artist of Chalmers' abilities, especially since Scottish painters had been showing how this should be done for over half a century. Indeed, as far as that goes Chalmers was not defeated. His most fully realized and finished figure, that of the old woman, expressively poised to make a narrative point, seems to require no amendment, and the psychological tension between herself and her listeners is well established. What was it then that did defeat Chalmers? His letters on the subject of this and other paintings, and his random remarks on art, suggest the pursuit of some

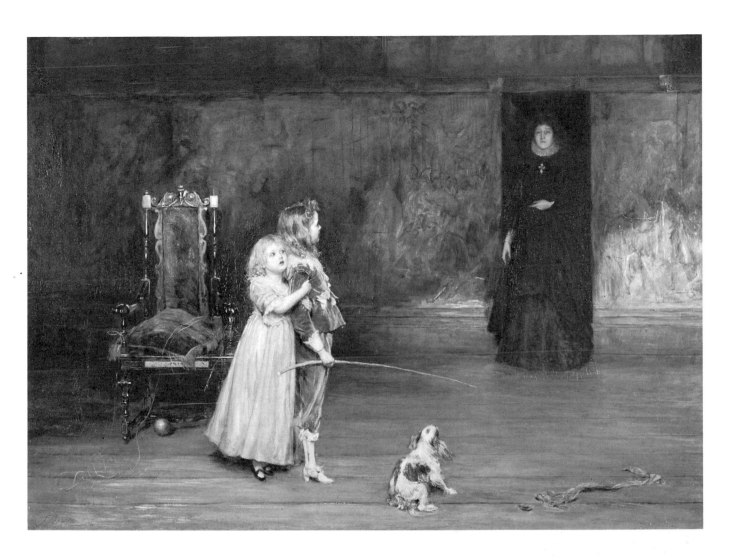

Fig. 8.15 Scene from
 Scott's *Peveril of the Peak*,
John Pettie (1839–93); oil on
 canvas, 97 × 129.5 cm
 (38⅛ × 51 in)
Dundee Art Galleries and
 Museums (Orchar
 Collection)

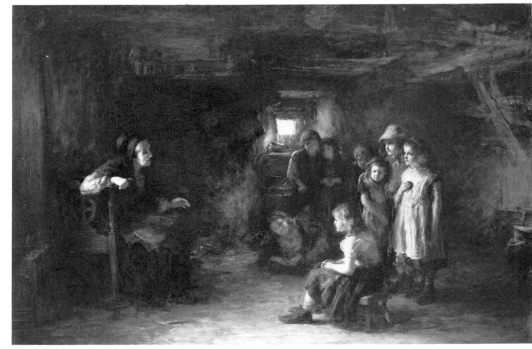

Fig. 8.16 *The Legend*,
 1864–78 (unfinished)
George Paul Chalmers
 (1833–78); oil on canvas,
 102.9 × 154.3 cm
 (40½ × 60¾ in)
National Gallery of
 Scotland, Edinburgh

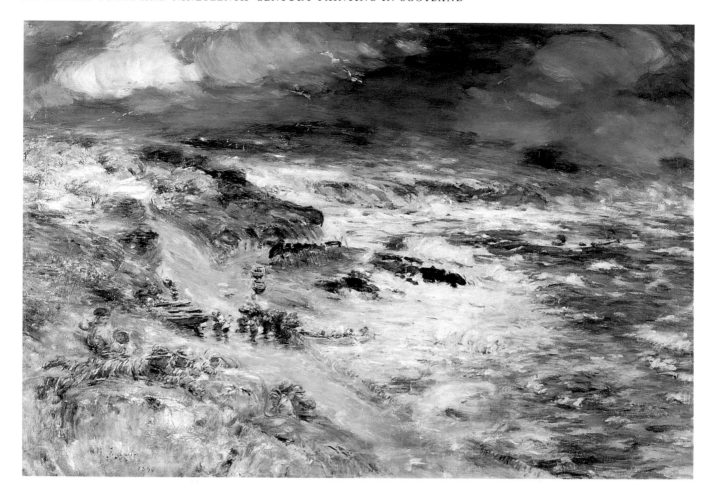

Fig. 8.17 *The Storm*, 1890
William McTaggart (1835–1910); oil on canvas, 121.9 × 183 cm
(48 × 72 in)
National Gallery of Scotland, Edinburgh

intangible quality of emotion arising from the treatment of colour, of atmosphere and the fall of light, and perhaps from the artist's very touch on the canvas. It is evident that he wanted his picture to be artistically significant to a degree that his insignificant little genre subject could not be in its own right.

In a work such as McTaggart's *The Storm* (fig. 8.17), the disintegration of the tradition may at first appear to have been fully accomplished. Faced by this assault on his senses of storm-lashed paint which is also a storm-lashed sea, the viewer may snatch hopefully at comparisons with Impressionism, or propound wild theories of an anticipation of Abstract Expressionism. Yet all the time, a narrative, both epic and homely, local and national, is being laid out for his reading as precisely as it had been by Wilkie, eighty years before.

It is one of McTaggart's great strengths – a strength which twentieth-century critics have often miscounted as a weakness – that, unlike Chalmers, he found no intrinsic conflict between his painterly and narrative purposes. In his *Storm* a story, operating in time, with a beginning, a middle and a potential end, the story of a small fishing community turning out from their cottages to launch a rescue boat and line to aid a fishing vessel in distress, can be picked out bit by bit, treated in surprisingly delicate detail. One notes, for example, the telescope in the hand of one of the helpless onlookers, the women's skirts and shawls, hurtling round their bodies in the force of the wind, even the thin line, trailing from the prow of the rescue boat. These minutiae do not diminish the force or majesty of *The Storm* as a whole or belittle its physical power but give it, by their different scale, and the consequent abrupt visual and mental adjustment required from the viewer, another dimension and a human meaning. This picture, painted at the beginning of the decade in which the artist was also to produce his epics of Celtic cultural

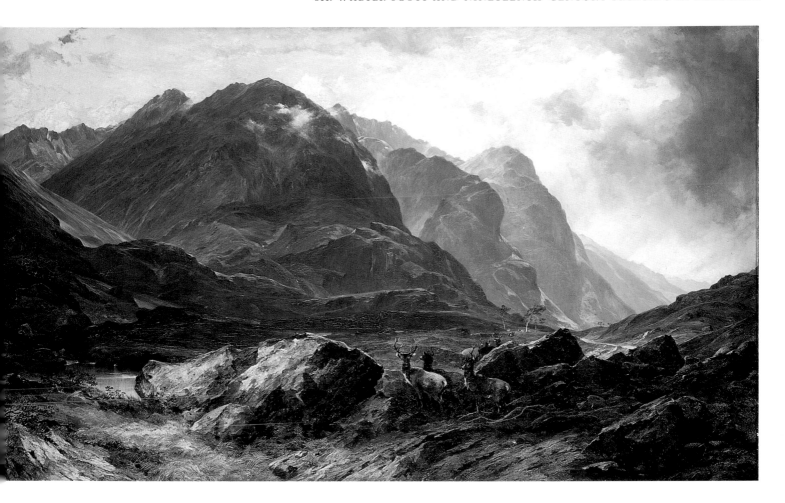

Fig. 8.18 *Glencoe*, 1864
Horatio McCulloch (1805–67); oil on canvas, 112 × 183.3 cm
 (44 × 72 in)
Glasgow Art Gallery & Museum

flowering and decay – the *St Columba* and *Emigrants* – is surely both a historical painting and a description of manners, but of a new kind.

McTaggart himself, in an interview given five years before his death, seems to have implied that he had deliberately rejected the romanticism of such earlier landscape painters as McCulloch, who had followed Scott in his depiction of the Highlands (fig. 8.18). McTaggart's rejection was, he claimed, made in favour of humanity – 'humanity's the thing'. Yet this rejected view, after all, is only a partial view of Scott, who in his novel of Scottish manners, *The Antiquary*, had made one of his most dramatic descriptive set pieces out of an account of a life and death struggle with a storm at sea, and one of his most poignant descriptive pieces out of the account of the funeral of a young fisherman

drowned at sea after his boat had been swamped and overturned. This perpetual battle against the elements, accompanied by perpetual risk, was seen by Scott as shaping the whole character and culture of the fishing community. 'She's but a rickle o' auld rotten deals nailed thegither, and warped wi' the wind and the sea' says the bereaved father, of the fatal boat, 'and I am a dour carle, battered by foul weather at sea and land till I am maist as senseless as hersell. She maun be mended though again the morning tide – that's a thing o' necessity.' McTaggart's *Storm* has, as a portrayal of a heroic community linked by shared danger necessarily encountered in a harsh environment, much more in common with Harvey's *Covenanters* than the casual viewer might ever have guessed, and a closer affinity with Scott's view of human life in *The Antiquary* than the artist himself seems to have been prepared even to admit.

How many Swallows make a Summer? Art and Design in Glasgow in 1900

ROGER BILLCLIFFE

And at this end of the nineteenth century, in the midst of the busiest, noisiest, smokiest cities, that with its like fellows make up the sum-total of the greatness of Britain's commercial position, there is a movement existing, and a compelling force behind it . . . which . . . may yet, perhaps, put Glasgow on the Clyde into the hands of the future historians of Art, on much the same grounds as those on which Bruges, Venice and Amsterdam find themselves in the book of the life of the world.

Brave words, written by Francis Newbery in 1897 for an introduction to a book entitled *The Glasgow School of Painting*, which chronicled the work of about twenty Glasgow painters whose rise to European fame had outstretched the capacity of their artistic birthplace to accommodate, or fête them. Newbery was basing his prophecy not just on the work of the so-called Glasgow Boys but also on the knowledge that there was in the city yet another group of young painters, architects and designers who would build on the Boys' international reputation. He must have realized that this group, centred around the young Charles Rennie Mackintosh, was going to be of importance not just in a national, Scottish sense, but as leading players in a scenario which was to encompass both sides of the Atlantic. Newbery was right in his prediction; but he was also wrong, because as a relative newcomer to the city he had failed to realize that Glasgow as a city, and Glaswegians, whether as private individuals or as civic dignitaries, were not yet ready as patrons of the arts to claim a

place for Glasgow among the city-states listed in his prologue.

By the time Newbery's words were published, most of the Glasgow Boys had left the city, lured by the respect, acclaim and commissions that London (and even Edinburgh) was able and accustomed to confer on artists. The early criticisms of Mackintosh's work, which were later to grow in volume and vituperation and contribute to the acute depression which forced him to leave Glasgow in 1913, had already been voiced by 1897. After the public disquiet heard on completion of the first phase of the Glasgow School of Art in 1899 Newbery would have seen that history was about to repeat itself and that Mackintosh, too, would be forced to leave the city. Without Mackintosh, and the intellectual and creative force that he represented, the Glasgow Style accelerated its artistic demise, following the path of fashion-led commercial diktat. When popular demand for works in the 'artistic' or 'quaint' style tailed off about 1914, the Glasgow Style died. Alongside it the art dealers' galleries in Glasgow were also closing and The Royal Glasgow Institute of the Fine Arts (the city's largest annual open exhibition and a venue for the more avant-garde Scottish painters in the 1880s) was becoming the home of the academic in art, just as all such mixed exhibitions across the country, from the Royal Academy downwards, were taken over by the unadventurous and the prosaic. Even the successors of Alexander Reid, doyen of Glasgow

dealers who had shared lodgings with Van Gogh in Paris and introduced the French Impressionists to Glasgow in the 1890s, were forced to close his Glasgow shop, La Société des Beaux Arts, and move to London. Despite having clients like William Burrell and William McInnes, just as Mackintosh had such loyal patrons as Catherine Cranston, Fra Newbery and Walter Blackie, Reid discovered that ultimately, in Glasgow, two (or three or four) swallows do not make a summer.

Conditions like these had acted as a spur to the young Glasgow Boys at the beginning of the 1880s. They resented that the visual arts were dominated by the cliques which controlled the Royal Scottish Academy in Edinburgh, effectively barring painters who lived in Glasgow from membership of the Academy, and, as a result, from the rewards of being an accepted and successful artist in Scotland. In Glasgow their entry to The Glasgow Art Club was similarly restricted; only on the walls of the Glasgow Institute, where the Council contained a proportion of more open-minded lay members, did they find any welcome. Although few of them had the private means to free themselves from the necessity of selling their paintings for a living they were sufficiently principled not to compromise themselves by producing the kind of trite, sentimental pictures that made a comfortable living for most Glasgow painters of the day. The Boys were ambitious and keen to experiment with new forms of painting; having seen in the annual exhibitions of the Glasgow Institute works by J. F. Millet and his fellow Barbizon painters, they were determined to develop further this group's canon of rustic realism.

In France there were many young painters who had been brought up, like the Boys, in an academic tradition but some were aware of the recent discoveries made by Monet and the Impressionists. One was Jules Bastien-Lepage, a prodigiously talented young man who narrowly failed to win the Prix de Rome and who then went off to his native village of Damvillers, to become the village painter. Just as a village had its farrier, its carter or its grocer, Lepage determined that it should have its painter, and he set out to record the daily lives of his fellow villagers. With deft handling, an emphasis on finish and a very particular quality of light, Lepage produced a blend of academic painting and some of the subject matter of Impressionism. His were not, however, paintings which were concerned with the moment, with the fleeting effects of light, but more with the enduring, almost timeless qualities of village life. The paintings were dubbed 'naturalist', perhaps to distinguish them from the more socially aware 'realist' paintings of the period. Lepage and many of his followers were not wanting to make social statements in these paintings; their intention was to record aspects of life both in the village and the city, presenting them as bald statements of fact.

The Glasgow Boys never worked together as a single group and their origins were in two or three discrete friendships. James Guthrie, E. A. Walton and Joseph Crawhall began to create their own version of naturalism while painting in Crowland in Lincolnshire in 1882. These pictures differ from those of Lepage in their obvious reaction to the value of sunlight. Guthrie's *To Pastures New* (fig. 9.1) has none of the consistent and overall low-key light of Lepage's paintings; there are distinct shadows, bright colours and, above all, a sense of movement in the composition which is rarely seen in the rural subjects which Lepage painted in the early 1880s. Painted in Cockburnspath, Berwickshire, in 1884–5, *Schoolmates* (Ghent, Musée des Beaux Arts) repeats this movement of figures across the canvas, but not the unusual device of having the children walk off the edge of the canvas, as do the geese in *To Pastures New*. Guthrie had decided to follow the example set by Lepage and settled in Cockburnspath in 1883. Unlike Walton, Crawhall, George Henry and Arthur Melville, who joined him during the summer months, Guthrie remained in the village throughout the winter, adopting the role of the village painter like his mentor. Only in the winter paintings, such as *A Hind's Daughter* (fig. 9.2), does Guthrie adopt the palette of Lepage, but he retains a distinctly Scottish character in his handling of the paint, which can be traced back through his first teachers, John Pettie and W. Q. Orchardson, to the Trustees Academy under Scott Lauder. Despite the 'Frenchness' of the subject matter, in the use of solid pigment, clear colour and the fluid manipulation of the paint these are very much Scottish paintings.

James Paterson and W. Y. Macgregor formed a second group who began to challenge the artistic establishment in Scotland at the end of the 1870s. Macgregor painted one of the few scenes of Glasgow urban life in 1883, a study of a costermonger counting her takings at

Fig. 9.1 *To Pastures New*, 1882–83
James Guthrie (1859–1930); oil on canvas, 90 × 150 cm
(35½ × 59 in)
Aberdeen Art Gallery & Museums, Aberdeen City Arts
Department

Fig. 9.2 *A Hind's Daughter*, 1883
James Guthrie (1859–1930); oil on canvas, 91.5 × 76.2 cm
(36 × 30 in)
National Gallery of Scotland, Edinburgh

her vegetable stall (fig. 9.3). Macgregor never exhibited the painting and radically altered it in 1884 by painting out the figure, presumably after seeing Guthrie's Crowland paintings. Macgregor, trained at the Slade and four or five years older than most of the other Boys, was seen as the 'father' of the school and he probably realized that the artistic leadership had passed to Guthrie, whose figurative painting was markedly superior to his own.

A third group of painters, including John Lavery, William Kennedy, Alexander Roche and Thomas Millie Dow, had chosen to leave Scotland at the beginning of the decade to study in Paris, where they also had encountered Lepage and his fellow Naturalist painters. The village of Grez-sur-Loing, on the edge of the Fontainebleau Forest – which was something of a Mecca for Irish, English and American painters in the 1870s and 1880s – became their Cockburnspath. Lavery, born in Belfast but brought up in Scotland, was the most advanced and painted a large picture of the banks of the Loing and its bridge in the village, *On the Loing: An Afternoon Chat* (1884, Belfast, Ulster Museum). The grey light of Lepage is much more evident in this painting than in Guthrie's naturalist work, although Kennedy, Roche and Millie Dow adopted a brighter palette for their French work.

In 1885 all of these artists came together at the annual exhibition of the Glasgow Institute where the critics and public realized that there was something vital about the painting of these young men. The Guthrie and Lavery camps had known each other before the latter set out for France but they were drawn closer together by the obvious affinities in their new work. Despite the critical attention it received, however, sales were few. Many critics, while tacitly acknowledging the apolitical nature of these paintings still found their choice of quotidian subject matter repellent. The art columns of the local magazines, such as *Quiz* and *The Bailie*, – although generally supportive – poked fun at the large 'but extremely well painted' boots worn by the children in these paintings and wondered whether anyone would want to hang them on their walls. The middle-class collectors who bought their pictures at the Institute took their cue from such criticism and any sales went to family and friends of the artists. Lavery, always the most ambitious and also financially dependent on selling his paintings, began to select more acceptable

Fig. 9.3 *The Vegetable Stall*, 1883–84
William York Macgregor (1855–1923); oil on canvas,
 105.5 × 150.5 cm (41½ × 59¼ in)
National Gallery of Scotland, Edinburgh

Fig. 9.4 *A Tennis Party*, 1885
John Lavery (1856–1941); oil on canvas, 77 × 183.5 cm
 (30¼ × 72¼ in)
Aberdeen Art Gallery & Museums, Aberdeen City Arts
 Department

Fig. 9.5 *The Herd Boy*, 1886
Edward Arthur Walton (1860–1922); watercolour,
 53.5 × 57 cm (21 × 22½ in)
Private Collection

subjects without compromising his adherence to the Naturalist style. The *Tennis Party* (fig. 9.4) was an immediate success. The middle classes at play was a valid modern subject; it also offered the challenge of portraiture, as most of the likely purchasers of such paintings might have expected to know some, at least, of the people depicted. Certainly, the spatial complexities of this painting, long and narrow in format, with its accurate depiction of movement across the court, set a high standard for the other painters to follow. For some months Walton and Guthrie maintained their commitment to rural subjects, with Walton now excelling in the watercolours that would bring a new freshness of light and colour to his work. *The Herd Boy* (fig. 9.5) and *A Day Dream* (fig. 9.6) marked his greatest achievement in rustic naturalism but he was soon to join Lavery in painting more acceptable pictures of middle-class life in the city. Guthrie, too, after a period in which he almost gave up painting for good, turned to similar subjects, usually in pastel, before devoting the rest of his life to portraiture, which

Fig. 9.6 *A Day Dream*, 1885
Edward Arthur Walton (1860–1922); oil on canvas,
 139.7 × 116.8 cm (55 × 46 in)
Courtesy Andrew McIntosh Patrick

had long been a British painter's most lucrative subject-matter.

As the emphasis on rustic naturalism diminished, some of the younger painters turned away from the large figurative studies at which Guthrie, Lavery and Walton had excelled. James Paterson had always been more interested in landscape, and paintings of the hills and rivers around his home in Moniaive became his equivalent of the Grez and Cockburnspath paintings of his colleagues (fig. 9.7). Two other members of the group, George Henry and E. A. Hornel began to move away from naturalism, placing a new emphasis on the symbolic power of colour in a group of paintings which have no parallel in Britain. While France had been the inspiration for much of the early Glasgow School painting, the Boys created something which can be located within a peculiarly Scottish approach to painting. A fondness for the liquidity of paint, a sense of craftsmanship in its manipulation and an awareness of the power of colour identifies the best of Scottish painting during the nineteenth century. Hornel and Henry were keenly aware of that tradition, especially in its interpretation by Arthur Melville, whose powerful watercolours of Spain, North Africa and the Middle East had such an effect on them.

Henry's *A Galloway Landscape* (fig. 9.8) is the most important work of this latter phase of Glasgow School painting. In its flattening of perspective, emphasis on two-dimensional pattern and symbolist use of colour it would seem to owe much to the work of Gauguin and his friends in Pont Aven. It is not clear, however, whether Henry would have known these paintings, although other Scottish artists, such as Charles Mackie (1862–1920), had links with the Breton painters. The influence of Japanese art, particularly the wood-block prints which began to enter Europe during the 1860s, also had a specific effect on Henry and Hornel. The latter began to dress his models in Japanese costume even before his visit to Japan with Henry in 1894. In *Summer* (fig. 9.9), Galloway geishas chase a butterfly through a Scottish copse, scarves and hair flying in a whirling composition where the defining lines between figurative and landscape details are softly blurred to heighten the emphasis on pattern and brushstroke.

In the early 1890s these paintings by Henry and Hornel had a marked effect on a group of young painters, architects and designers who were completing

their training at the Glasgow School of Art. James Herbert MacNair bought one of Hornel's Japonaise paintings, *The Brook* (Glasgow, Hunterian Art Gallery) and his close friend, Charles Rennie Mackintosh designed bedroom furniture for David Gauld, one of the Boys whose experience as a stained glass designer had brought a strong decorative element to paintings such as *St Agnes* (fig. 9.10). The *cloisonné* effect that flattened these paintings was similar to the linear style of watercolours that Mackintosh and MacNair made for a student magazine at the Glasgow School of Art. Along with Margaret and Frances Macdonald, who were also studying at the School, they came to be known as 'The Four'. This intriguing name reflected the mystery of their work, a mixture of personal iconography and traditional images, all handled in a spare, attenuated style reminiscent of the work of Aubrey Beardsley and of Jan Toorop whose work they had seen in early issues of *The Studio*. The Macdonald sisters (who were later to marry Mackintosh and MacNair) were even more extreme than the men in their stylization of natural forms. Introduced to a number of different media at the School of Art, they would often combine metalwork, silversmithing, embroidery or gesso relief with their paintings to produce images which, despite occasional immaturity of handling, were powerful emblems in this new symbolism (fig. 9.11). From the mid-1890s, the two men, both architects, translated their new ideas into designs for furniture, each piece reflecting more the traditions of vernacular furniture-making than elegant cabinet-making. With an overlay of metal strapwork in hinges, handles and escutcheons, the paintings were given a more three-dimensional form. Suddenly a whole group of young designers and illustrators was working in a similar vein, encouraged by their mentor, Fra Newbery, but generally ridiculed by society outside the School of Art.

While the Glasgow Boys followed European fashion, Mackintosh and his friends led a movement that was to sweep across the Continent and spread to America. Although based to some extent on the English Arts and Crafts movement the Glasgow Style is distinctly different. Symbolism, often obscure but apparently based on traditional Celtic imagery, played a much greater part in the work of these Glasgow designers. The pieces were usually executed by the designers

themselves, rather than given to artisan-craftsmen to produce, which was quite contrary to the practice of the English Arts and Crafts movement. This is particularly true of the metalwork, textiles and embroideries, but less true of furniture although MacNair is believed to have made some of his own cabinets and chairs. Mackintosh, in particular, was not a strong adherent of Arts and Crafts principles of quality or honesty of construction. In a lecture entitled 'Seemliness' he exhorted 'art workers' to put Art first in their pieces and to think and act as if they were artists rather than just craftsmen or designers, a philosphy in complete contrast to that of the Arts and Crafts movement. In his own work as a designer, his beliefs led him to develop a wholly original style which, unlike his architecture, owes little to precedent or historic convention. The interiors of his houses and tea rooms were conceived as total works of art, combining the fine and decorative arts to produce a unified whole that is without parallel in the work of his contemporaries. Hoffmann and Mackintosh's other Viennese friends and the Greene brothers in California were to produce interiors which Mackintosh did not equal in the quality of execution. In the breadth of imagination and lyrical use of space and ornament, however, his only equal is Frank Lloyd Wright, an exact contemporary who must have been aware of Mackintosh's achievements from journals and exhibition catalogues.

From the early interiors for the Eighth Exhibition of the Vienna Secession in 1900 to the completion of the remodelling of Catherine Cranston's house, Hous'hill, in 1904, Mackintosh worked at a frenetic pace. An obsessional eye for detail ensured that even the least significant element of a commission would be stamped by his creative genius. In these four years his style moved away from the early formalizations of natural shapes (fig. 9.12) to an inventive exploration of geometric patterns. For a while, in 1903–4, both existed together. The Hous'hill bookcase (fig. 9.13) was one of the last white-painted pieces Mackintosh designed; in its formal stylization of a tree, the dividers between the shelves representing the branches and the lozenges of glass the leaves, it is also one of the most successful of his 'organic' style. The Tree of Knowledge had fascinated Mackintosh since his student years and this is his most exciting and accomplished version. The chair from The Hill House (fig. 9.14), with its spare

Fig. 9.7 *Autumn, Glencairn*, 1887
James Paterson (1854–1932); oil on
 canvas, 101.5 × 127 cm
 (40 × 50 in)
National Gallery of Scotland,
 Edinburgh

Fig. 9.8 *A Galloway Landscape*,
 1889
George Henry (1859–1943); oil on
 canvas, 121.9 × 152.4 cm
 (48 × 60 in)
Glasgow Art Gallery & Museum

Fig. 9.9 *Summer*, 1891
E. A. Hornel (1864–1933); oil on canvas, 127 × 101.5 cm
 (50 × 40 in)
Board of Trustees of the National Museums and Galleries on
 Merseyside (Walker Art Gallery, Liverpool)

Fig. 9.10 *St Agnes*, 1889
David Gauld (1865–1936); oil on canvas, 61 × 35.5 cm
 (24 × 14 in)
Courtesy Andrew McIntosh Patrick

and exact lines, is the clearest example of Mackintosh's practice of form following function. For him, the function of this chair was not to be sat upon but to act as a visual counterpoint in a room where the walls were covered by a stencil of briar roses in red and green and the other furniture was predominantly white. Carefully positioned by Mackintosh within the room, the chairs can not be moved without destroying the composition immediately and making their design seem perverse and wayward.

Mackintosh's insistence on having his own way in such commissions must have cost him the kind of work which went to other contemporaries, such as George Walton and E. A. Taylor. While superficially similar to Mackintosh (figs 9.15 and 9.16), and much more imaginative than most commercial furniture-makers

of the period, neither Walton nor Taylor, nor any of the other dozen or so Glasgow Style designers such as George Logan (fig. 9.17) rivalled him in imagination. Usually made by trained cabinet-makers, their furniture combines traditional methods with the new forms and imagery and was more accessible to clients who were attracted by the concept of the modern designs but unable to give the level of commitment which Mackintosh's total designs needed from his patrons. Walton, in fact, was an innovative designer. Commissioned by Miss Cranston for her Tea Room interiors before she met Mackintosh, Walton went on to become chief designer for Kodak in Europe. Thus he spread the Glasgow Style across Europe in a more commercial manner than Mackintosh, whose work was seen mainly in exhibitions of modern design.

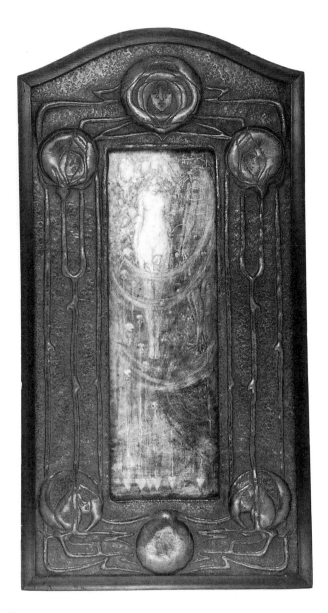

Fig. 9.11 *Autumn,* 1898
Frances Macdonald (1874–1921); pencil and watercolour on
 vellum, 45.4 × 14.7 cm (18 × 5¾ in); frame, beaten lead,
 70 × 37.7 cm (27½ × 14 in)
Glasgow Art Gallery & Museum

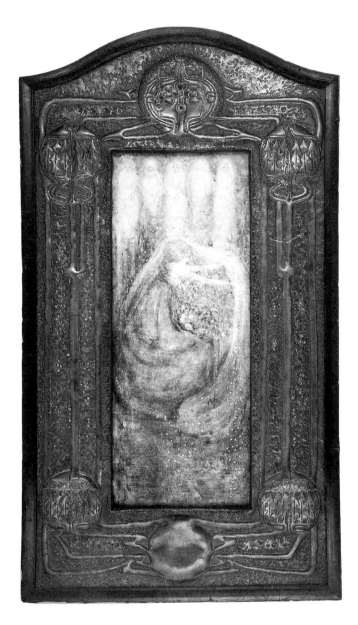

Fig. 9.11a *Winter,* 1898
Margaret Macdonald (1864–1933); pencil and watercolour on
 vellum, 47.2 × 19.6 cm (18½ × 7¾ in); frame, beaten lead,
 72.3 × 40 cm (28½ × 15¾ in)
Glasgow Art Gallery & Museum

The total commitment that Mackintosh demanded
from his clients naturally reduced the number of com-
missions he received. Furthermore, his relationship
with public taste in Glasgow was not a happy one.
From the early years of the 1890s his work had attracted
adverse criticism and even ridicule from the public. His
posters for the Glasgow Institute exhibitions and the
Scottish Musical Review were met with laughter and
abuse. Although his interiors for Miss Cranston drew
attention and undoubtedly increased business at her

Tea Rooms, her customers were content to be amused
by the exquisite spaces Mackintosh provided for them
rather than inspired to commission such rooms for
their own homes. His relations with more public clients
fared little better. The building of the Glasgow School
of Art, particularly in its later phase after 1906, was
fraught with argument with the Governors, primarily
over cost. Mackintosh had already brought in the first
phase of the School over budget, although this was not
entirely his fault, but by the time he was recalled to

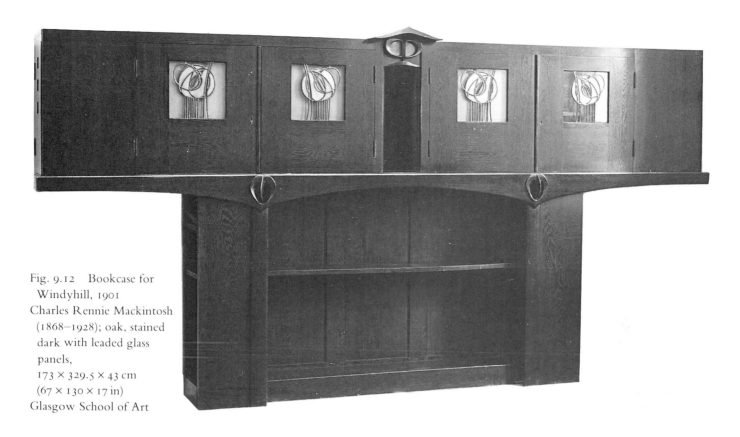

Fig. 9.12　Bookcase for
　Windyhill, 1901
Charles Rennie Mackintosh
　(1868–1928); oak, stained
　dark with leaded glass
　panels,
　173 × 329.5 × 43 cm
　(67 × 130 × 17 in)
Glasgow School of Art

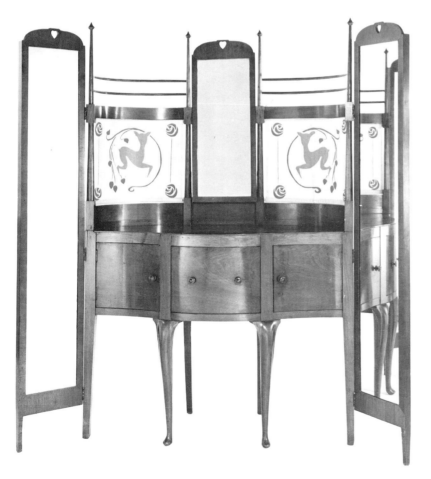

Fig. 9.15　Dressing table
　with mirror, 1901
George Walton (1868–1933);
　oak, 177.8 × 196.8 × 44.5 cm
　(70 × 77$\frac{1}{2}$ × 17$\frac{1}{2}$ in)
Glasgow Art Gallery & Museum

Fig. 9.14　Bedroom chair
　for The Hill House, 1903
Charles Rennie Mackintosh
　(1868–1928); ebonized wood
　(chestnut?),
　140 × 40.5 × 33.5 cm
　(55 × 16 × 13$\frac{1}{4}$ in)
National Trust for Scotland

complete it he had become committed to his philosophy of total control, insisting on designing every detail. Having quite mundane items specially made increased costs that the Governors were no longer prepared to meet. The School Board that commissioned Mackintosh's Scotland Street School provoked more argument when it insisted that the windows should have large panes of glass in order to cut down on maintenance costs, rather than the many mullioned and transomed windows Mackintosh had specified.

Mackintosh seems to have been unable to tolerate such suggestions or orders from a client even when they were more minor and his reputation for being difficult to work with contained some truth. His demands may well have been justified on aesthetic, if not financial grounds, and a better building probably would have resulted had he been fully able to realize his plans, but he seems to have been incapable of knowing when to withdraw gracefully. By 1913 Glasgow and Mackintosh had had enough of each other. Like the Glasgow Boys before him he discovered that the city had not enough patrons to support men of his imagination. It was a double blow for Mackintosh, since he had refused to leave the city or Scotland when his reputation was high abroad. He had wanted to create a Scottish style, to develop centuries of tradition in his search for a new architecture for the twentieth century. The Glasgow Boys had been more openly ambitious for acclaim and, when they saw that Glasgow was unwilling, rather than unable, to support them, they left for more hospitable quarters. Virtually the only public commission the Boys received in Glasgow was for the murals for the banqueting hall of the City Chambers, grudgingly bestowed ten years after the Chambers opened and five years after most of the group had left Glasgow. While museums in Munich, Berlin, Budapest, Pittsburgh and Paris bought their paintings, they were unrepresented in their own city's Art Gallery before 1914, save for the occasional

Fig. 9.13 White bookcase for Hous'hill, 1904
Charles Rennie Mackintosh (1868–1928); (pine?), painted white, with inlays of coloured glass, 122 × 46 × 46 cm (48 × 18¼ × 18¼ in)
Scottish National Gallery of Modern Art, Edinburgh

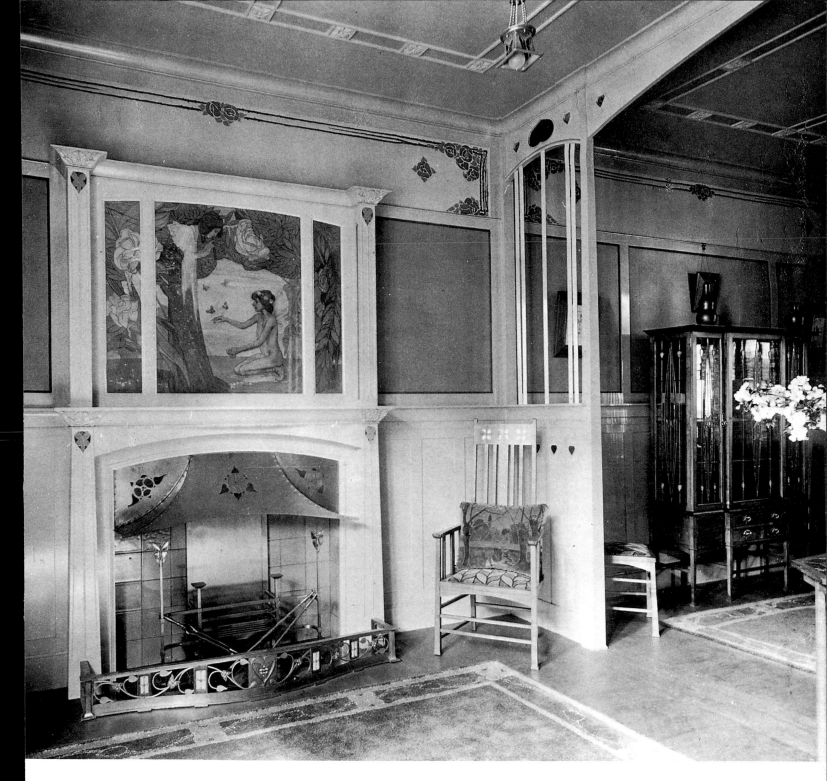

Fig. 9.16 Drawing Room, 1901
Designer: E. A. Taylor (1874–1951); Maker: Wylie & Lochhead
 for their pavilion at the Glasgow International Exhibition,
 1901
Photo: Glasgow Art Gallery & Museum

gift or bequest and the ubiquitous Hornel, ever a favourite with Glasgow's city fathers.

Although the painters of the Glasgow School and the designers of the Glasgow Style have long been considered a rare phenomenon, it should not be surprising that such a large number of talented young people should suddenly surface in a city like Glasgow. At the end of the nineteenth century its population was almost a million and other such cities in Britain had similar bursts of creativity. In Birmingham and Liverpool there were painters and designers who reflected local conditions and local pride. Other naturalist painters gathered together at Newlyn in Cornwall. Edinburgh had supported dozens of painters since the mid-eighteenth century and in the 1890s it too found itself host to an active group of young designers and archi-

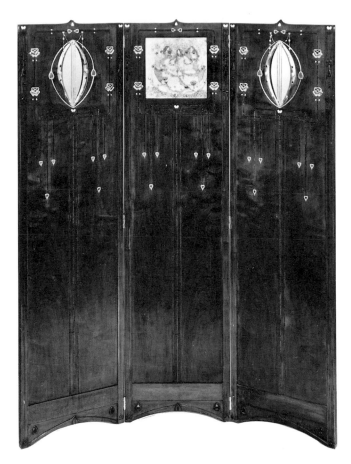

Fig. 9.17 Screen, 1902
George Logan (1866–1939) and Jessie M. King (1875–1949);
walnut, sycamore, silver, turquoise, red amethyst, white
stone, leather, mother-of-pearl, vellum; 172.1 × 137.2 cm
($67\frac{3}{4}$ × 54 in)
Glasgow Art Gallery & Museum

tects. Two main differences seem to differentiate the Glasgow phenomenon from its counterparts elsewhere. The first was the political situation in Scotland, where the country's largest and most prosperous city was denied a proper role in the affairs of the nation by vested interests in the capital, Edinburgh. The law, medicine, the church, government and the civil service were all centred on the capital, a much smaller and less dynamic city than Glasgow, and power in the visual arts was concentrated in the hands of the small band of Edinburgh men who controlled the Royal Scottish Academy. The Glasgow Boys' adoption of French manners and style was partly a rejection of the kind of painting which then dominated Scotland through the Academy and other Establishment bodies. This particular angst was unrepeated elsewhere and gave their

rebellion, such as it was, a particular edge and vibrancy lacking in other similar movements in Britain. Nationalism in its broader sense, was the second, perhaps more important element in Glasgow's artistic vitality at the turn of the century. The Boys may have looked to France for inspiration to break the stranglehold of mediocrity on most Scottish painting of the 1870s and 1880s, but they translated the new French ideas into paintings which were recognizably Scottish. Their awareness of the identifiable qualities of Scottish painting gave a new life and integrity to naturalism, which in Newlyn, for instance, was used mainly to dress up old ideas in new clothes.

As an architect, Mackintosh was perhaps even more aware of his roots than the Boys. His aim was to build upon the traditions of Scottish architecture to create a new style for the twentieth century. This national pride perhaps kept him in Scotland when he should have left but it also formed a rock on which he built his architectural aesthetic. As a designer, it provided him with a culture which was to inspire his early work and suckle the imagination from which would flow some of the most startling icons of the new century. These owe no obvious debt to Scottish culture but their originality was such that they came to symbolize Glasgow as unique images of their time. Mackintosh built on this heritage and added something new to it in a way that links him forever with the city of his birth. Although Glasgow gave him life, its lack of vision ultimately destroyed him. For all their commercial and industrial acumen, the middle classes of Glasgow could not provide the kind of support which Guthrie and Lavery, Mackintosh and Walton needed. There was only one Burrell, one Reid, McInnes or Coats and few other collectors or patrons in Glasgow who had any serious interest in the more adventurous painters and designers. This was not enough; it was in dozens that they were needed, even hundreds, to support such a burst of talent as Glasgow saw in 1900. Who is to say whether, a century later, the lessons have been learned?

A 'GLEAM OF RENAISSANCE HOPE': EDINBURGH AT THE TURN OF THE CENTURY

ELIZABETH CUMMING

The march of intellect has wavered much in the world's history, but the march of art has wavered more. That a nation like ours, posing as the world's mental pioneer, can endure placidly the chaotic ugliness of its manufacturing towns, and the sordidness of its average street everywhere, is a striking proof of the fluctuating advance of aesthetics. Yet the instinct of beauty, though it often sleeps, never dies. From time to time the creative mandate, 'let there be light', goes forth, and what was without form and void resolves itself into ordered loveliness.

In 1897 the Scottish critic Margaret Armour, writing in the London art journal *The Studio*, thus welcomed the mural decoration by John Duncan and Charles Mackie of a group of buildings in Edinburgh's Lawnmarket (fig. 10.1). Using tales from Scottish history and legend as their subjects, these artists and their assistants created work which ranks as a major example of *fin-de-siècle* British painting. They responded to European symbolism but achieved even more: they forged an alternative art for Scotland built on a surge of romantic nationalism within the city and a desire to contribute positively to British art. Both ideas were part of the vision of one Scot, the botanist and sociologist, Patrick Geddes. The extent to which Edinburgh, Scotland's capital, achieved its cultural renaissance independently of outside influence (especially from London) is, however, a question which demands an answer.

Geddes dreamed of making 'the dingy grey of our cities gain something of the pure azures and flash across its smoky wilderness the gleam of renaissance hope'. For him, as for many British romantic idealists of the time, the transformation of the dark void of Armour's 'chaotic ugliness' into the light of 'ordered loveliness' meant the resuscitation of an entire culture in the face of industrialism. The condition of art and design was a direct measure of the moral state of civilization: any change would not only affect material culture but hold widespread implications for the fields of sociology, economics and ecology.

Geddes had espoused the cause of social and artistic reform for a decade. In late 1884 with a group of local architects and designers he had formed the Edinburgh Social Union whose purpose, like so many British societies of the time, was philanthropic. The Union set out to improve the quality of life for the working classes living in the historic, but squalid, tenements of Edinburgh's Old Town in the shadow of the Castle. Like the Kyrle Society in London, Glasgow, Leicester and Birmingham, it employed local artists to decorate the interiors of hospitals, mission halls and schools and also organized amateur craft classes.

By the early 1890s, however, the Union had changed direction. It turned its attention to professional design training, and with it came a much more direct liaison with London designers. The art committees were now controlled by dons (including Gerard Baldwin Brown, the University's first Watson Gordon Professor of Fine

Fig. 10.1 Mural in the Common Room, Ramsay Lodge,
 Edinburgh, c. 1894
Detail of *The Awakening of Cuchullin*
John Duncan (1866–1945); oil
Photo: AIC Photographic Services

Art), commercial designers and artists, all anxious to translate English Arts and Crafts practice into a local idiom. In 1891 A.H. Mackmurdo, architect and founder of the Century Guild in London nine years earlier, was invited to lecture on design, and C.R. Ashbee, another leading English architect-designer, offered to train a craftsman to lead a 'School of Artistic Handicraft'. The Social Union still decorated public buildings, but no longer only those of the under-privileged. In 1893 Phoebe Traquair, an early Union decorator, was appointed to paint the vast interior of Robert Rowand Anderson's Catholic Apostolic Church in East London Street.

The whole of Britain was benefiting from the rich resources of her Empire and the growth of industrial trade by the turn of the century. The political and economic confidence which characterized the 1890s,

together with the new 'free design' rules formulated by the Arts and Crafts movement, provided a firm basis for the impetus for design reform and, in Scotland, a national art. In Edinburgh the opinions and activities of a number of incomers to the city, such as Baldwin Brown, contributed to the spread of Arts and Crafts beliefs. The National Association for the Advancement of Art and its Application to Industry, a society of leading British artists, sculptors, architects and design reformers, held its second congress in Edinburgh in November 1889 and thereby stamped recent city developments with its official approval. The meeting, now remembered primarily for William Morris's derision of the new Forth Bridge as the 'most supreme specimen of ugliness', was particularly important to the formulation and dissemination of Arts and Crafts principles in Edinburgh and Britain.

From the early 1890s relations between leaders of design reform in Scotland's capital and England were highly ambivalent, the Scots accepting some new ideas but rejecting others and developing a core of independent principles. Geddes considered the narrowing and 'Englishing' of the Union activities irrelevant to

Fig. 10.2 *Surface Water,* illustration published in *The Book of Summer,* a volume of *The Evergreen,* 1896
Illustrator: John Duncan (1866–1945); Publisher: Patrick Geddes & Colleagues, Edinburgh; page size: 23.5 × 17.4 cm ($9\frac{5}{8} \times 6\frac{3}{4}$ in)
Photo: AIC Photographic Services

his scheme of urban and moral renewal to which he was still deeply committed. Craftwork had to contain a deeper social prescription than simply the reform of design. He therefore viewed with some trepidation the new government-funded School of Applied Art, which, under the direction of the architect Robert Rowand Anderson opened in 1892. However much Geddes admired Anderson as an architect, he believed

its craft and design classes could not avoid supporting the needs and standards of a capitalist society, to whose values Geddes was fundamentally opposed.

Anderson called for a national school of art and design free to operate as far as possible from London domination and to base modern design on the details, materials and spirit of the art of pre-industrial Scotland. The School's 1894 report stated that the aim of its ruling committee was to develop 'a national character because there is in Scotland an art of the past with a distinctly local colouring capable of being developed and applied to the wants and necessities of the present day'. Anderson sympathized with Arts and Crafts design reformers and in particular admired the way they drew from the past to inspire the present. Part-time students employed by local interior design and furniture firms such as Scott Morton & Co. and Whytock & Reid were encouraged to draw and measure museum pieces. The National Art Survey of Scottish decoration, furnishings and buildings, carried out by the School's architectural bursars from 1895, was central to Anderson's educational and design principles and gave his School a lasting local influence.

By this date Geddes was broadening his vision towards a synthesis not only of art, craft and socialism but also between science and culture and he wanted to apply his theories to a wider spectrum. In 1891 he established an Outlook Tower in Short's Observatory in the Old Town, developing a sociological study centre where the breadth of human life could be studied in microcosm, using exhibitions, publications and direct observation. In addition, in order to further the advancement and closer integration of culture in its widest sense, he helped found a *comité-écossais* (subsequently the Franco-Scottish Society) in 1889 with Louis Pasteur as President, established international summer schools and, with John Duncan, opened University Hall School of Art (subsequently the Old Edinburgh School of Art) in 1892.

The artists of the Geddes circle of the 1890s were encouraged to look at foreign as well as indigenous art in their quest for a new direction. Some were already doing so: Duncan had trained in Düsseldorf and Mackie had recently befriended a leading member of the Gauguin circle, Paul Serusier, at Pont Aven in Brittany. Patrick Geddes & Colleagues, the publishing house directed by Rossetti's biographer, William Sharp,

issued a Celtic Library (including Sharp's own symbolist poetry under the *nom de plume* 'Fiona Macleod') and the wide-ranging Ethic Art Series (with studies on the work of Bach, Beethoven and Puvis de Chavannes) in association with the Union pour l'Action Morale in Paris and the Ethical Culture Society in New York. Its most famous publication was a quarterly journal of the arts and sciences, *The Evergreen: A Northern Seasonal* (1895–96). *The Evergreen* published a drawing by Serusier as well as illustrations by a range of Scottish artists from E. A. Hornel and James Pittendrigh Macgillivray to Mackie and Duncan. Some of the most intense illustrations were by Duncan: *Surface Water*, an illustration to his poem of the same title and published in *The Book of Summer* in 1896, was nearer stylistically to the work of German illustrators such as Heinrich Vogeler than to Scottish or Celtic prototypes (fig. 10.2).

The Old Edinburgh School of Art was anti-establishment in both its informality and the scope of its educational programme. Duncan aimed to provide examination-free vocational training for the artistic trades, for 'printer and bookbinder, embroiderer, jeweller silversmith, and brassworker', and open classes in subjects from Celtic ornament to Dante. The teachers associated with the School – W. G. Burn Murdoch, James Cadenhead, Robert Burns, Mackie and Duncan – operated a *bottega* system, a method of practical, instinctive group learning based on respect for materials and an appreciation of history.

A vivid sense of renaissance characterized the workings of the School. Its teachers decorated the interiors of buildings recently commissioned from local architects Sydney Mitchell and Stewart Henbest Capper or restored by G. S. Aitken for Geddes's privately and publicly funded Town and Gown Association. Duncan and Geddes wanted to extend W. E. Henley's summary rule on art, published in 1891 in *The National Observer*, as simply the decoration of 'flat spaces with interesting forms and beautiful colours'. For Geddes 'each piece of work ... simple or complex' obtained 'a certain definite and historic value as a step in the resuscitation of primeval or local art'. The walls of Ramsay Lodge, one of five university hostels founded by Geddes in the Lawnmarket area, were decorated by Burn Murdoch and by Duncan whose scenes from myth, legend and history such as *The Awakening of Cuchullin, The Taking of Excalibur* and *The Journey of Mungo* were framed with Celtic patterns by the School's principal design teacher, Helen Hay, in 1894 and 1895. Their paintings used Geddes's 'symbolic synthesis of colour, form and line' to create a new Celtic art. Of these panels *Cuchullin* was perhaps the most compelling both artistically and iconographically, a symbol of the reawakening of the Celtic spirit (fig. 10.1). For Geddes's own apartment at 14 Ramsay Garden Charles Mackie painted scenes from the Scots ballad *Sir Patrick Spens*, their Nabis style reflecting his friendship with Serusier.

In some ways the activities of the Lawnmarket *coterie* can be seen as an East coast equivalent of those of Mackintosh and his circle. Both groups examined their native heritage, looked at developments abroad and synthesized a new art based, in the words of the Glaswegian Jessie Newbery, on the 'sum of tradition'. Turning to the past in their search for modernism, their relationship with Celtic precedent went far wider and deeper than mere copyism and removed them from the mainstream of current Scottish art and design: they envisaged a new Scottish art capable of contributing to European culture.

These Edinburgh artists and designers can, however, also be viewed as part of the British Arts and Crafts movement. Their practice was in many respects close to work in England, and especially London: Arts and Crafts designers and architects from William Morris to W. R. Lethaby had encouraged designers to look to regional traditions to shape contemporary architecture and object design. The range of craft classes offered by the Old Edinburgh School, the experimental mural media from tempera to sgraffito, and its general philosophy of art as a way of life were all basic rules in Arts and Crafts practice.

The balance between combing local history for inspiration and subscribing to London activities was fully achieved from the mid-1890s by individual artists and designers elsewhere in the capital. Annie Macdonald, a friend of Traquair, related how she and the first curator of the Portrait Gallery, John Miller Gray, began to search out 'old bindings in libraries and felt that it was a beautiful art but now fallen to be only a trade'. A group of Edinburgh binders, led by Macdonald, Traquair and Jessie McGibbon, was affiliated not only to the new Edinburgh Arts and Crafts Club, but in London to the Guild of Women-Binders in 1898. Their

Fig. 10.3 *Traicté de la forme et devis comme on faict les tournois ... mis en ordre par Bernard Prost, 1878, 1898*
Binder: Annie Macdonald (d. 1924); moulded natural morocco, 25 × 17 cm ($9\frac{3}{4}$ × $6\frac{3}{4}$ in)
Trustees of the National Library of Scotland, Edinburgh

embossed and blind-tooled covers in morocco or pigskin were modern designs recalling Scottish medieval work in spirit only (fig. 10.3). After 1900 enamelling become a popular middle- and upper-class craft, again in line with English practice. Many took their lead from Lady Gibson Carmichael (a pupil of the London Arts and Crafts enameller Alexander Fisher) and her pupil and friend Phoebe Traquair. Like English enamellers they revived the medieval settings of casket and triptych and experimented with brilliant translucent colours. Their work was often pictorial: in *The Ten Virgins* casket, *c.* 1907 (fig. 10.4), Phoebe Traquair successfully adapted imagery from her decoration of the Catholic Apostolic Church ten years earlier.

The work of Traquair reflected English ideas and taste but combined them with Celtic imagery. In a previous mural decorative scheme for the Song School of St Mary's Cathedral (1888–92), her combination of narrative realism and mystical allegory was stylistically influenced by Rossetti and Burne-Jones. Wishing to represent the achievements of modern life as much as symbolist ideas, she included portraits of the artists and poets she most admired: in one section of the south wall she placed English poets and painters Alfred Tennyson, Robert Browning, G. F. Watts and Dante Gabriel Rossetti alongside a friend, the Edinburgh painter and collector Sir Joseph Noel Paton (fig. 10.5).

From the mid-1890s new Edinburgh design thus took three principal forms: a synthetic art expressing a new Scottish identity; official design inspired by English principles but executed according to local, Scottish ideas; and craftwork relying on London for guidance and a market. Compared with these, the work of commercial designers serving a British market was considerably less innovative. Some textile and interior designers such as the Edinburgh Social Union co-founder, William S. Black, and William Scott Morton were working as much for a London as an Edinburgh market and largely ignored the current nationalistic revival. Two designs from 1893 illustrate the classicism of their work. Black's figural design *The Seasons* for the London textile and wallpaper firm Jeffrey & Co. (fig. 10.6) was admired by the designer and writer Lewis F. Day, indicating that Black was accepted by the London mainstream. The lavish and richly carved, panelled and gilded house interior carried out for a whisky merchant and art collector, Arthur Sanderson, was a major commission for the Scott Morton firm (fig. 10.7). With carved figures of Athena and Hera, a Parthenon frieze in 'Tynecastle' fibrous plaster, and inscribed quotations from Homer and Plato, this unified Aesthetic interior in the 'Athens of the North' reflected how often design depended on a client's taste and affluence. This style of decoration, somewhat reduced and modified, was popularized: for example, Scott Morton's second Edinburgh firm, the Tynecastle Company, reproduced the frieze in two sizes, plain or painted, for houses throughout Britain.

The architect Robert Lorimer also balanced English and Scottish ideas. Trained in both Edinburgh and London, he supported Arts and Crafts principles of design integration, craftsmanship and local identity.

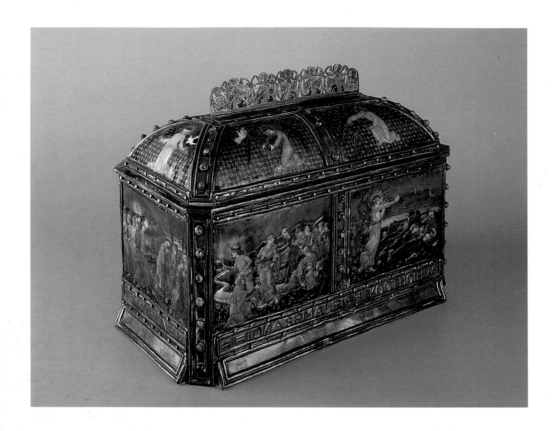

Fig. 10.4 *The Ten Virgins* casket, *c.* 1907
Phoebe Traquair (1852–1936); silver gilt, set with semi-precious stones and with six plaques enamelled on copper,
23.2 × 17.1 × 31.7 cm
($9\frac{1}{8}$ × $6\frac{3}{4}$ × $12\frac{3}{8}$ in)
Hunterian Art Gallery, University of Glasgow

Fig. 10.5 Detail of *The Powers of the Lord, c.* 1890–91, mural in the Song School, St Mary's Cathedral, Edinburgh, 1888–92
Phoebe Traquair (1852–1936); oil, beeswax and turpentine
Photo: AIC Photographic Services

Lorimer's furniture of the 1890s, most of which was made by the Edinburgh firm of Whytock & Reid, were always simple, their plain forms derived from traditional Scottish pieces of the seventeenth to early nineteenth centuries. Detailing was provided by either a single traditional structural feature, such as a bold, rhythmic stretcher (fig. 10.8) or marquetry inlay of fruitwoods or mother-of-pearl. (The latter had been used by Lethaby and Gimson, two London architect-designers working with others as Kenton & Company in 1890–92.) Lorimer, however, was additionally inspired by the tapestries of fifteenth- and sixteenth-century France and the Low Countries, some of which he used to furnish clients' homes. He treated his mar-

Fig. 10.6 Design for a wallpaper, *The Seasons*, 1893
Designer: William S. Black (fl. 1880–1915);
Manufacturer: Jeffrey & Co, London; pen and ink, 114 × 76 cm (44$\frac{7}{8}$ × 29$\frac{7}{8}$ in)
Victoria and Albert Museum, London

Fig. 10.7 Entrance hall and staircase of house for Arthur Sanderson, Learmonth Terrace, Edinburgh, 1893
Designer: William Scott Morton (1840–1903);
Manufacturer: Scott Morton & Co.
Photo: AIC Photographic Services

quetry designs pictorially: on the front of a linen cup-board, probably designed in the mid-1890s for his sister, swans drink, birds perch in a tree and rabbits play (figs 10.9 and 10.9a). Lorimer, Duncan and Mackie therefore all based their art on a mixture of Scottish and European ideas, but, while the first emphasized historical precedent, the others were at least as much inspired by contemporary art and ideas.

A great deal of Edinburgh design in the period 1890 to 1930 was in fact predominantly narrative. The city's dramatic medieval and renaissance townscape and its colourful romantic history, so vividly described by Scott, Stevenson and many others over the previous century, provided the inspiration for a detailed, figural art. A combination of human and animal forms, strong colour, an interest in texture and sometimes new materials (both Traquair and Duncan experimented with mural techniques to achieve a medium to with-stand the Scottish climate) epitomized the new art. The tale of Denys of Auxerre (from Walter Pater's

Fig. 10.8 Table with drawer, 1893
Designer: Robert Lorimer (1864–1929); Maker: Whytock & Reid, Edinburgh; oak, marble top, 70 × 113.5 × 56 cm ($27\frac{1}{2}$ × $44\frac{5}{8}$ × 22 in)
Trustees of the National Museums of Scotland, Edinburgh

Fig. 10.9 Linen cupboard, c. 1893–94
Designer: Robert Lorimer (1864–1929); Maker: Whytock & Reid, Edinburgh; walnut, inlaid with holly, fruitwoods and mother-of-pearl, 187.7 × 151.8 × 58.1 cm ($73\frac{7}{8}$ × $59\frac{3}{4}$ × 23 in)
Private collection
Photo: AIC Photographic Services

Imaginary Portraits, 1887) was translated iconographically by Phoebe Traquair in her suite of four embroideries: she metamorphosed Denys, the central character, into Orpheus and placed him within a colourful animal kingdom (fig. 10.10). The architectural and domestic ironwork of Thomas Hadden, one of a number of Edinburgh craftworkers on whom Lorimer consistently relied, also used birds and animals. Many of his designs were made for Lorimer's country house commissions and restorations and were meant to add, as had medieval church carvings, scale, colour and wit: the ironwork screen made for his own fireside (fig. 10.11) was a typical combination of Jacobean scrollwork and 'banana' bird decoration.

Traquair and Lorimer were contributors to London's Arts and Crafts Exhibition Society during the 1890s and, unlike Mackintosh, continued to show there after 1900. Many designers, however, felt the need for regional societies to establish a Scottish identity and

Fig. 10.9a Detail of linen cupboard
Photo: AIC Photographic Services

Fig. 10.10 *The Entrance*, 1893–95
Phoebe Traquair (1852–1936); silks and gold thread,
180.7 × 71.2 cm (71$\frac{1}{8}$ × 28 in)
National Gallery of Scotland, Edinburgh

Fig. 10.12 *The Lord of the Hunt*, 1912–16, 1919–24 (detail)
Designer: William Skeoch Cumming (1864–1929); Weavers:
The Dovecot Tapestry Studio; wools, 404 × 985 cm
(159 × 388 in)
Private Collection
Photo: Glasgow Museums & Art Galleries

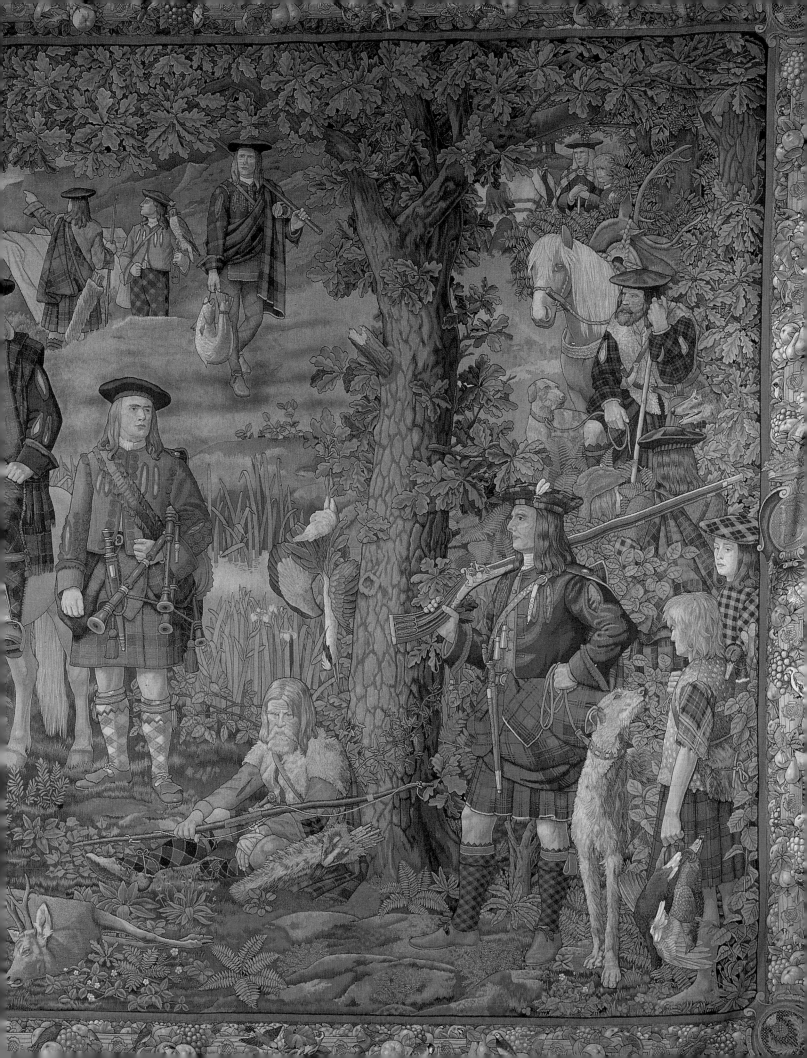

Fig. 10.11 Firescreen, c. 1920
Thomas Hadden (1874–1941); wrought iron, 'armour bright'
 finish, 84.2 × 66.2 × 21 cm (33⅛ × 26 × 8¼ in)
Private collection
Photo: AIC Photographic Services

Fig. 10.13 Tureen with lid, c. 1925–30
Decorator: Richard Amour, Bough Studio; earthenware,
 30 × 41 × 41 cm (11¼ × 16⅛ × 16⅛ in)
Huntly House, Edinburgh City Museums

reach a local market. In 1891 the Society of Scottish Artists was established to exhibit contemporary decorative art and in 1898 the Scottish Society of Art Workers, 'aiming at a national character' and the Scottish Guild of Handicraft, brought together Scottish artist-craftsmen and women in Glasgow.

Throughout the 1890 to 1930 period most Edinburgh designers wanted to be part of the larger British Arts and Crafts movement but at the same time recover Scots or Celtic cultural and, by implication, a degree of political independence from England. In the first tapestries commissioned by the fourth Marquess of Bute for his seat, Mount Stuart, from his own private company, the Dovecot Studios, the search for a new national art took the form of pictorial, nostalgic romanticism. However, the studios, established in the Corstorphine district in 1912, were staffed by young, local weavers trained by others from the Morris company workshop at Merton Abbey. These were worked in the Arras (Gobelins) manner to designs by the artist William Skeoch Cumming, and depicted the glories of a lost, bygone age before English domination of the Scots. The subjects of the tapestries, such as *The Lord of the Hunt* (fig. 10.12) and *Prayer for Victory, Prestonpans* were therefore Highland and Jacobite, with each historical detail of costume meticulously researched by Skeoch Cumming.

In the 1920s and 1930s Edinburgh artist-designers such as Robert Burns, a former Lawnmarket School artist and a teacher at the new Edinburgh College of Art from 1908, and the Amour family's Bough ceramic decorating studio, both created exciting new combinations of colour and pattern (fig. 10.13). Burns painted decorative panels for D. S. Crawford's Edinburgh tearooms (fig. 10.14) and illuminated manuscripts for A. H. Crawford in the 1920s and 1930s, the last of which, *The Song of Solomon* (1933) and *Ecclesiastes* (1934–35), were non-Scottish in subject. For the tearooms Burns also designed furniture and the Bough studio painted the crockery, thus providing an integrated interior design. Much of their work has a flavour of the smartness of European art deco. But if bold colour unified with inventive, rich patterning characterizes the best native Scottish design – from Pictish standing stones and Celtic metalwork to the tartans of the Victorian age – then these examples are still as Scottish as any Edinburgh products of the previous forty years.

Fig. 10.14 *Diana and her Nymphs,* decorative panel for
Crawford's Tearooms, *c.* 1925
Robert Burns (1869–1941); oil and gold leaf, 198.1 × 198.1 cm
(78 × 78 in)
National Gallery of Scotland, Edinburgh

11

Scottish Modernism and Scottish Identity

TOM NORMAND

In recent years the notion of a Scottish identity has become a central feature of cultural life, perhaps because Scotland has, for so long, been subject to the subtle repression of her most positive characteristics. Certainly the popularly projected images of Scottish 'customs', such as the paraphernalia of tartanry, are a cruel parody of actual Scottish life. In consequence an authentic expression has been absent from the cultural life of the nation. Of course there are notable exceptions, original thinkers of international status who have produced important creative works, principally in poetry and literature. In the absence of a clearly defined national identity, however, artists and intellectuals have generally accepted, at second hand, the insights of more confident national cultures.

This is surely the central dilemma of Scottish painting in the modern period, for it can make no appeal to an authentic, indigenous tradition and is in effect rootless. In consequence the key characteristic in twentieth-century Scottish art has been an uncertainty regarding a meaningful subject-matter and style. Everywhere in an exhibition of works by Scottish artists are echoes of French sensualism, shadows of English romanticism, and the occasional smear of German, and even American, expressionism. Though a product of a kind of cultural imperialism, it is one in which artists have, more or less, willingly participated. This was not entirely a failing of nerve or lack of confidence in the native culture, but was in part due

Fig. 11.1 *Rhythm*, 1911
John Duncan Fergusson (1874–1961); oil on canvas,
162.8 × 114.3 cm (64$\frac{1}{8}$ × 45 in)
University of Stirling

shape of its people. This would surely have been a genuine resource for a modern and distinctly Scottish art, but it is one which was abandoned as most ambitious Scottish painters fell headlong into the ethos of modernity.

Notwithstanding these features, Monet and Matisse were identifiably French painters, just as Kirchner could only have been German, and Nicholson, for all the tasteful radicalism of his technique, was clearly an English painter. Individuals like these brought to modernism the weight of a tradition, and the confidence of self-knowledge which provided their art with a subtle cultural specificity to balance and augment the universalist programme of the Modern Movement. Scottish artists, on the other hand, never successfully rediscovered that culture which had been

Fig. 11.2 *Still Life with Flowers and Fruit,* 1916
Samuel J. Peploe (1871–1935); oil on canvas, 40.8 × 45.9 cm ($16\frac{1}{6}$ × $18\frac{1}{16}$ in)
Kirkcaldy Art Gallery and Museum

Fig. 11.3 *Kirkcudbright,* 1919
Samuel J. Peploe (1871–1935); oil on canvas, 34.4 × 40.8 cm ($13\frac{9}{16}$ × $16\frac{1}{16}$ in)
Kirkcaldy Art Gallery and Museum

to the nature of the Modern Movement itself. Universalist in character, distinctly metropolitan in its tastes, and abstractly esoteric in its manner, the modernist project was a conscious attempt to abandon nationalism and cultural specificity. Moreover, its rarefied, even élitist, character created a logical disjuncture with the material culture, the lived reality of the nation in the

buried for centuries and which Scottish intellectuals had been too compromised to advance. Elsewhere this has been described as 'the Scottish intelligentsia's readiness to embrace damning conceptions of the national culture' (Beveridge and Turnbull 1989), and this notion can quite properly be applied to modern Scottish art. Thus Scottish modernism became a kind of mirror of

those hegemonic cultures that surrounded it, and artists were all too ready to make an aesthetic appeal to those dominating surrogates.

Nowhere, in the early part of this century, was this dilemma better illustrated than in the case of J. D. Fergusson, and particularly in his painting *Rhythm* (fig. 11.1), completed in 1911. Fergusson was an ambitious artist who turned towards France as early as the 1890s and had settled there by 1907. Technically committed to a modernist aesthetic language, he developed a Fauvist manner using high-keyed colour and a moderately Expressionist brushstroke. This was generally accompanied by a *cloissonist* outline in the style of the Post-Impressionists. His choosing to emulate the French manner can be read as a deliberate rejection of the dominance of English tastes in Scottish intellectual life, and as a recognition of the paucity of English modernism itself. Certainly Fergusson was eager to emphasize the common, if uncertain, Celtic roots shared by French and Scottish culture, and to accentuate the dimension of Celticism in his own work. In this light *Rhythm* became a seminal work. It positively embraced a modern style which was clearly Frenchified, from the sensualism of the painted surface to the symbolic romanticism of its theme, while tackling a subject, the nude, which had no substantial tradition in either English or Scottish art. (It must be said, however, that the improbable anatomies of Fergusson's nude women were a peculiarity all of his own.)

Yet Fergusson also wanted to supply this work with some native Scottish dimension and here a mythologized Celtic past became of paramount concern. The sinuous quality of the line, the intertwined natural and human elements, and the emblematic pantheism of the scene were a common grammar, used since the 1890s to recall a vaguely Celtic culture. Fergusson was quite clear about this in his discussion of a companion piece to *Rhythm*, the painting titled *Rose Rhythm* of 1916, a portrait of the dancer Kathleen Dillon:

One day she arrived with a remarkable hat. I said 'that's a very good hat you've got'. She said, 'Yes! isn't it? I've just made it.' It was like a rose, going from the centre convolution and continuing the 'Rhythm' idea developed in Paris and still with me. Looking at K[athleen] I saw that the hat was not merely a hat, but a continuation of the girl's character, her mouth, her nostril, the curl of her hair ... going from the very centre convolutions to her nostrils, lips, eyebrows, brooch, buttons, background cushions, right through. At last, this was my statement of a thing thoroughly Celtic. (Morris 1974)

So here, and with *Rhythm*, was one of the finest examples of a French modernism, developed by a Scottish artist in order to give expression to a covert Scottish theme.

However, the Celticism voiced here was a fragmentary and romantic sentiment. Centred upon an incomplete, often fictional, notion of the Celtic twilight this revival had extended its certainties little beyond the Book of Kells and other illuminated manuscripts. The Scottish dimension to *Rhythm* represented a longing for, rather than an imminent arrival at, a native identity in Scottish painting. Ironically the desire for this authentic statement could only be completed in a foreign style, a parody of the French which in a sense completely undermined both the modernist ambition of the work and its culturally located intentions.

Elsewhere in Fergusson's art, and that of the circle with which he is most commonly associated, the Scottish Colourists, there was little attempt to open up and explore the indigenous culture. Increasingly Fergusson developed a visually exciting, if superficial and intellectually redundant mannerism, based upon Fauvist principles. His subject matter concentrated on landscape, more often than not the French landscape, and naked bathers basking in a southern light. These were complemented by some vigorous portraits and still lifes which, for all their technical display, became the clichéd repetition of a flimsy idea.

The same may be said of the currently fashionable work of the Scottish Colourists – Samuel Peploe, Francis Cadell and Leslie Hunter – which rarely even approached the limited ambitions of a figure like Fergusson. All three artists emulated developments first broached in French painting but undoubtedly Peploe was the most compromised. Peploe was to join Fergusson in Paris during 1910, and, although a strong sense of design pervades his paintings, notably in the still lifes, his greatest skill was as a creator of the accomplished pastiche. In a work like *Still Life with Fruit and Flowers* (fig. 11.2) of 1916, and the innumerable still lifes in a

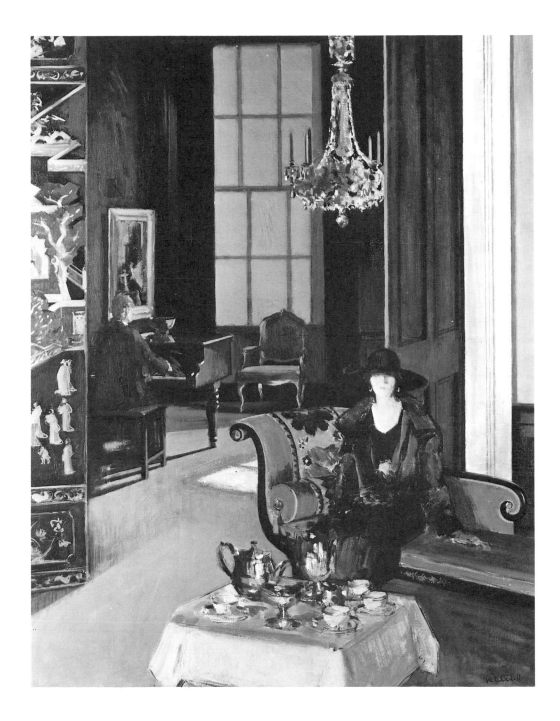

Fig. 11.4 *The Orange Blind,* 1927
Francis C. B. Cadell (1883–1937); oil on canvas, 112.2 × 86.7 cm (44⅛ × 34⅛ in)
Glasgow Art Gallery & Museum

similar style that were Peploe's stock in trade, the memories of Cézanne's work linger irrevocably. The feeling for modelling in paint, the sense of structure and form, echo Cézanne's still lifes from the period around 1895. Often, for good measure, Peploe would add the hard outline commonly associated with Post-Impressionism and perhaps a Japanese motif to secure the modernist credentials of the painting. All of this made for an immediately impressive composition strong on design and pattern, but failed to sustain a close examination of its technique, motivations and intentions. Indeed these were works which were all style and no substance. Peploe, perhaps more than any

other artist of this group, could conjure up a modern technique only by turning his back on the native elements of his culture. In the final analysis he achieved neither a radical modernism nor a significant Scottish contribution to painting, for, even where he turned to an indigenous subject, as in *Kirkcudbright* (fig. 11.3) of 1919, he created only a stylized and mongrel Cézannesque landscape, all block-like forms and Gallic light.

A similar charge might be levelled against Francis Cadell, although in his many paintings and sketches of the island of Iona there was something of a real search for a Scottish subject matter which would resonate with the early history of the nation and its symbols.

Fig. 11.5 *Houseboats, Loch Lomond, 1926*
G. Leslie Hunter (1879–1931); oil on canvas, 45.9 × 56.1 cm
($18\frac{1}{16}$ × $22\frac{1}{16}$ in)
Glasgow Art Gallery & Museum

More typical works, however, like *The Orange Blind* (fig. 11.4) of 1927, demonstrate Cadell's capacity to produce the sophisticated, mannered interior scenes most often associated with his portraiture. In the early years of this century this would have looked like advanced and even intense painting, though clearly it exhibited more of those tasteful and decorous qualities which would make it acceptable to a fashion-conscious patron. The work of Leslie Hunter was more significant, particularly the studies of riverboats and houses at Loch Lomond that he undertook towards the

end of his life. *Houseboats, Loch Lomond* (fig. 11.5), was a typically fresh and vital painting. Free and open in his technique, Hunter deliberately eschewed the heavy-handed modelling of his peers in favour of a spontaneous, almost sketchy approach that conveyed an unpretentious immediacy. More importantly Hunter had selected a subject that reflected an aspect of the contemporary life of Scottish people. This unity of a culturally specific social theme and the advanced, expressionistic elements of Hunter's technique provided for some of the most successful and identifiably Scottish painting in the early years of this century.

Overall, the work of the Scottish Colourists was symptomatic of the gnawing difficulties faced by ambitious but culturally dislocated Scottish artists. While figures like Peploe and Cadell withdrew into an

ever more compromised counterfeit French style, the task of reviving a modern Scottish culture fell to those intellectuals associated with the Scottish Renaissance. Inspired by the example of Hugh MacDiarmid and the Vernacular movement in poetry, the Scottish Renaissance movement attempted to expand the cultural base of Scottish intellectual life into the broader political and social dimension – the material life of the Scottish

Fig. 11.7 *A Point in Time,* 1929–37
William Johnstone (1897–1981); oil on canvas,
137.2 × 243.8 cm (54 × 96 in)
Scottish National Gallery of Modern Art, Edinburgh

people. In part this required the reorientation of cultural activity away from the magnet of the metropolitan centres. Hence the journal of the Scottish Renaissance movement, *The Modern Scot,* first issued in 1930, was edited by James H. Whyte in St Andrews, where he also ran a small gallery showing works by contemporary Scottish artists. Here the debate concerning Scottish identity and the nature of a truly Scottish art took a central role. In 1935, the October edition of *The Modern Scot* contained a long article, compiled by Whyte, entitled '"The Modern

Movement", A Painter's Symposium'. Various artists then showing at Whyte's gallery offered their views on the state of Scottish painting and its future. Almost all the artists believed that Scotland possessed little indigenous art of any merit and that any future for Scottish art would be determined by the extent to which the nation was freed to shape its own destiny. The artist Graham Murray complained that:

The defeat of the Celts, their art and culture let [sic] the Scots under continental influences, also in the plastic arts. So there is truly no particular Scottish painting.

More positively, the portrait painter S. d'Horne Shepherd suggested that:

Scottish art is sharing in a national revival: its still dubious future depends largely on the future of the nation.

The most erudite statement, however, came from the painter and critic William McCance:

When the Scot can purge himself of the illusion that Art is reserved for the sentimentalist and realise that he, the Scot, has a natural gift for construction, combined with a racial aptitude for metaphysical thought and a deep emotional nature, then out of this combination can arise

Fig. 11.6 *Conflict*, 1922
William McCance (1894–1970); oil on canvas, 87.5 × 100.5 cm
($34\frac{7}{16}$ × $39\frac{9}{16}$ in)
Glasgow Art Gallery & Museum

an art which will be pregnant with idea, and have within it the seed of greatness.

It was here that the optimism of the Scottish Renaissance movement was given full voice, for McCance sought to isolate those aspects of what he took to be Scottish 'character', and offered them as a prototype for a regenerated culture. This was a laudable aim, but it also signalled the fear that lay in the heart of Scottish intellectuals, namely that the native culture itself had become so adulterated that the only hope left was the residue of 'Scottishness' present in the broader society.

This was also a favourite theme of MacDiarmid's, who constantly remarked that the national tradition had been fragmented and buried. It is important to stress however that this was never a narrow and regressive chauvinism. A prominent dialectic between nationalism and internationalism imbued MacDiarmid's writing, and it was characteristic of those figures associated with the Scottish Renaissance that they saw Scotland contributing properly to the inter-

national community of thought only when the country had successfully discovered its native character and culture. More often than not this was focused on a desire to throw off English political dominance and cultural imperialism.

The irony, and the sadness, of the situation was aptly highlighted in the position of those Scottish artists most often heralded by MacDiarmid and most closely associated with the Scottish Renaissance, William McCance and William Johnstone. Both artists spent the bulk of their working life in and around London: McCance moving south as early as 1920 while Johnstone left Scotland in 1931. Of the two McCance was the weaker painter; his work, like the characteristic *Conflict* (fig. 11.6) from 1922, being derived from English Vorticism. Johnstone, however, was certainly one of the best painters Scotland produced, inspiring MacDiarmid to write a cycle of 'Poems to Paintings by William Johnstone' in 1933, and later proclaiming:

> In many respects (above all in the quality and particularly the 'direction' of his work) William Johnstone is not only the most important, but the only important living Scottish artist, and the only one of international importance.... So his name is hardly ever mentioned. (MacDiarmid 1966)

Johnstone's *A Point in Time* (fig. 11.7) of 1929–37 clearly illustrated his capacity to create a subtle and evocative abstract imagery, which conjured with notions of landscape while echoing the metaphysical fantasies of Celtic pantheism. This painting demonstrated how the goals of the Scottish Renaissance artists could be fulfilled with the creation of an internationally credible art that was also redolent of a distinctly Scottish metaphysic. Yet Johnstone could only complete his work within the parameters of the metropolis, and like McCance was seduced by its values and attitudes. This dimension of their practice perpetuated the schizophrenia of Scottish cultural life, and further conspired in the rootlessness of cultural production.

Throughout the middle decades of this century these problems were repeated in a more or less acute fashion. Stanley Cursiter's *Sensation of Crossing the Street* (see fig. 4.22) of 1913 was an interesting work though hardly endemic to his Orcadian homeland. The fragmented imagery and attempt to capture a dynamic sense of time, space and movement owed its genesis to

Fig. 11.9 *In Ardnamurchan,*
1936
William Gillies (1898–
1973); watercolour on
paper, 51 × 63 cm
(20⅛ × 24¹³⁄₁₆ in)
Scottish National Gallery of
Modern Art, Edinburgh

Fig. 11.10 *Figures in a
Farmyard,* 1953
Robert Colquhoun (1914–
62); oil on canvas,
185.4 × 143.5 cm
(73 × 56½ in)
Scottish National Gallery of
Modern Art, Edinburgh

Italian Futurism. By 1913 this was a common currency amongst, particularly, the English avant-garde. From 1910 Marinetti had been giving lectures in London and the Sackville Gallery held a major exhibition of Futurist work during 1912. A few of these paintings were shown at the Society of Scottish Artists exhibition, in Edinburgh, during 1913. Cursiter's work in this style was accomplished and highly decorative and exhibited a tasteful quality that separated it from the more cerebral elements of the Italian paintings. But it was quite unrecognizable as a Scottish painting and highlights the dependency of the majority of Scottish modernists upon Continental and English precedents.

Much the same might be said of the Edinburgh trained painters John Maxwell and William Gillies, who both went on to teach generations of artists at Edinburgh College of Art. During the 1930s their work became virtually indistinguishable from the growing mass of whimsical neo-Romantic landscape painting that was coming to characterize the English school. Maxwell's *View from a Tent* (fig. 11.8) of 1933, like Gillies' *In Ardnamurchan* (fig. 11.9) of 1936, aptly demonstrated that disinterestedness, finesse and cultured spontaneity which became the hallmark of Edinburgh-

169

Fig. 11.8 *View from a Tent*, 1933
John Maxwell (1905–62); oil on panel, 76.2 × 91.5 cm
 (30 × 36 in)
Scottish National Gallery of Modern Art, Edinburgh

painting in the following decades. Nevertheless the sense of searching for an authentic and meaningful expression is all but lost here in the propensity of these works to make their appeal to an informed bourgeois sensibility accustomed to English tastes.

This is not to say that Scottish artists invariably failed to make important contributions to the Modern Movement. For some time Robert Colquhoun, with paintings like the 1953 *Figures in a Farmyard* (fig. 11.10) (which certainly could not be condemned to categories like 'tasteful' and 'elegant'), was regarded as a Scot whose commitment to, and adaptations of, modernist principles would have lasting significance. Equally, in the 1950s, the work of Eduardo Paolozzi, both in his sculpture (fig. 11.11) and in the innovative *Bunk* collages, proved to be of substantial international status. Furthermore, a figure like William Gear stood for some time at the very forefront of post-war abstraction creating, in a painting like *Autumn Landscape, September 1950* (fig. 11.12), the type of sublime and powerful imagery which was to carry American painting to the centre of the world stage.

In a sense these artists only became significant international figures by moving away from Scotland, both physically and psychologically. To be a Scottish artist

was to be condemned to parochialism and senti-mentalism. This is not to say that these were the inherent characteristics of Scottish art, rather this was the perception of Scottishness fostered by the experi-ence of government from London and the domination of the metropolitan vision. Moreover, this perception was, to some extent, internalized by Scottish artists with the result that the search for an authentic national discourse in art became something of an embar-rassment. Consequently, and to the eternal shame of the nation, a figure like Charles Rennie Mackintosh is found in the 1920s in exile in the south of France. Whatever the qualities of Mackintosh's watercolours of this period (for example, his *Port Vendres, La Ville* [fig. 11.13] is an exceptional work where the sculptural qualities of Cézanne were combined with Mackintosh's subtle architectural imagination), they could never

fulfil the promise of the Glasgow School of Art. This architectural masterpiece was a synthesis of the subtlest dimensions of an indigenous architectural tradition and the most advanced European modernism. Equally a figure like Edward Baird, whose *Unidentified Aircraft* (fig. 11.14) of 1942, might, at least within the British context, be considered a radical quasi-surrealist work, remained too identifiably Scottish, too clearly based in the provincial town of Montrose, to merit any consideration. These, and many more, were the casu-alties of the colonial experience, wherein only those Scottish artists who became psychologically attuned to an undifferentiated, anonymous or subtly Anglicized modernism found themselves fêted.

Significantly those artists and designers who con-sciously worked outside of the modernist tradition have come closest to expressing a national identity in

Fig. 11.11 *His Majesty the Wheel*, 1958–59
Eduardo Paolozzi (b. 1924); bronze, 183 × 70 × 50 cm
($72\frac{1}{16}$ × $27\frac{9}{16}$ in × $19\frac{11}{16}$ in)
Scottish National Gallery of Modern Art, Edinburgh

Fig. 11.12 *Autumn Landscape, September 1950*, 1950
William Gear (b. 1915); oil on canvas, 182.2 × 127 cm
($71\frac{3}{4}$ × 50 in)
Laing Art Gallery, Newcastle upon Tyne

their work. They have done this, quite straight-forwardly, by examining the Scottish landscape and the Scottish people within the figurative tradition. Whereas modernism had seduced its practitioners into the various strategies of abstraction, more unfashionable artists concentrated their energies on the life of the Scottish people and there gave expression to a deeper consideration of nationhood.

An early example of this trajectory in Scottish art was provided in the figure of Muirhead Bone, who at

Fig. 11.13 *Port Vendres, La Ville*, 1924–26
Charles Rennie Mackintosh (1868–1928); watercolour on
paper, 46×46 cm ($18\frac{1}{8} \times 18\frac{1}{8}$ in)
Glasgow Art Gallery & Museum

the turn of the century undertook a study of everyday life in his native Glasgow. Bone's subject matter was generally the commonplace, the working life and the important cultural events taking place in the city, which he usually presented in the form of etchings and drypoints. Where the esoteric dimensions of modernist practice had often alienated cultural discourse from the uninitiated populace, Bone presented an immediate and culturally specific art. His *The Dry Dock* (fig. 11.15) of 1899 and even *Queen Street Station* (1910), would be instantly recognizable to any Glaswegian and moreover served as a celebration of his, or her, everyday life

Fig. 11.14 *Unidentified Aircraft,* 1942
Edward Baird (1904–49); oil on canvas, 71 × 91.5 cm (28 × 36 in)
Glasgow Art Gallery & Museum

and achievements. Bone, like so many others, moved to London after his first successes, but in a real sense he gave an early expression to that other cultural life where the elements of Scottish character and ability were relatively untarnished.

MacDiarmid came to recognize this dimension of Scottish life as the repository of a reinvigorated national culture. Indeed he constantly asserted the need to discover those activities which define Scottish character and place them at the centre of a regenerated national

Fig. 11.15 *The Dry Dock,*
1899
Muirhead Bone (1876–
1953); etching and
drypoint, 23.8 × 18.6 cm
($9\frac{3}{8} × 7\frac{5}{16}$ in)
Glasgow Art Gallery &
Museum

Fig. 11.16 (TOP RIGHT) *The*
Queen Mary, 1930–36
(model)
John Brown and Co. Ltd,
Clydebank, for the
Cunard White Star Ltd;
original test tank model
used for determining final
hull shape; Scale 1:57.9
Glasgow Museums & Art
Galleries, Museum of
Transport

Fig. 11.17 *Intermission,*
1935
James Cowie (1886–1956);
oil on canvas,
96.9 × 112.2 cm
($38\frac{1}{8} × 44\frac{1}{8}$ in)
Board of Trustees of
National Museums and
Galleries on Merseyside
(Walker Art Gallery,
Liverpool)

life. More significantly he argued that those elements of practical life in which the Scots distinguished themselves – shipbuilding, engineering, industry, science – so readily illustrated in everything from the *Queen Mary* (fig. 11.16) to John Logie Baird's television set, should become the example and model for an authentic Scottish art. In his essay 'Aesthetics in Scotland' Mac-Diarmid noted:

> What has taken place in Scotland up to the present is that our best constructive minds have taken up engineering and only sentimentalists have practised art. We are largely a nation of engineers. Let us realise that a man may still be an engineer and yet concerned with a picture conceived purely as a kind of engine which has a different kind of functional power to an engine in the ordinary sense of the term. (MacDiarmid 1984)

In a sense Bone had already offered something of a paean to these practices and this idea, but its core insight, the notion that Scottish art is best served in unearthing the indigenous material life of the people of Scotland, was more fully developed in the work of figures like James Cowie and even James McIntosh Patrick.

Cowie, in particular, was an exceptional artist, his

work, carefully composed, profoundly linear and perfectly modelled has all the virtues of a craftsman's pride in creative labour. Moreover, his ability to convey character and type within a poetic framework which was identifiably northern, lends a specificity to his painting which fully articulated the atmosphere of the Scottish scene. Thematically his works range from the informal reading session in *Intermission* of 1935 (fig. 11.17), with its emphasis on the duty and pleasure of learning, to the metaphysics of *Evening Star*, 1943–44 (fig. 11.18), which explored the mysterious echoes of the classical world. His quiet emphasis on the serious personality, the search for knowledge and understanding, and the subdued desire to examine the meta-

Fig. 11.18 *Evening Star*, 1943–44.
James Cowie (1886–1956);
oil on canvas laid on wood panel, 134.9 × 132.5 cm ($53\frac{1}{8} \times 52\frac{1}{8}$ in)
Aberdeen Art Gallery and Museums, Aberdeen City Arts Department

physical and fantastic realms form a kind of abstract Scottish history. In this way Cowie traversed the horizons of Scottish life surveying, in a minute empirical manner, the qualities and virtues of the Scottish psyche.

It was here, in those works which sought out the culturally specific and had their root in the life and character of the Scottish people, that an authentic and meaningful culture was developed. Inevitably this culture was largely ignored in the modern period, or abandoned to the wasteland of the provincial and second rate. But interestingly it was here, in the figurative tradition, very often narrative and certainly imbued with a self-conscious national identity, that contemporary Scottish art was to find its model and source.

In the 1980s Scottish artists, led by the activities of young Glasgow painters and designers, found a new self-confidence and began to produce native works

that were uncommonly successful on the international scene. In many ways these works had been presaged by the paintings of figures like Joan Eardley and John Bellany. While Eardley's *Two Children* (fig. 11.19) still recalls the Victorian sentimental infatuation with the playful innocence of youth, nevertheless, in transferring the theme from a rural to an urban setting, the artist began to evoke a distinctly Scottish subject and location within a radical painterly language. Moreover, the painting's figurative and narrative qualities, coupled with the attempt to rid the subject of mawkish sentiment, reflected the desire to produce serious works on everyday themes. Similarly John Bellany, particularly in his early works like *Kinlochbervie* (fig. 11.20) of 1964, pushed deep into his ancestral heritage to produce a rigorously defiant art which placed, at its very centre, the integrity of the community from which he had emerged and which formed the backbone

of Scottish life. Possessing an authentic and profound, indeed epic, poetry, these works are accessible precisely because they reflect lived experience and a genuine, if unofficial and submerged, history. Bellany's success is testimony to the ways in which an indigenous Scottish art can respond to both a native history, and a hostile international art market, and triumph over both.

Examples like these secured for more recent painting and sculpture a paradigm which eschewed the regressive hedonism of much that had passed for Scottish modernism, and embraced an alternative set of values more properly Scottish. Consequently through the 1970s, and particularly in the 1980s, diverse works have emerged which were not only of international stature, but presented a vision bearing all the marks of native ingenuity. Broadly this has involved the creation of works distinctly intellectual, dealing with themes and ideas which best fit the enquiring nature of the Scottish character, and indeed relate back to the philosophical speculations of Enlightenment Scotland. Moreover, contemporary work demonstrates a new emphasis on the figurative tradition, and is characterized by craftsmanship, technical command, and the desire for imagery which includes discourse. Indeed, this element of narrative is a crucial dimension of a genuinely Scottish art. Historically it always has been a key co-ordinate in native art, while in the contemporary period it has provided the platform from which artists could recover a meaningful dialogue with the public. Finally there has been an upsurge in works which touch, however obliquely, upon aspects of Scottish national identity. The shadows of Scotland's history and people are retraced in a mixture of elegy, wonder and irony. The strongest contemporary works are inspired by the memories of an authentic national consciousness and seek out modes of expression which make these relevant to the modern experience. In this way art has been created which is neither parochial nor retreatist but fully explores the interval between nationhood and international community.

The strongest and most provocative amongst the artists exhibiting these characteristics, certainly during the 1970s, was Ian Hamilton Finlay. Finlay undoubtedly recovered the intellectual and philosophic dimensions previously submerged in the spate of sensual, painterly works that had come to epitomize modern Scottish art. Moreover, he did this by recalling an iconography and the canons of austerity, rigour and purity of thought, which had been the virtues of classical art. In this sense he reached back into a neo-classical tradition central to Scottish intellectual life in the eighteenth century, and most spectacularly expressed in the paintings of Gavin Hamilton and Alexander Runciman. Finlay, however, was acutely aware of the distance between the classical psyche and the contemporary experience. In consequence his art displays an ironic displacement, juxtaposing the grandeur of the classical with the terrifying uncertainty of the present. In a sculpture such as '*Et in Arcadia Ego*' – *after Nicolas Poussin* (fig. 11.21), this displacement was most clearly articulated. Here the arcadian landscape of Poussin's original is reproduced while the mausoleum originally discovered by the shepherds now takes the form of a tank. The logic of the classical order is invaded by the totems of contemporary chaos and layers of meaning are built up to explore the instability of our present situation. These features of Finlay's work – penetrating, provocative, refusing to view art as a forum for mere technical display – have helped bring Scottish modernism back into an avenue of genuinely productive insight. By reaching out for the conceptual, and reasserting the primacy of the intellect above the reductively aesthetic, Finlay established a precedent which could be fruitfully explored by younger Scottish artists in the 1980s.

Extensions of this approach have become prevalent in the last decade, most spectacularly perhaps in the work of Steven Campbell. While Campbell clearly moves much closer to the figurative and narrative traditions than Finlay did, he also shadows a number of Finlay's concerns. In his painting Campbell reconnoitres many of the cultural markers of contemporary western civilization, for example in *Two Humeians Preaching Causality to Nature*, 1984 (fig. 11.22), and set out to deploy a series of puzzles, riddles and games around his signs. These develop into ironic reflections, subtly interrogating the means by which cultural values are reduced to style and presentation. But at the broader level these works reaffirm an encounter with art that is not passive and sensory, but active and contemplative, and this is a feature which now abounds in Scottish art. Amongst the many protagonists of this rich vein of painting, Gwen Hardie, in works like *Cowardice* (fig. 11.23), has developed the

Fig. 11.19 *Two Children, c. 1962.*
Joan Eardley (1921–63); oil and collage on canvas, 135 × 135 cm (53⅛ × 53⅛ in)
Cyril Gerber Fine Art, Glasgow
Photo: George Oliver

figurative approach into a thematic exploration centred upon the issue of gender, while Stephen Conroy in *Healing of a Lunatic Boy* (fig. 11.24), recalls not only the technical precision but also the poetic metaphysics of Cowie. These are important examples precisely because they return Scottish art to a programme which is pioneering rather than derivative, and because they demonstrate how modern art can evolve from the remnants of a native tradition. Moreover, these works find their strength in the most abstract of Scottish characteristics, the desire for metaphysical and theoretical enquiry. But, in the last two decades, another stream of contemporary work has reflected more directly on Scottish identity itself as a resource of cultural enlightenment.

Most notably Will Maclean has, since the early 1970s, been creating box constructions which conjure with the fragmented icons of the Gaelic world. *Memories of*

a Northern Childhood (fig. 11.25), from 1977, recreates through precise carvings the detritus of a marginalized and systematically eroded culture, and transforms this into a poetic expression at once elegy and eulogy. The entire existence of a culture seems to be recalled in the remnants of these symbols and the ways in which they might be reinterpreted by the artist. The material and spiritual dimensions of a vanishing world are given voice and their intrinsic merits brought forth. Works like this tap the buried root of Scottish identity; its existence is reinvented as echoes of the material life of Scottish communities. This, however, is not a narrow nationalism, for Will Maclean is concerned above all with any community threatened by an increasingly homogenous world culture. Hence his iconography extends to ethnic traditions, such as the symbolic worlds of the Inuit and the American Indian. Moreover, his underlying concern remains with the

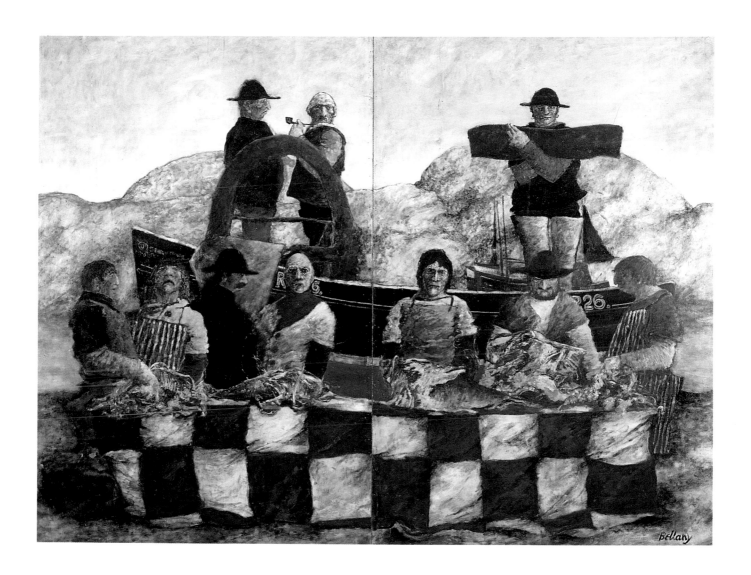

Fig. 11.20 *Kinlochbervie*, 1964
John Bellany (b. 1942); oil on canvas, 243.5 × 320 cm
($95\frac{7}{8}$ × 126 in)
Scottish National Gallery of Modern Art, Edinburgh

Fig. 11.21 *'Et in Arcadia Ego' – after Nicolas Poussin*, 1976
Ian Hamilton Finlay (b. 1925) with J. Andrews; stone,
20 × 28 × 7.5 cm ($7\frac{7}{8}$ × 11 × 3 in)
Scottish National Gallery of Modern Art, Edinburgh

Fig. 11.22 *Two Humeians Preaching Causality to Nature*, 1984
Steven Campbell (b. 1953); oil on canvas, 293.2 × 239.7 cm
(115$\frac{7}{16}$ × 94$\frac{3}{8}$ in)
Walker Art Center, Minneapolis

expression of an authentic interaction between man and nature. The three panels of *Leviathan Elegy* (fig. 11.26) from 1982, for example, are a poetic document of the early whaling industry and the interdependence between human community and the natural world.

In Will Maclean's work, those groups and communities largely silenced by the dominant orthodoxies of metropolitan and standardized cultures are given a voice. In the work of the younger Glasgow artists a similar phenomenon has occurred. Peter Howson has selected his subjects from the fringes of Scottish urban life, while a painter like Ken Currie has chosen to articulate the history of that class most generally excluded from the official culture. Currie's ambitious *Glasgow History Murals*, like his *Glasgow Triptych* (fig. 11.27), documents working-class struggle in urban Scotland. Here is an art which abstains from the decorative formalism of the modernist tradition and takes as its subject the real experience of the Scottish nation. More significantly Currie's motivation has been a response to those groups that have most actively created the conditions of Scottish enterprise and prosperity. This work develops the technical flair of the Mexican artist Diego Rivera's mural technique into an extended reflection on the underside of Scottish history.

Interestingly, the most recent work of the photographer Calum Colvin, for example, *Flying a Kite* (fig. 11.28), demonstrates a curious reversal of strategy. Colvin has taken the ersatz culture that has so often represented the public image of Scottish life, and gently mocked its tourist clichés. The panoramas of mountains and glens, the comic kilted Highlanders, the inauthentic parody of Scottish 'customs' are opened out to reveal their intrinsic inanities. While Currie examines the underlying historical reality of contemporary Scottish life, Colvin explores and ridicules the cosy myth of its

Fig. 11.23 *Cowardice*, 1986
Gwen Hardie (b. 1962); oil on canvas, 220 × 160 cm (86$\frac{5}{8}$ × 63 in)
Photo: Fischer Fine Art, London

Fig. 11.24 (OPPOSITE) *Healing of a Lunatic Boy*, 1986
Stephen Conroy (b. 1964); oil on canvas, 123.8 × 93.5 cm
(48$\frac{3}{4}$ × 36$\frac{13}{16}$ in)
Scottish National Gallery of Modern Art, Edinburgh

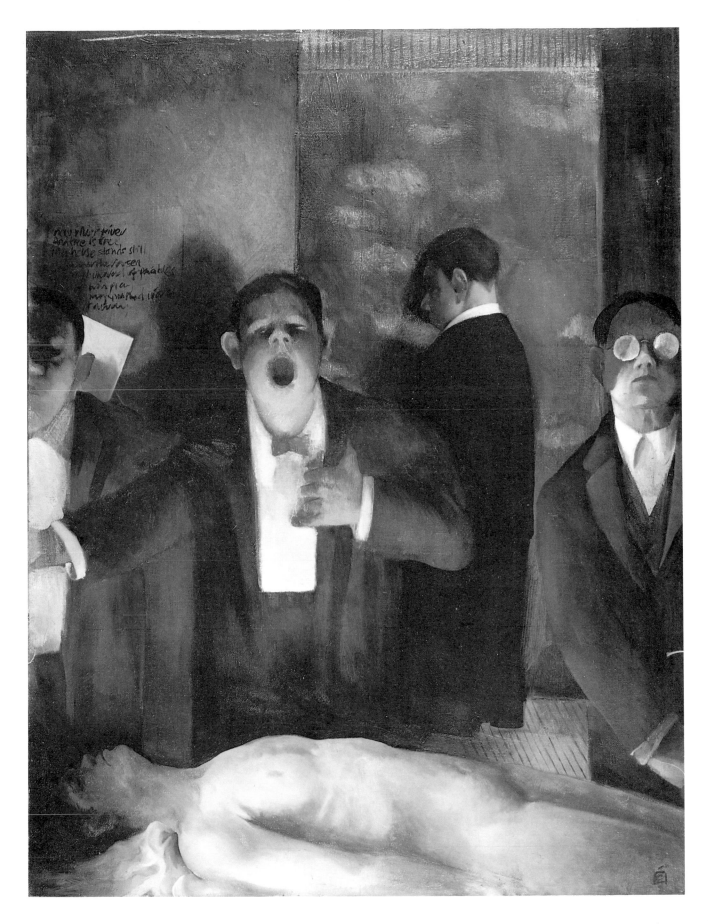

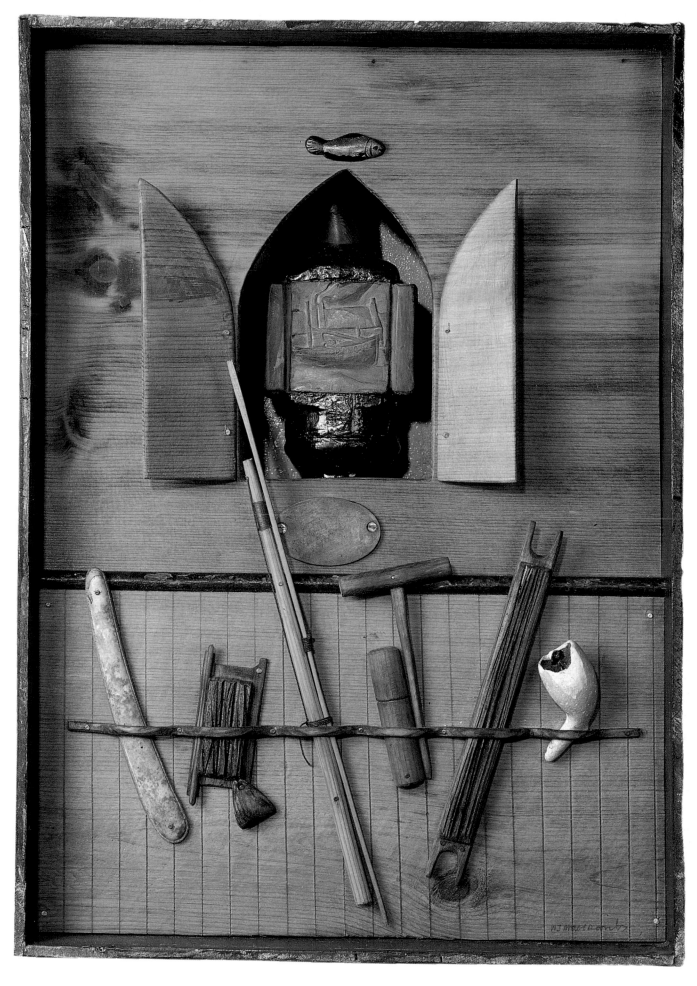

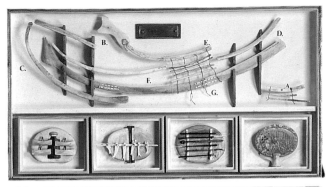

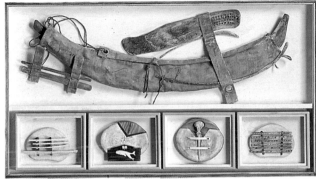

public face, a myth produced largely from the colonial experience. At its best then, modern Scottish art has become a subtle and provocative culture of resistance, casting off imposed values and discovering anew the indigenous spirit of the nation.

Certainly this can be seen as backward looking, but a nation that has had its native roots broken and replaced with a caricature of a culture can only progress by the rediscovery of its authentic self. Given this situation the strategies of the younger Scottish artists have a profound significance, one which is neither narrow nor chauvinist but entirely necessary if identities and values are not to be lost in some commercially debased monoculture of the future. Consequently when a painter like Kate Whiteford produces a subtly evocative work like *Lustra* (fig. 11.29), it is not simply a restated Pictish symbolism, but the recovery of the

Fig. 11.28 (TOP) *Flying a Kite*, 1989
Calum Colvin (b. 1961); cibachrome photograph,
76.2 × 101.6 cm (30 × 40 in)
Salama-Caro Gallery, London

Fig. 11.29 (ABOVE) *Lustra*, 1983
Kate Whiteford (b. 1952); oil and gold pigment on canvas,
200 × 300 cm ($78\frac{3}{4} × 118\frac{1}{8}$ in)
Harris Museum and Art Gallery, Preston

Fig. 11.26 (ABOVE LEFT) *Leviathan Elegy*, 1982
Will Maclean (b. 1941); painted whale bone and found objects,
203 × 137 × 10 cm ($79\frac{15}{16} × 53\frac{15}{16} × 3\frac{15}{16}$ in)
Aberdeen Art Gallery & Museums, Aberdeen City Arts Department

Fig. 11.25 (OPPOSITE) *Memories of a Northern Childhood*, 1977
Will Maclean (b. 1941); wood, slate and found objects,
48 × 35 × 15 cm ($18\frac{7}{8} × 13\frac{3}{4} × 5\frac{15}{16}$ in)
Private Collection

Fig. 11.27 *The Apprentice*, centre panel of
 Glasgow Triptych, 1986
Ken Currie (b. 1960); oil on canvas, 214.2 × 275.4
$(84\frac{5}{16} \times 108\frac{7}{16}$ in)
Scottish National Gallery of Modern Art, Edinburgh

most valuable dimensions of human experience – the loss, discovery and the renewal of the human spirit. The future of Scottish art and culture lies in works like these.

Throughout the 1980s an increasing number of important examples of this self-confident and authentically Scottish art have been produced: from Will Maclean's extraordinary elegiac boxed motifs, invoking the solemn persistence of marginalized cultures in their unequal struggle with modernity; through Kate Whiteford's visionary exploration of Scotland's prehistory, paralleling her concern to unearth the symbolic echoes of vanished civilizations; to Ken Currie who brings to light those classes and activities ignored by the official culture. Diverse artists with distinct programmes in their art, all are committed to releasing the forgotten and submerged from the shadows of obfuscation – itself a metaphor for all that is best in modern Scottish art. Forgetting the indecisions, reversals and servile mimicry of much that has passed for Scottish modernism, these artists reveal the immanent qualities of a native culture which can declare its vitality in the face of the world.

Bibliography

1. Art and Design, 3000 BC to AD 1000

Bradley, Richard, *The Social Foundations of Prehistoric Britain*, Longman, London, 1984

Clarke, D. V., Cowie, T. G. and Foxon, A., *Symbols of Power at the time of Stonehenge*, HMSO, Edinburgh, 1985

Graham-Campbell, James and Kidd, Dafydd, *The Vikings*, British Museum Publications, London, 1980

MacGregor, Morna, *Early Celtic Art in North Britain*, Leicester University Press, Leicester, 1976

Ritchie, Graham and Anna, *Scotland: Archaeology and Early History*, Thames and Hudson, London, 1981

2. Art and the Church before the Reformation

The Acts of the Parliaments of Scotland, II, AD MCCCCXXIV – AD MDLXVII, 1814

Allen, J. R. and Anderson, J., *The Early Christian Monuments of Scotland*, Society of Antiquaries of Scotland, Edinburgh, 1903

Apted, M. R. and Robertson, W. N., 'Late Fifteenth Century Church Paintings from Guthrie and Foulis Easter', *Proceedings of the Society of Antiquaries of Scotland*, 95 (1961–62), 1964, pp. 262–79

Caldwell, D. H. (ed.), *Angels, Nobels & Unicorns: Art and Patronage in Medieval Scotland*, National Museum of Scotland, Edinburgh, 1982

Carter, C., 'The *Arma Christi* in Scotland', *Proceedings of the Society of Antiquaries of Scotland*, 90 (1956–57), 1959, pp. 116–29

Davis-Weyer, C., *Early Medieval Art 300–1150*, Prentice Hall, Englewood Cliffs, NJ, 1971

Dickinson, W. C. (ed.), *John Knox's History of the Reformation in Scotland*, Nelson, London, 1949

Eeles, F. C., *King's College Chapel Aberdeen: its fittings, ornaments and ceremonial in the sixteenth century*, Aberdeen University Studies, No. 136, Oliver & Boyd, Edinburgh and London, 1956

Fawcett, R., *Scottish Medieval Churches*, HMSO, Edinburgh, 1985

Forbes-Leith, W., *The Life of St Margaret Queen of Scotland by Turgot Bishop of St Andrews*, 3rd edn, David Douglas, Edinburgh, 1896

Hamer, D. (ed.), *The Works of Sir David Lindsay of the Mount 1490–1555*, I, Scottish Text Society, 3rd series, 1, William Blackwood, Edinburgh and London, 1931

Hay, G., 'A Scottish Altarpiece in Copenhagen', *Innes Review*, 7, 1956, pp. 5–10

Henderson, I., *The Picts*, Thames and Hudson, London, 1967

McRoberts, D., *Catalogue of Scottish Medieval Liturgical Books and Fragments*, James S. Burns and Sons, Glasgow, 1953

McRoberts, D., 'The Fetternear Banner', *Innes Review*, 7, 1956, pp. 69–86

McRoberts, D., 'Notes on Scoto-Flemish Artistic Contacts', *Innes Review*, 10, 1959, pp. 91–6

McRoberts, D., 'Material Destruction caused by the Scottish Reformation', in D. McRoberts (ed.), *Essays on the Scottish Reformation 1513–1625*, James S. Burns and Sons, Glasgow, 1962, pp. 415–62

McRoberts, D., *The Heraldic Ceiling of St Machar's Cathedral Aberdeen*, Friends of St Machar's Cathedral Occasional Papers, No. 2, 1973

McRoberts, D., 'The Fifteenth-Century Altarpiece of Fowlis Easter Church', in A. O'Connor and D. V. Clarke (eds), *From the Stone Age to the 'Forty-Five: Studies Presented to R. B. K. Stevenson*, John Donald, Edinburgh, 1983, pp. 384–98

Medieval Art and Architecture in the Diocese of St Andrews (11th to 16th Century): The British Archaeological Association Conference Transactions for the Year 1986, J. Higgitt (ed.), Leeds [forthcoming]

Migne, J.-P. (ed.), *Patrologiae Cursus Completus . . . Series Secunda (Latina)*, 172, Paris, 1854

Mill, A. J., *Mediaeval Plays in Scotland*, St Andrews University Publications, No. 24, William Blackwood, Edinburgh and London, 1927

Norton, C. and Park, D., *Cistercian Architecture in the British Isles*, Cambridge University Press, Cambridge, 1986

Richardson, J. S., *The Mediaeval Stone Carver in Scotland*, Edinburgh University Press, Edinburgh, 1964

Royal Commission on the Ancient and Historical Monuments of Scotland, *Argyll: An Inventory of the Monuments*, 1, Iona, HMSO, Edinburgh, 1982

Steer, K. A. and Bannerman, J. W. M., *Late Medieval Monumental Sculpture in the West Highlands*, HMSO, Edinburgh, 1977

Thompson, C. and Campbell, L., *Hugo van der Goes and the Trinity Panels in Edinburgh*, National Galleries of Scotland, Edinburgh, 1974

3. In Search of Scottish Art: Native Traditions and Foreign Influences

Armstrong, R. B., *The Irish and Highland Harps*, David Douglas, Edinburgh, 1904

Brydall, R., 'The Monumental Effigies of Scotland from the Thirteenth to the Fifteenth Century', *Proceedings of the Society of Antiquaries of Scotland*, 29 (1894–95), pp. 329–409

Calder, J. (ed.), *The Wealth of a Nation in the National Museums of Scotland*, National Museums of Scotland and Richard Drew, Edinburgh, 1989

Caldwell, D. H., *The Scottish Armoury*, William Blackwood, Edinburgh, 1979

Caldwell, D. H., *Highland Art*, National Museum of Antiquities of Scotland, Edinburgh, 1980

Caldwell, D. H. (ed.), *Angels, Nobels & Unicorns: Art and Patronage in Medieval Scotland*, National Museum of Scotland, Edinburgh, 1982

Caldwell, D. H., 'The Art of Scottish Firearms', *Man at Arms*, 17/1, Jan/Feb 1985, pp. 26–30

Callender, J. G., 'Fourteenth-Century Brooches and Other Ornaments in the National Museum of Antiquities of Scotland', *Proceedings of the Society of Antiquaries of Scotland*, 58 (1923–24), pp. 160–84

Fawcett, R., *Scottish Medieval Churches*, HMSO, Edinburgh, 1985

Finlay, I., *Scottish Crafts*, Harrap, London, 1948

Finlay, I., *Scottish Gold & Silver Work*, Chatto & Windus, London, 1956

McRoberts, D., *Catalogue of Scottish Medieval Liturgical Books and Fragments*, James S. Burns & Sons, Glasgow, 1953

National Museum of Antiquities of Scotland, *Brooches in Scotland*, HMSO, Edinburgh, 1971

Richardson, J. S., *The Medieval Stone Carver in Scotland*, Edinburgh University Press, Edinburgh, 1964

Steer, K. A. and Bannerman, J. W. M., *Late Medieval Monumental Sculpture in the West Highlands*, HMSO, Edinburgh, 1977

Stevenson, J. H. and Wood, M. *Scottish Heraldic Seals*, R. Maclehose & Co. Ltd, Glasgow, 1940

Stewart, I. H., *The Scottish Coinage*, Spink & Son Ltd, London 1976

4. Scotland's Artistic links with Europe

Apted, M. R., and Hannabus, S., *Painters in Scotland 1301–1700: A biographical dictionary*, Scottish Record Society, New Series, Edinburgh, 1978

Hardie, W., *Scottish Painting*, Cassell Studio Vista, London, 1990

Holloway, J. E. and Errington, L. M., *The Discovery of Scotland*, National Galleries of Scotland, Edinburgh, 1978

Holloway, J. E., *Patrons and Painters: Art in Scotland 1650–1760*, National Galleries of Scotland, Edinburgh, 1989

Irwin, D. and F., *Scottish Painters at Home and Abroad 1700–1900*, Faber, London, 1975

Thomson, D., *Painting in Scotland 1570–1650*, National Galleries of Scotland, Edinburgh, 1975

5. Scottish Design and the Art of the Book, 1500–1800

Alden, John Eliot, 'John Mein, Publisher: an essay in bibliographical detection', *Papers of the Bibliographical Society of America*, XXXVI, 1942, pp. 199–214

Alden, John Eliot, 'Scotch type in eighteenth-century America', *Studies in Bibliography*, III, 1951, pp. 270–4

Beattie, William, *The Scottish tradition in printed books*, Saltire Society, Nelson, Edinburgh, 1949

Bushnell, George H., 'Scottish bookbindings and bookbinders: 1450–1800', *The Bookman's Journal*, XV, 1927, pp. 67–88

Dickson, Robert and Edmond, John Philip, *Annals of Scottish printing from the introduction of the art in 1507 to the beginning of the seventeenth century*, Macmillan & Bowes, Cambridge, 1890

Gaskell, Philip, 'The early work of the Foulis Press and the Wilson Foundry', *The Library*, 5 ser., VII, 1952, pp. 77–110; 149–77

Loudon, J. H., *James Scott and William Scott, bookbinders*, Scolar Press in association with the National Library of Scotland, London, 1980

Mitchell, William Smith, *A History of Scottish Bookbinding 1432 to 1650*, University of Aberdeen, Oliver & Boyd, Edinburgh, 1955

Morris, John, 'Wheels and herringbones: some Scottish bindings 1678–1773', *Bookbinder*, I, 1987, pp. 39–50

Nilsson, Axel, *Bokbandsdekorens stilutveckling*, Röhsska Konstlöjdmuseet, Göteborg, 1922

Sommerlad, M. J., *Scottish 'wheel' and 'herring-bone' bindings in the Bodleian Library: an illustrated handlist*, Oxford Bibliographical Society Occasional Publications, No. 1, Bodleian Library, Oxford, 1967

6. The Eighteenth-Century Interior in Scotland

Bamford, Francis, 'Dictionary of Edinburgh Furniture Makers', *Furniture History Society*, XIX, 1983

Cornforth, John, *English Interiors 1790–1848*, Barrie and Jenkins, London, 1978

Gow, Ian, 'The Northern Athenian Room: Sources for the Scottish Interior', *The Review of Scottish Culture*, No. 5, 1989

Gow, Ian, *The Scottish Interior*, Edinburgh University Press, Edinburgh, 1990

Howard, Deborah (ed.), Proceedings of the William Adam Tercentenary Conference, *Architectural Heritage Society of Scotland Journal*, 1990

Irwin, Francina, 'Scottish Eighteenth-Century Chintz and its Design', *The Burlington Magazine*, CVII, 1965, pp. 457–8

Jones, David, *Looking at Scottish Furniture, 1570–1900*, Exhibition catalogue, Crawford Centre for the Arts, St Andrews, 1987

Mackay, Sheila (ed.), *Scottish Georgian Interiors*, Moubray House Press, Edinburgh, 1987

Mackay, Sheila (ed.), *Scottish Renaissance Interiors*, Moubray House Press, Edinburgh, 1987

Swain, Margaret, 'A Georgian Mystery, Lady Mary Hog and The Newliston Needlework', *Country Life*, 12 August 1882

Swain, Margaret, *Tapestries and Textiles Palace of Holyroodhouse*, HMSO, London, 1988

Warrack, John, *Domestic Life in Scotland 1488–1688*, Methuen, London, 1920

7. Industrial Design in Scotland, 1700–1990

Ahrons, Ernest L., *The British Steam Locomotive 1825–1925*, Ian Allan, London, reprint 1963

Campbell, R. H., *Carron Company*, Oliver & Boyd, Edinburgh, 1961

Gillies, J. D. and Wood, J. L., *Aviation in Scotland*, Royal Aeronautical Society, Glasgow and West of Scotland Branch, 2nd edn, 1968

Glasgow Museums and Art Gallery, *Scottish Cars – Their history and a descriptive guide to some of those that survive*, Glasgow Art Gallery and Museum, 1962

Gloag, John and Bridgewater, D. A., *A History of Cast Iron in Architecture*, Allen & Unwin, London, 1948

Harvey, W. and Downes-Rose, H., *William Symington: Inventor and Engine Builder*, Northgate Publishing Co. Ltd., London, 1980

Highet, Campbell, *Scottish Locomotive History 1831–1923*, Allen & Unwin, London, 1970

Hume, John R. 'Shipbuilding Tools' in John Butt and John Ward (eds), *Scottish Themes*, Scottish Academic Press, Edinburgh, 1975

Hume, John R. and Moss, M. S., *Beardmore, History of a Scottish Industrial Giant*, Heinemann, London, 1979

Hume, John R. and Moss, M. S., *Clyde Shipbuilding from Old Photographs*, Batsford, London, 1975

Lowe, James W., *British Steam Locomotive Builders*, Good & Son, Cambridge, 1975

March, Edgar J., *Sailing Drifters*, David & Charles, Newton Abbot, reprint 1969

Moss, M. S. and Hume, John R., *The Making of Scotch Whisky*, James & James, Edinburgh, 1981

Moss, M. S. and Hume, John R., *Workshop of the British Empire*, Heinemann, London, 1977

Reilly, Valerie, *The Paisley Pattern*, Richard Drew, Glasgow, 1987

Smith, E. C., *A Short History of Marine Engineering*, Cambridge University Press, Cambridge, 1937

Swain, M. H., *The Flowerers: the origins and history of Ayrshire needlework*, Chambers, Glasgow, 1955

Tarrant, Naomi, 'The Turkey Red Dyeing Industry in the Vale of Leven' in John Butt and Kenneth Ponting (eds), *Scottish Textile History*, Aberdeen University Press, Aberdeen, 1987

Walker, Fred M., *The Song of the Clyde*, Patrick Stephens, Cambridge, 1984

Wear, Russell, *The Locomotive Builders of Kilmarnock*, The Industrial Railway Society, London, 1977

8. Sir Walter Scott and Nineteenth-Century Painting in Scotland

Armstrong, Sir Walter, *Sir Henry Raeburn*, London, 1901

Caw, Sir James L., *William McTaggart*, Glasgow, 1917

Cockburn, Lord, *Memorials of his own Time*, Edinburgh, 1856

Cunningham, Allan, *The Life of Sir David Wilkie*, 3 vols, London, 1843

Errington, L. M., *Tribute to Wilkie*, National Galleries of Scotland, Edinburgh, 1985

Gibbon, J. M., 'Painters of the Light: An Interview with William McTaggart RSA', *Black and White*, 30 September 1905

National Gallery of Scotland, *Catalogue of Paintings and Sculpture*, Edinburgh, 1957

The Scots Magazine and Edinburgh Literary Miscellany, July 1814, pp. 524 33

Scott, Sir Walter, *The Lay of the Last Minstrel*, Edinburgh, 1805

Scott, Sir Walter, *Marmion*, Edinburgh, 1808

Scott, Sir Walter, *The Lady of the Lake*, Edinburgh, 1810

Scott, Sir Walter, *Waverley: or 'tis sixty years since*, Edinburgh, 1814

Scott, Sir Walter, *The Antiquary*, Edinburgh, 1816

Scott, Sir Walter, *The Fair Maid of Perth: or St Valentine's Day*, Edinburgh, 1828

Simpson, Rev A. L., *Works of Sir George Harvey, PRSA*, Edinburgh, n.d.

9. How many Swallows make a Summer? Art and Design in Glasgow in 1900

Billcliffe, Roger, *Mackintosh Watercolours*, John Murray, London, 1978

Billcliffe, Roger, *Charles Rennie Mackintosh: The Complete Furniture, Furniture Drawings and Interior Design*, 3rd edn, John Murray, London, 1986

Billcliffe, Roger, *The Glasgow Boys*, John Murray, London, 1985

Buchanan, William (et al), *The Glasgow Boys*, Scottish Arts Council, Glasgow, 1968

Howarth, Thomas, *Charles Rennie Mackintosh and the Modern Movement*, 2nd edn, Routledge and Kegan Paul, London, 1977

Larner, Gerald and Celia, *The Glasgow Style*, Paul Harris, Edinburgh, 1979

Glasgow Art Gallery and Museum, *The Glasgow Style*, Glasgow Museums and Art Galleries, Glasgow, 1984

10. A 'Gleam of Renaissance Hope': Edinburgh at the Turn of the Century

Cumming, Elizabeth, *Arts and Crafts in Edinburgh 1880–1930*, Edinburgh College of Art, Edinburgh, 1985

Gow, Ian, 'Sir Rowand Anderson's National Art Survey of Scotland', *Architectural History*, 27, 1984, pp. 543–54

Hardie, Elspeth, 'William Scott Morton', *The Antique Collector*, March 1988, pp. 70–79

Hardie, Elspeth, 'Tynecastle Tapestry in the United States', *The Antique Collector*, May 1989, pp. 108–16

Master Weavers: Tapestry from the Dovecot Studios 1912–1980, Canongate, Edinburgh, 1980

Parry, Linda, *Textiles of the Arts and Crafts Movement*, Thames and Hudson, London, 1988

Savage, Peter, *Lorimer and the Edinburgh Craft Designers*, Paul Harris, Edinburgh, 1980

Swain, Margaret, *Scottish Embroidery, Medieval to Modern*, Batsford, London, 1986

11. Scottish Modernism and Scottish Identity

Auld, A., *Scottish Painting 1880–1930*, Exhibition catalogue, Glasgow Museums and Art Galleries, Glasgow, 1973

Beveridge, C. and Turnbull, R., *The Eclipse of Scottish Culture*, Polygon, Edinburgh, 1989

Fergusson, J. D., *Modern Scottish Painting*, Wm MacLellan, Glasgow, 1943

Gage, E., *The Eye in the Wind: Contemporary Scottish Painting since 1945*, Collins, London, 1977

Hall, D. and Brown, A., *Twentieth-Century Scottish Painting*, Exhibition catalogue, 369 Gallery, Edinburgh, 1987

Halsby, J., *Scottish Watercolours 1740–1940*, Batsford, London, 1986

Hardie, W. *Scottish Painting 1837–1939*, Studio Vista, London, 1976

Hartley, Keith, *Scottish Art Since 1900*, Lund Humphries, London, 1989

Hartley, K. (et al.), *The Vigorous Imagination*, Exhibition catalogue, National Galleries, Edinburgh, 1987

Honeyman, T. J., *Three Scottish Colourists*, Nelson, Edinburgh, 1950

MacDiarmid, H., *The Company I've Kept*, Hutchinson, London, 1966

MacDiarmid, H., *Aesthetics in Scotland*, Mainstream, Edinburgh, 1984

Moffat, A., *New Image Glasgow*, Exhibition catalogue, Third Eye Centre, Glasgow, 1985

Morris, M., *The Art of J. D. Fergusson*, Blackie, Glasgow, 1974

Robertson, P., *From McTaggart to Eardley Scottish Watercolours and Drawings 1870–1950*, Exhibition catalogue, Hunterian Art Gallery, Glasgow, 1986

Tonge, J., *The Arts of Scotland*, Kegan Paul, London, 1938

Whyte, J. H. (ed.), *The Modern Scot*, J. H. Whyte, Dundee, 1930–36

Contributors

JOHN C. BARRETT is a Lecturer in Archaeology at the University of Glasgow and an editor of the *Scottish Archaeological Review*. He is currently working on a study of southern Britain in the second millennium BC.

ROGER BILLCLIFFE came to Glasgow in 1969 as Assistant Keeper of the University Art Collections, with special responsibility for the design of the proposed Hunterian Art Gallery. In 1977 he was appointed Keeper of Fine Art at Glasgow Art Gallery & Museum and since 1979 has worked for The Fine Art Society, where he is now a Director. Since 1977 he has published five books on the work of Charles Rennie Mackintosh; in 1985 he published a major study on the Glasgow Boys and, more recently, on the Scottish Colourists.

DAVID H. CALDWELL is the Curator in charge of the Scottish collections from 1100 to 1700 in the National Museums of Scotland. He is an archaeologist and has published several works on Scotland, particularly on weapons and warfare.

ELIZABETH CUMMING is an art historian and freelance exhibition organizer. Between 1975 and 1984 she was Keeper of the City of Edinburgh Art Centre. Her doctoral thesis was written on the artist-designer Phoebe Traquair and she has contributed to a number of exhibition catalogues on Scottish artists. She is the co-author, with Wendy Kaplan, of a study of the Arts and Crafts movement in Britain, America and Europe to be published in 1991 as part of the *World of Art* series.

LINDSAY ERRINGTON is Assistant Keeper of British Art at the National Gallery of Scotland. She has organized several exhibitions on Scottish painting, in particular on David Wilkie (1985) and William McTaggart (1989). She was Slade Professor of Fine Art at Cambridge University in 1989, lecturing on nineteenth-century Scottish art.

IAN GOW is Assistant Curator of Architectural Collections at the National Monuments Record of Scotland and the Honorary Curator of the Royal Incorporation of Architects in Scotland. He has published many articles on the decorative arts and architecture of Scotland including (with Timothy Clifford) *The National Gallery of Scotland, An Architectural and Decorative History*, 1988, and has recently completed the book *The Scottish Interior*.

JOHN HIGGITT is a Senior Lecturer in the Department of Fine Art at the University of Edinburgh. His research and publications are in the fields of medieval inscriptions and their audience, manuscript illumination, iconography and Scottish medieval art.

JAMES HOLLOWAY is Assistant Keeper at the Scottish National Portrait Gallery. He has written extensively on eighteenth-century Scottish art. His most recent book, *Patrons and Painters: Art in Scotland 1650–1760*, was published in 1989.

JOHN HUME is Senior Lecturer at Strathclyde University specializing in Industrial History and Archaeology. He is currently seconded as a Principal Inspector at Historic Buildings and Monuments, and has written a number of books and articles on the history of Scottish industry.

WENDY KAPLAN is an art historian and museum consultant. Between 1979 and 1987 she was Research Associate at the Muséum of Fine Arts, Boston, where she organized the exhibition ' "The Art that is Life": The Arts and Crafts Movement in America, 1875–1920' and was principal author of the exhibition catalogue. She has written many other works on nineteenth- and twentieth-century design history and has edited numerous publications.

JOHN MORRIS is an Assistant Keeper at the National Library of Scotland. He has published articles on the history of bookbinding, and on illustrated books.

TOM NORMAND is a Lecturer in the History of Art at the University of St Andrews. He has published articles on aspects of Scottish and English painting in various journals and periodicals including *Alba, The Burlington Magazine, Cahier: Internationaal Centrum Voor Structuuranalyse und Constructivisme*, and *The History of the Human Sciences*.

Index

Numbers in *italics* refer to illustrations